FSA

FSA

The
American
Vision

WITHDRAWN

Gilles Mora and Beverly W. Brannan

Abrams, New York

ACKNOWLEDGMENTS

I would like to thank the team at du Seuil responsible for producing this book.

Gilles Mora

I would like to thank the following people. At the Library of Congress, Jeremy Adamson, chief of the Prints and Photographs Division, and Jesse James and Evelio Rubiella of the Office of the General Counsel. The FSA-OWI folks: the late Louise Rosskam and her daughters Ani Rosskam and Susie Marchon; the late Bernarda Bryson and her family, Jonathan and J. B. Shahn, Amanda Slamm, and Harry Bryson Pope; Grace Rothstein; Jean Bubley; Jerry Raines; Pablo Delano; and Ann Vachon. Also, alphabetically, Pete Daniel, Laura Katzman, Sarah Miller, Mary Panzer, John Peterson, Leonard Rapport, Gary Saretzky, and George Storey. I am grateful to decades of stewards of the FSA-OWI collection; Richard Doud for his interviews; and the Schlesinger Library for permission to quote from the Marjory Collins papers. Finally, to my family, John, Kate, and Molly, who waited impatiently for me to finish yet another project. It has been a pleasure to work with Gilles Mora and staff of du Seuil.

Beverly W. Brannan

NOTE TO READERS

In this volume, each chapter dedicated to an FSA photographer presents his or her photographs in two parts. The first constitutes a series on a specific subject or place, underscoring the photographs' documentary aspect as well as revealing the photographer's working method. Many of these images are previously unpublished and significant only in the context of the series. The second part collects some of the best works the same photographer took while on assignment for the FSA. The accompanying captions are the ones the photographers submitted with their photographs, lightly edited for spelling, sense, and occasionally space.

CONTENTS

BEVERLY W. BRANNAN "TO MAKE A DENT IN THE WORLD"

The goal of the Farm Security Administration photographic project was not just to record facts, but to make a difference.[1] "Every one of us had been hired not just for talents he may have possessed, but for his commitment, his compassionate view of the hard life so many people were struggling against," observed FSA staff member Edwin Rosskam. According to Rosskam, the project's director, Roy Stryker, had "hired these artists to make a dent in the world."[2]

RESETTLEMENT ADMINISTRATION BEGINS

Franklin Delano Roosevelt (1882–1945), who was governor of New York while campaigning for the U.S. presidency, valued Columbia University economics professor Rexford Tugwell (1891–1979) as a member of his "brain trust"—the informal cabinet of policy advisers he'd drawn from Columbia's faculty—with original ideas for dealing with intractable economic problems. After his 1932 election on a platform of providing a "New Deal" of better opportunities for everyone, Roosevelt brought Tugwell into his administration as assistant secretary of agriculture and charged him with finding ways to bring the New Deal to farmers struggling to survive under existing programs.

America's economy had relied on agriculture so long that the Department of Agriculture had evolved into one of the largest bureaucracies in the federal government. Generally its programs subsidized farmers who were doing well, with the expectation that they would employ agricultural workers. By the onset of the Great Depression, that system was already breaking down. Instead of using the federal assistance to hire laborers, farmers were using it to mechanize their operations. They dismissed their farm workers, sending them into a jobless nightmare, and at a time when social welfare programs for the unemployed were inadequate to the need.

In 1934 Tugwell, then undersecretary of agriculture, invited Roy Stryker (1893–1975), who had been his economics graduate assistant at Columbia, to spend the summer as a "specialist in visual information" at the Department of Agriculture, gathering illustrations for various publications.[3] As the taciturn Tugwell was alone for the summer, Stryker lodged at his house and commuted with his boss. On their way home one evening, Stryker proposed a pictorial source book on agriculture.[4] Tugwell endorsed the idea, and Stryker continued working on the source book over the winter by spending school vacations in the Department of Agriculture archives in Washington, D.C. Back at Columbia, some twenty students, funded by a National Youth Administration grant, collected and photographed thousands of images for the project.[5]

Academic excitement about the pictorial history reflected economic theorists' engagement with farm issues at that time. Theorists needed captioned pictures to help them understand actual farm work. Stryker recalled, "About this time the Resettlement Administration was aborning. It was a glint in the papas' eyes, the two papas being Tugwell and the President."[6] In 1935 the Resettlement Administration was created, independent of the Department of Agriculture. Tugwell was in charge of experimenting with ways to help farmers and other workers in extreme situations, sometimes by "resettling" them in more promising locations. The

1. In this essay "FSA collection" refers to both the entire file generated in 1935–43 and the works created in 1937–42, when the Historical Section reported to the federal Farm Security Administration. The portion from 1935–37, when it reported to the Resettlement Administration, will be called "RA." The portion from 1942–43, when it reported to the Office of War Information, will be called "OWI." For a history of this groundbreaking photo project, see Fleischhauer and Brannan, eds., *Documenting America.*

2. Edwin Rosskam, "Not Intended for Framing: The FSA Archive," *Afterimage,* 8:8 (March 1981), pp. 10–11.

3. Stryker, interview with Doud, June 13, 1964. (Richard K. Doud conducted interviews in the mid-1960s with Stryker and many of the FSA photographers for the Smithsonian Institution's Archives of American Art. Most of the transcripts may be consulted online; see Bibliography.)

4. Transcript of a conversation among former FSA staff members at Vachon's New York apartment, 1952 (hereafter abbreviated as Vachon transcript), p. 2, John Vachon Papers; Stryker, interview with Doud, June 13, 1964.

5. Vachon transcript, pp. 3–6; Stryker, interview with Doud, June 13, 1964.

6. Vachon transcript, p. 6.

mission—to provide direct assistance to the destitute—put Tugwell's agency in conflict with the Department of Agriculture, so Tugwell had to bypass the department's information office to ensure photographic documentation of his agency's projects.[7] To that end, Tugwell had Stryker develop the Historical Section of the new Resettlement Administration.

ROY EMERSON STRYKER

The Roy Stryker who reported to Washington, D.C., in July 1935 was something of a displaced farmer himself. He had grown up on a subsistence cattle farm in Colorado, where the politics were Populist.[8]

Although the Stryker ranch was distant from urban centers and cultural institutions, the family stayed well informed. Stereographic cards (two nearly identical photographs that presented a three-dimensional image when seen through a special viewer) offered both entertainment and education in the later nineteenth and early twentieth centuries; they were so popular that nearly every household in America, even the Strykers' isolated cattle ranch, had "stereos."[9] "I knew about pictures," he said. "I grew up with them. We had on our table and around our house stereoscopes [the viewers]; we had two or three basketsful of stereos. We had pictures that my family had collected, the so-called cabinet pictures taken by these transient photographers of Box Canyon, Bear Creek Falls [both in Colorado], the tramway, and so on. I saw those and I was intrigued."[10] Stryker's interest was an early hint of his abiding visual orientation, although his eye was still untrained. After 1888, when Kodak introduced push-button cameras that were preloaded with roll film and produced "snapshots," amateur photography became so popular that it nearly replaced studio photographs. Stryker's older brother took snapshots, but Roy admitted, "I didn't know whether they were good or bad. I had no consciousness of that."[11]

Stryker's young adulthood was long on experience but short on salary. He attended mine engineering school, homesteaded, and worked as a cowboy. He served as a doughboy soldier in the American Expeditionary Force in France in World War I but never saw combat. Back in Colorado after the war, he and his future wife, high school teacher Alice Frasier, attended gatherings of the Social Gospel reform movement in Denver and worked with the city's Boys Clubs, where they learned firsthand about urban problems. Stryker read liberal publications such as the *New Republic* and the *Nation* and, through local contacts, gained admission to Columbia University, which he had dreamed of attending since his military service.[12] He and Frasier married in 1921 and went to New York. Colorado friends had arranged subsidized housing for them at the Union Settlement House; to qualify for it, one of them had to study for the ministry at Union Theological Seminary, so Alice, a college graduate, studied divinity. For a year they both worked with the children who visited the settlement house.

From 1921 to 1924 Roy worked toward his undergraduate degree in economics at Columbia. His professors included Rexford Tugwell and J. Russell Smith, both of whom had joined the faculty in 1920 after leaving the Wharton School of Business in Philadelphia to protest its economics department's stodgy elitism. They and others taught the required Contemporary Civilization class. A pioneering effort at interdisciplinary education in the United States, the two-

7. George Stoney, unpublished interview with Mary Panzer, Dec. 15, 2001.

8. Founded in 1890, the Populist party represented the interests of workers. It called for the reform of the banking system, the elimination of the gold standard and the unlimited coinage of silver, the nationalization of the railways, and a progressive income tax.—Ed.

9. Stryker, interview with Doud, 1965.

10. Ibid.

11. Ibid.

12. Stryker, interview with Doud, June 13, 1964.

year course provided beginning students a solid grounding in Western art, philosophy, economics, and culture. "Contemporary Civ" teachers combined the intellectual with the practical, wanting their students to know how things looked as well as how they worked. The innovative curriculum included, for example, mandatory walking tours of New York City's varied places of business—including financial institutions, hospitals, morgues, farms, tugboats, and clothing manufacturers—to provide students direct observation of American urban life.[13]

From 1924 to 1934 Stryker pursued an advanced economics degree while also serving as Tugwell's graduate assistant. He took the students in his discussion section of Tugwell's Contemporary Civilization class to places they had never been, such as picket lines, factories, and labor meetings, where they could observe and even help address labor problems from the bottom up. His tours were so popular that they began to overflow with participants, including the sons of wealthy industrialists and students from other discussion sections. They even attracted students from other parts of the university, so, at the university's request, Stryker devised nearly sixty different tours.[14]

In Stryker's first year in graduate school, Tugwell asked him to illustrate *American Economic Life,* which he and Thomas Munro were compiling as the basic textbook for the Contemporary Civ course.[15] While other economics graduate students focused on economic treatises, Stryker studied visual representations of economics. A gifted teacher, tour guide, and visual specialist, he became adept at explicating the "common man" and economic issues to people unfamiliar with either.

To research his project Stryker read *The Survey* (1912–21), a heavily illustrated journal for professional social workers, and its successor magazine, *Survey Graphic* (1921–48), which examined progressive approaches to social problems for a general audience.[16] He studied *Pageant of America: A Pictorial History of the United States,* a fifteen-volume publication that informed through illustrations and photographs.[17] He scanned signs, commercial advertising, and government photographs from the Department of Agriculture. He scrutinized the "Mid-Week Pictorial" of the *New York Times* and rotogravure pages from other newspapers.

He also analyzed Mathew Brady's photographs of the Civil War, although their content made them less relevant to his project than works by Lewis Hine, a pioneering photographer whose interest in social reform was similar to Stryker's.[19] Hine had worked for the National Child Labor Committee from 1908 to 1924, and his visual documentation of abuses was influential in strengthening child labor laws in the United States. Hine provided many of the illustrations for *American Economic Life* and spent long hours teaching Stryker to "read" photographs.

Using J. Russell Smith's heavily illustrated geography text *North America* as his model, Stryker wrote didactic captions for the new textbook's photographs, aiming to teach viewers to analyze what they saw. He hoped they would learn to recognize cause-and-effect relationships: people who were old before their time because of ceaseless, grueling work at low pay; farmers who fell to sharecropper status as production costs rose above prices they could realize for their harvest. Alice Stryker prepared the textbook's charts and graphs.[20] After the editing was completed, Stryker spent an additional year overseeing the printing.

The book proved successful, and Stryker continued to study and teach at Columbia and

13. Ibid.

14. Hurley, *Portrait of a Decade,* pp. 8–11.

15. Tugwell, Munro, and Stryker, *American Economic Life.*

16. Stryker, interview with Doud, June 13, 1964; Stryker, interview with Doud, 1965; Finnegan, *Picturing Poverty,* pp. 62–63.

17. Ralph Henry Gabriel, ed., *Pageant of America: A Pictorial History of the United States,* 15 vols. (New Haven: Yale University Press, 1925–29).

18. Stryker, interview with Doud, June 13, 1964.

19. Stryker, interview with Doud, 1963.

20. Stryker, interview with Doud, June 13, 1964.

to work on projects for the economics department. However, in ten years of graduate school he never completed the requirements for even a master's degree.[21] Tugwell eventually forced him to confront the fact that he was not a scholar. The dejected Stryker taught for a year in Brooklyn and addressed some health problems in the spring of 1935 before reporting to Washington, D.C., for what Tugwell advised would be a greater teaching job. Ultimately Stryker's post in Washington would draw upon every aspect of his extended apprenticeship and provide a foundation for everything he would do after he left the capital.

A MATTER OF STYLE

In July 1935, when the forty-two-year-old Stryker arrived in Washington to set up the Historical Section, the public information office for the Resettlement Administration (RA), he faced a delicate challenge. He had to set the tone for a new government agency proposing direct-assistance programs in conflict with the policies of the well-established Department of Agriculture. Highly placed people at the RA were aware of a developing documentary movement and determined to participate in it. Tugwell wanted the RA to produce films, radio broadcasts, prints, posters, and photographs based on real life in America. They would focus on those hardest hit by the Great Depression, in contrast to the newspaper photographs, rotogravure sections, and newsreels of the 1930s, which emphasized celebrity and wealth.

In 1952 Stryker recalled a conversation he had with Tugwell during his initial days at the RA:

> I got very much intrigued by the place of the moving farmer, the migrant. [Tugwell] said that we were going to have a lot of trouble. The press isn't going to be kind to us. [The Historical Section is] going to have to turn to new devices, the movie and the still pictures and other things, and he said our problem is to try to tell the rest of the world that here is a lower third, and that they are human beings like the rest of us. Their [shoes] are a bit shabbier and their clothes are a bit more holey and worn, but they are human beings. That was our job.[22]

Precedents existed for photographing the impoverished. Through his discussions with Lewis Hine, Stryker had learned of the photographs of Jacob Riis, who, a generation before Hine, had worked for social and political reformers who were attempting to bring to public attention such matters as immigrant housing and labor conditions.[23] The photographs by Riis and Hine and the use made of them spurred people to take action to improve social conditions, but that type of overtly reformist style had gone out of fashion by the early 1920s.

Progressive-era reform photography had tracked the United States's rural-to-urban transformation in the late 1800s and early 1900s. At the same time, interest had grown internationally in establishing photography as a fine art on par with painting or sculpture. Classical subject matter, color toning, unusual surface textures, and a soft, painterly focus characterized what came to be known as the Pictorialist style. Pictorialists, led in America by Alfred Stieglitz, sought to express beauty in photographs of daily life, contemporary architecture, and industrial equipment. Photographs like Stieglitz's "Winter, Fifth Avenue" (1893) and his shots of New York

21. Ibid.
22. Vachon transcript, p. 16.
23. Hurley, *Portrait of a Decade*, p. 13.

City's Flatiron Building (1903) poetically depict urban life and presage the portrayal of industrial, modern America in fine art. Serious photographers worked in this style for two or three decades before abandoning it for seeming too removed from contemporary life, but Pictorialism left its lyrical mark on the earliest Farm Security Administration (FSA) photographers. Dorothea Lange, for example, studied Pictorialism at the renowned Clarence White School of Photography in New York City from 1918 to 1919; in her early years working in California, she photographed modern dancers and family members in that style.[24] Arthur Rothstein—president of the Columbia University camera club and one of the twenty student photographers for the pictorial source book on agriculture Stryker produced at Columbia[25]—was another FSA photographer who had worked in a Pictorialist vein early in his career.[26]

In the 1920s, however, avant-garde art photographers as well as commercial photographers for elite fashion magazines like *Vogue* began using so-called straight photography to express the modern industrial aesthetic and to showcase merchandise. Paul Strand, with his clarity of vision and his mastery of printing, was one of the most admired photographers working in the straight mode. His written recommendations for future FSA photographers Marion Post Wolcott and Jack Delano, which impressed Stryker tremendously, show that those emerging talents were accomplished in the straight style even before joining the Historical Section.

Travel and landscape surveys presented other models for Stryker's unprecedented mission, but most such projects reflected a decidedly commercial perspective: The stereographic photographs he viewed in his youth were commercial productions; even Mathew Brady's Civil War photos, notwithstanding the lament for wasted life they evoked, had been made for sale. Likewise, the work of the pioneering landscape photographer William Henry Jackson, who worked for the World Transportation Commission and the Detroit Photographic Company, among others, was widely reproduced in postcard format.

Depression-era viewers and creators alike expected photographs to fit into predetermined categories, but ultimately Stryker's Historical Section, in its effort to document crisis conditions, would draw on all photographic styles—reform, newspaper, commercial, Pictorial, and straight. In the end, though, it may have been the nature of the crisis and the response to it that most shaped the distinctive documentary movement that emerged, making such a dent in the world of images.

RESETTLEMENT ADMINISTRATION, 1935–37

Tugwell selected people he thought were suited to a job, gave them a broadly stated assignment, and expected them to carry it out without further supervision. Initially Stryker struggled to define his own mission. In 1964 he told his interviewer, Richard K. Doud of the Archives of American Art, "We did not start with any nice, preconceived plan.... Number one. Number two: We had a very intelligent administrator [in Tugwell] who gave [us] a great deal of freedom and had very great confidence in me and he let us grow like Topsy. Because it served his purpose."[27]

Stryker sought out others' views in developing the Historical Section's direction. His Historical Section was only one aspect of the RA; the Special Skills Section, employing artists,

24. In December 1999 Henry Mayer, who was then working on a biography of Dorothea Lange, showed me such scenes in the unprocessed portions of the Dorothea Lange Collection, Oakland Museum; Fulton, ed. *Pictorialism into Modernism*, p. 196.

25. Vachon transcript, pp. 3–6; Stryker, interview with Doud, June 13, 1964.

26. Vachon transcript, p. 52.

27. Stryker, interview with Doud, June 13, 1964.

printmakers, and filmmakers, and Suburban Resettlement were others.[28] Visually oriented people from the other departments were quickly drawn to the gregarious Stryker. Urban Resettlement photographer Carl Mydans and Federal Emergency Relief Administration graphic designer and amateur photographer Theodor Jung transferred to Stryker's office soon after he arrived. During his first summer on the job he spoke at length with photographer Walker Evans, graphic artist Ben Shahn, and filmmaker Pare Lorenz about the kind of images the RA should produce. Three spiralbound economic reports to the Federal Emergency Relief Administration written by agricultural economist Paul Taylor—and illustrated with Dorothea Lange's photographs—helped clarify their thinking.[29] The dialogue among Stryker and those initial photographers gradually gave rise to a documentary team with a unified vision.

An expert at selecting photographs that communicated effectively, Stryker had little experience hiring the photographers who could produce them. He quickly realized that what made a good photographer was curiosity; it was

> a desire to know, it was the eye to see the significance around them. Very much what a journalist or a good artist is, is what I looked for. Could the man read? What interested him? What did he see about him? How sharp was his vision? How sharp was his mental vision as well as what he saw with his eyes? Those are the things you look for.[30]

Discussions with his staff also raised Stryker's own awareness of styles of avant-garde art photography then developing in Russia, Germany, and France[31] and the growing practice of photography as leftist reportage, especially as it filtered into the American scene via *The New Masses,* the *New Theatre* magazine, and the Film and Photo League.[32] Although Stryker himself may not have read the publications or attended the league's lectures, members of his staff certainly did.

Stryker eventually decided upon a field methodology for his project. He would send photographers out to shoot before-and-after stories about Resettlement projects to show the need for action and the results the RA achieved. The photographers read J. Russell Smith's cultural geography *North America* and met individually with Stryker for tutorials before leaving Washington; he made sure they would arrive knowing how to get the most from their limited time at each locale. Carl Mydans credited him with being "an inspired educator. He has the unusual quality among educators of being able to transfer his enthusiasm to others."[33]

In 1964 Stryker explained that, by teaching others what he saw in pictures, he taught himself. The tutorials sharpened his own perceptions and enabled him to articulate observations he had not previously discerned. In expanding the photographers' understanding of their assignments, Stryker himself developed an expanded frame of reference.[34] As he observed again and again, "My own growth and my own change then [picked up on these things I observed]. I was going through a change."[35] He was "looking much more sharply, much more intelligently."[36] In effect, he became the test audience for the photographs his unit produced. He passionately wanted others to share the experience of gaining new insights. "I was helping clarify the complexity and the blur of life that most people suffer from. I didn't know at the time that I was doing it, but that's what I was doing."[37]

28. Ibid.

29. These notebooks now make up Library of Congress LOTS 897—"Migration of Drought Refugees to California, April 17, 1935," compiled by Paul S. Taylor; 898—"Rural Rehabilitation Camps for Migrants in California," compiled by Paul S. Taylor, 1935; and 961—"First Rural Rehabilitation Colonists, Northern Minnesota to Matanuska Valley, Alaska. Sailed from San Francisco, May 1st, 1935."

30. Stryker, interview with Doud, 1963.

31. Stryker, interviews with Doud, June 13, 1964, and 1965.

32. Stryker, interview with Doud, June 13, 1964; Denning, *The Cultural Front,* pp. 44–46, 58, 65, 80–82.

33. Mydans, interview with Doud.

34. Stryker, interview with Doud, June 13, 1964.

35. Vachon transcript, p. 22.

36. Stryker, interview with Doud, June 14, 1964, p. 31.

37. Ibid.

Another factor influencing the Historical Section's output was its members' ability to see America with an outsider's perspective. Stryker, Evans, and Shahn had traveled abroad, as had Marion Post Wolcott, Jack Delano, John Collier, and Marjory Collins, all of whom would join the project in years to come. As immigrants or children of immigrants, Rothstein, Mydans, Jung, Shahn, and Delano (as well as Edwin Rosskam and Esther Bubley, who would come on later) were keenly aware that other places were different from America. It was an alert and informed team of photographers that set about fulfilling the agency's political mandate and documenting something of the diversity of America: ordinary citizens living on failing farms, on depleted land, in abandoned mines, working hard to improve their circumstances.

The RA photographers trained their cameras on the "third of a nation" Roosevelt would refer to in his second inaugural address, in 1937, as "ill-housed, ill-clad, ill-nourished." People generally cooperated with the photographers by telling their stories and permitting their photographs to be taken. Field photography was fairly new at the time, so they may have been motivated by a desire for an instant of celebrity, or they may have been naive about publicity or surveillance, or they may have genuinely wanted to help someone sent from the nation's capital to make photographs of everything they did so that others could understand their particular situations.

As the discussions with the staff continued and deepened, discernment sharpened, and photographs came in from the field, Stryker discovered his true element:

> When the file began to grow, Walker lectured to me.... Ben's talk, Arthur's—the things he brought in were fresh and exciting, the Dorothea Lange stuff.... I was particularly interested in pictures. The file grew because pictures demand more pictures. It was like a man who starts taking heroin or some other narcotic. It was a narcotic, god damn it.... I began to take it, I liked it, and I needed more.[38]

FARM SECURITY ADMINISTRATION, 1937–42

Stryker recognized the benefit of Tugwell's modus operandi. Stryker paid little attention to budget and enjoyed relative freedom from Congressional oversight as he honed his mission and methodology and supplied publishers of periodicals with photographs from the front lines of economic and ecological disaster. "We survived probably like no other organization of this kind ever survived in government, or ever will survive, because we were fair-headed kids...."[39] We were protected, we were watched over... [by] Tugwell."[40] But Tugwell's efforts to have government relocate people who were in untenable situations proved too liberal for many Americans, and his dismissive treatment of the press made him a political liability to President Roosevelt. Soon after the 1936 election Tugwell resigned from the administration, and "resettlement" was replaced by "farm security" in the agency's name. Stryker recalled that "Tugwell was a... lightning rod. And after Tugwell left, he came for a visit, walked around, pulled out drawers [of pictures], turned to me, and said, 'We did better than we thought, didn't we?' That's all, virtually all, I ever heard from him after that time."[41]

Stryker soon realized that, like Tugwell, his subsequent bosses—Jack Fisher, C. B. "Beanie"

38. Stryker, interview with Doud, June 13, 1964.

39. Ibid.

40. Ibid. Stryker also acknowledged J. Franklin Carter and other New Dealers who helped the Historical Section.

41. Stryker, interview with Doud, June 13, 1964.

Baldwin, and Will Alexander—extended to the Historical Section "protection [that] saved [it] time after time." He observed that

> We grew because the climate was right in its broadest way of stating it. The times could stand pictures, we were a year ahead of *Life* and *Look,* ferment was on, we came at the right time in the picture business, the right time for this stupid word called "photojournalism" if you will. We rode that wave and by a strange set of co-incidences we then began to broaden our scope.[42]

Stryker benefited enormously from conversations with others who specialized in the visual. Romana Javitz, head of the picture file at the New York Public Library, a painter by training and a picture librarian since 1919, discussed with him photography as art, as museum object, as archive, as visual history, as storytelling, and as document. Through her experience with creative people in all fields of the arts, including Evans and Shahn, she helped Stryker learn to appreciate the art historical and inspirational nature of photography.[43] Robert and Helen Lynd, who wrote the sociological tract *Middletown,*[44] were among the intellectuals who expanded Stryker's appreciation of everyday life, but a conversation with any visually alert person could inspire Stryker to make lists of concepts and themes for his photographers to explore.

He also maintained connections with magazine and newspaper publishers around the country. He made regular visits to the New York offices of the *Herald Tribune,* to Florence Kellogg at *Survey Graphic,* Emma Little at the *New York Times,* and Ruth Goodhue at *Architectural Forum.*[45] The FSA picture book *Home Town,* with text by novelist Sherwood Anderson, was one product of such meetings. It grew out of years of chats with Goodhue; photographic assignments for pictures of small-town America's Main Streets, town squares, mayors, and town leaders; and ultimately the book-packaging skills of editor Edwin Rosskam, who joined the FSA in 1939.

Through extensive discussions with staff, academics, and publishers, Stryker began to codify his thoughts into informal shooting scripts that expanded the premise of what his photographers might document in any given enterprise or in everyday life. He began envisioning the portrayal of the same topics in different regions to facilitate cultural comparisons and to demonstrate the interconnectedness of subjects academia generally studied as separate disciplines.

As the FSA took root, the photographers Russell Lee, Marion Post Wolcott, John Vachon, Jack Delano, Edwin Rosskam, and Gordon Parks (initially an intern on a Rosenwald Fellowship) brought themselves to Stryker's attention. He became skilled at developing a motivated cadre of workers, most of them trained in the arts and all of them enormously concerned about the welfare of those who were most affected by the depression. He maintained close relationships with those who personally and professionally met his criteria; those who, like Walker Evans, did not see eye-to-eye with him soon left his employ.

Stryker sent shooting scripts to all the photographers but gave some more latitude to set their own agendas than others. Shahn and Lee, who could talk easily with Stryker, enjoyed particular freedom. Stryker joined Lee in the field several times and promised to join others, but

42. Ibid.

43. Javitz, interview with Doud.

44. Robert Lynd and Helen M. Lynd, *Middletown: A Study in American Culture* (New York: Harcourt, Brace and Company, 1929). Their sociological study of urbanizing small town America helped Stryker generate a comprehensive list of topics for his photographers to consider, such as "going to work," "coming home from work," and the like.

45. Stryker, interview with Doud, June 14, 1964, pp. 26–27, 36–37.

seems to have done so only with Arthur Rothstein once or twice. He was too worried about protecting his project from adversaries to spend much time outside Washington.[46]

Stryker respected the individual perspectives the photographers brought to the endeavor. He appreciated that Lee, a former factory manager, was an engineer "who wants to take it all apart and lay it on the table and say, 'There, sir, there you are in all its parts.'"[47] He also valued Delano, observing that "Jack, being much more the artist, was always trying to say, 'How can I say "Vermont" in one picture?' There were times I would get Russell and Jack together and say, 'If you guys would just trade a little bit.'" He noted, "It was an interesting contrast between two people."[49]

As the long-term members of the FSA photographic team approached their work from such different perspectives—and came from different backgrounds and generations, and had different aspirations—it is a testament to Stryker that such strong individuals held together as a group. Stryker acknowledged being patriarchal; they were like family.[50] Throughout the RA and FSA periods, when long-distance telephone calls were costly and rare, letters between Stryker and his photographers on location recorded itineraries, rationales for shifting agendas, and colorful anecdotes.[51]

Rothstein commented on their cohesiveness: They were "a group of photographers all working together under common leadership for a common goal, but they all maintained completely different and individual styles of photography."[52] When several of the photographers gathered in 1952 to discuss the group dynamic, elements they cited as melding them into a team were participation in a cause bigger than themselves,[53] the immediate positive recognition from their supervisor,[54] and confirmation that the photographs made a difference in people's lives.[55]

Members of the Historical Section shared a single goal—to improve the population's living conditions—and, to an extent, all of them were trying to help a new America rise from its economic collapse. Over the project's eight years its administrators and photographers were not only documenting but contributing to a paradigm shift. Between 1935 and 1943 the American economy completed a transition in its economic base—from traditional agriculture to mass culture, mechanization, and corporate structure—and in its focus—from individual subsistence to mass mobilization for international warfare.

The photographers themselves were part of the new order, at one with their times, technology, and subject matter, and, as their photographs circulated, they continued "to make a dent in the world." It was a time of ferment, Dorothea Lange recalled, her own awareness transformed from concerns about herself and her family to full social consciousness.[56] The very act of photographing people living in difficult circumstances, while trying to understand and to explain the crisis, created a new kind of photographic project. The FSA photographs were created to provide a view of particular conditions in particular places and to communicate person to person. Stryker remembered that the writer Jonathan Daniels contemporaneously stated that the FSA photographs had "a true taste of the time."[57]

OFFICE OF WAR INFORMATION, 1942–43

Although the photographs' aesthetic and technical qualities were consistently high throughout the Historical Section's duration, the larger FSA administration could not sustain the quality of

46. Stryker, interview with Doud, 1965.
47. Ibid.
48. Vachon transcript, pp. 40–41.
49. Stryker, interview with Doud, 1965.
50. Stryker, interview with Doud, June 14, 1964, p. 36.
51. This correspondence is available on microfilm with item-level index in Roy Stryker Papers.
52. Vachon transcript, p. 40.
53. Ibid., p. 45.
54. Ibid., pp. 40–45.
55. Ibid., pp. 40–41, 45.
56. Lange, interview with Doud.
57. Stryker, interview with Doud, June 14, 1964, p. 11.

its programs. In July 1940 Marion Post Wolcott noted that the projects had become formulaic. She wrote to Stryker that many of the camps for migrant laborers she photographed were poorly planned; she could take pictures that made them look nice, but that would be an illusion. She singled out one of the Florida camps she visited:

> It seems the camp is not a great success from the construction standpoint (as usual). They got rushed and had to spend the money immediately and instead of building shelters to meet Florida's peculiarities they simply transplanted the California ideas. Consequently the people are prostrate from the heat, poor ventilation in those tiny metal shelters (cold in winter) and holes and cracks for mosquitoes and flies by the millions and screening too large so that the special little biting gnats that chew around one's eyes, nose and mouth can come right thru. It's really disgusting. Every place I visit [it's] the same story: something wrong with the original planning, construction or setup, causing the whole project to suffer. It's a mess. Isn't it time they got over some of the experimental stages?[58]

It was clear to her that the mood of the agency and of the country was shifting away from stabilizing the farm situation. Tired from years of traveling on her own to produce the photographs needed, Post Wolcott had become disillusioned with the FSA; she was also frightened by the war that was engulfing Europe and threatening to engage the United States. She resigned from the FSA in January 1942.

The photographers were not the FSA's only critics in the early 1940s. Political conservatives who previously had objected to the agency had by that point organized their opposition. Their criticism intensified, and Roosevelt no longer held it forcefully in check as crises abroad deflected attention from the condition of American farmers. With the country mobilizing for war, requests for photographs of war preparations, temporary housing construction for war workers, and scrap-metal drives outpaced those for farm imagery, and the Historical Section's project shifted to the Office of War Information. John Collier, Marjory Collins, and Esther Bubley joined Rothstein, Lee, Vachon, Delano, and Parks there.

The longtime staff members and the newcomers would mix when several of them happened to be in Washington at the same time. Roy and Alice Stryker held ritual dinners at their apartment to strengthen group solidarity. The menu never changed: Alice always served meatloaf, green beans, and apple pie.[59] The photographers sat in the living room engaged in heated discussions with Stryker about issues to add to their agendas, technological innovations to be made in the lab, and the reasons for doing so. The photographers' new OWI responsibilities included reporting on the American war effort and rallying public support for America's eventual participation in the growing international conflict. No longer serving to educate Americans about Americans, the OWI photographers became advocates for the oppressed overseas.

Stryker and his photographers were concerned about the growing proportion of war-related assignments, and he found himself unable to continue in the new pro-mobilization environment. He saw advertising men taking over the agency and did not respect the approach they wanted to adopt. With the New Deal a dying concern, the new regime would provide him little

58. Post Wolcott letter to Stryker, July 1940, Roy Stryker Papers.

59. Louise Rosskam, interviews with Beverly W. Brannan and Laura Katzman, May 28, 1996, and November 29, 1999; also captured on unpublished video by Jeanine Butler, Butler Films, March 2003.

protection from enemies his project had made among conservative legislators. In fact, upper management challenged Stryker's hegemony by bringing in the photographer Alfred Palmer to help direct the OWI operation. Palmer was accustomed to working in an advertising mode and was eager to organize a patriotic campaign for the war effort.[60]

Stryker met with his boss, "Beanie" Baldwin, to discuss the situation. Tears in their eyes, they acknowledged the futility of trying to maintain the Historical Section in the new era.[61] Stryker left the OWI soon afterward to begin a promotional photographic campaign for Standard Oil of New Jersey, a job he initially had rejected because of his anticapitalist background. The OWI project ended a few months later, and Stryker had to return to Washington, calling in many political favors to make possible his greatest dream: for the file to be "mined, used, and understood."[62] He managed to have the photographs transferred to the Library of Congress, where they would be maintained intact as an archive.

RESULTS

Paul Vanderbilt, the librarian who oversaw the transfer of the Historical Section's files from the OWI to the Library of Congress, had explanatory captions typed and adhered to the mount of each photo. Then his staff microfilmed the photographs, cataloguing them by assignment to reflect what each photographer produced at each location. Finally they sorted the photographs by region and classified them by subject.[63]

Some powerful people denied that the troubling conditions the photographs documented could have existed in their locales and called for removal of the offending images. However, Luther Evans, who was then special assistant to head librarian Archibald MacLeish and later held that position himself, stood up to the threats to the archives' integrity and saw that they remained intact.[64] The archives have been accessible to those wishing to study them directly or on microfilm since 1946 and on microfiche since 1980. Since the early 2000s every negative, including those previously unprinted, has been available for downloading online, free of charge and free of copyright restrictions.

The FSA images communicate in a language photographs had not previously used on such scale or with such consistency over time. Each print conveys a photographer's record of a specific experience in a specific place—a record that enables the viewer to engage in an imaginary dialogue with the subject. Together the FSA photographers documented a unique moment in the country's history in a way that allowed the American public to conceive a meaningful national identity—one that continues to speak to people everywhere today. Describing portraits that Jack Delano made for the file, his son Pablo said, "When my father looked at a person, there was nothing between them. It was one soul communicating with another soul."[65]

FSA photographs share everyday experiences with wide audiences in ways that ring true across time and cultures. One family makes occasional trips to the Library of Congress, gathering around the microfilm reader to look at photographs of corn shucking at their farm in 1939. The grandfather sits in a wheelchair, holding his young grandchildren on his lap when they get tired of standing. The young adults stand or sit as close as possible to a screen that seems large for one researcher but is too small for six or eight. As each frame comes into view, the

60. "Roy Stryker and I were what might be considered 'friendly enemies.' He vocally judged me to be 'a glamour photographer who needed to be taught the facts of life.' In a philosophical way, I looked upon his theories and attitudes as very often 'prejudiced' and sometimes actually detrimental." Alfred Palmer to the author, August 27, 1990.

61. Stryker, interview with Doud, June 13, 1964.

62. John Vachon as quoted by Stryker, interview with Doud, June 14, 1964, p. 37.

63. For a fuller discussion of the arrangement of the file and the intellectual significance of the classification system, see Alan Trachtenberg, "From Image to Story," in Fleischhauer and Brannan, eds., Documenting America, pp. 43–73.

64. Stryker, interview with Doud, June 13, 1964.

65. Pablo Delano to Beverly Brannan, telephone conversation, August 24, 2003.

eldest recites the names of relatives and neighbors, now mostly deceased. The photographic and oral narratives reel out, complementing each other to describe what was happening the day the photographer arrived. Their family narrative is part of the national narrative.[66]

In 1964, some twenty years after the FSA project ended, Stryker looked back on it proudly. "It was a thoroughly satisfying job. I did have a feeling of accomplishment. No feeling of what was going to come out of it, none whatever. I had no sense at all of what we now know. But there was a sense of satisfaction."[67]

The photographs that emerged from Stryker's Historical Section between 1935 and 1943 became an important means through which the nation came to comprehend its own vastness and diversity. Over time, through their high quality of image and ease of access and reproduction, the FSA photographs have become a monument in the world's visual heritage. They figure prominently in the history of art photography as the most important project in the documentary mode. Their eloquence enables people to communicate across time and space. The photographers knew at the time that they were creating something very special; they had "a certain esprit that became a part of it," Stryker remembered.[68]

If Stryker was surprised and delighted in the 1960s that the FSA photos still excited people,[69] how would he feel knowing that his project continues, decades later, to help people around the world see what was happening? It is tempting to imagine his showing Tugwell the file now, speaking with him about more than seventy-five years of sustained international interest in the photos, and saying, "We did better than we thought, didn't we? We made a dent in the visual world."

66. Observed by the author, mid-1990s to 2000.

67. Stryker, interview with Doud, June 14, 1964, p. 35.

68. Ibid.

69. Stryker, interview with Doud, 1963.

THE EARLY YEARS
(1935–37)

DOROTHEA LANGE

BEN SHAHN

WALKER EVANS

CARL MYDANS

THEODOR JUNG

ARTHUR ROTHSTEIN

Dorothea Lange developed an interest in the problems of migrant populations long before she worked for the RA and its successor, the FSA. In fact Roy Stryker hired her, in the summer of 1935, after seeing her photos of migrants illustrating economist Paul S. Taylor's report on the subject, *Notes on the Field.* This study by Lange's future husband examined the fate of migrant workers who had gone to California to escape the economic disaster of the Dust Bowl[1] in the central plains. From 1935 through late 1939 Lange worked for the FSA sporadically, alternating leaves of absence with specific FSA assignments. Although many of the assignments were in the South, Lange maintained a base in California—the only photographer working for Stryker who did so.

Looking back years later at her first photograph of Americans fleeing their birthplaces and seeking refuge in California, which she took in April 1934, Lange remarked upon the significance of the phenomenon she had devoted several years

1. The Dust Bowl was the area of the prairie states rendered infertile by the devastating sand storms of 1935. The loss of these vast farmlands precipitated a severe economic crisis.

DOROTHEA LANGE
AMERICAN EXODUS

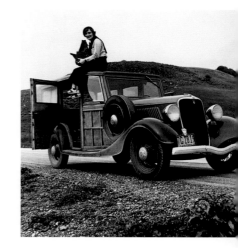

to documenting: "That was the beginning of the first day of the landslide that cut this continent.... This shaking off of people from their own roots.... It was up to that time unobserved."[2] Taylor (whom Lange married in December 1935) was the first to demonstrate that the migration was not an isolated incident but an authentic economic catastrophe that would have an impact far beyond the borders of California. Supported by Lange's photographic evidence, Taylor's work elevated the migrant phenomenon to national prominence.[3] Lange's celebrated photograph "The Migrant Mother," taken in February 1936 in the migrant workers' camp in Nipomo, California, was particularly influential in raising awareness of the problem.

The FSA archives contain 841 negatives Lange took between 1935 and 1939 on the subject of the exodus. Her iconographic images formed the core of the book *An American Exodus* (1939), and served as the central visual inspiration for the John Ford film *The Grapes of Wrath* (1940).

G.M.

2. Lange, interview with Doud.

3. See Milton Meltzer's excellent treatment of this subject in his biography *Dorothea Lange, A Photographer's Life,* particularly p. 92 and following.

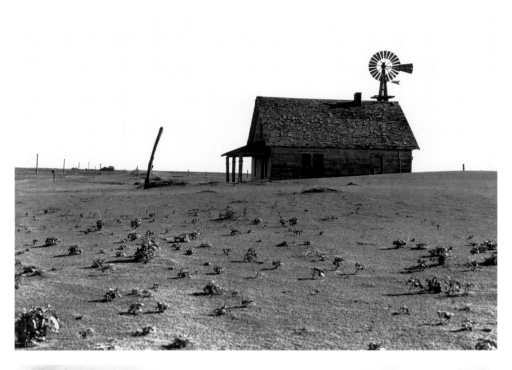

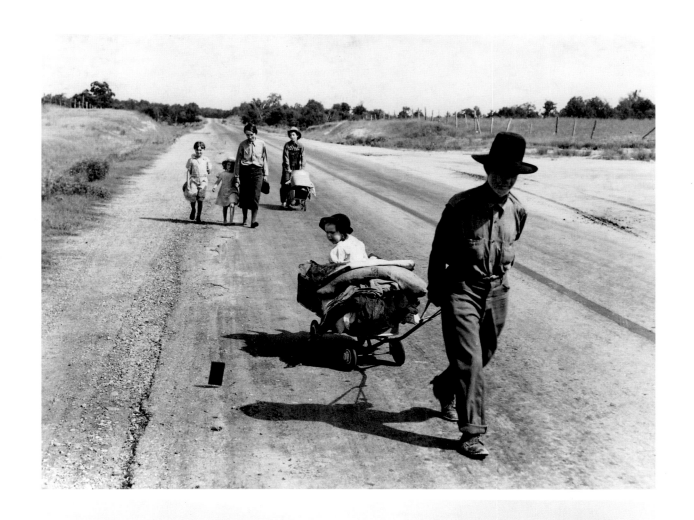

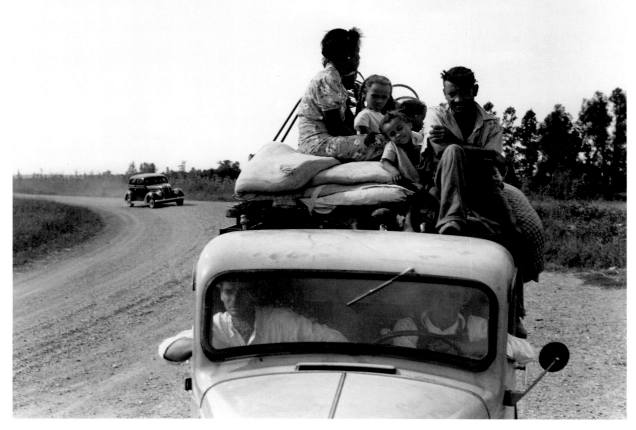

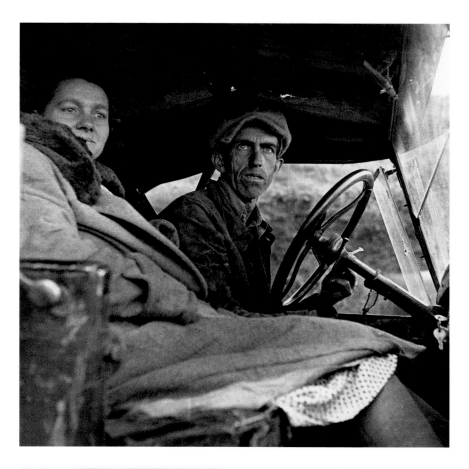

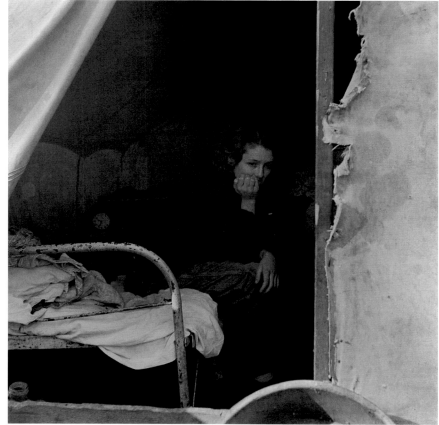

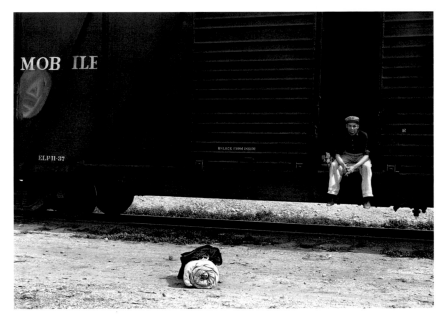

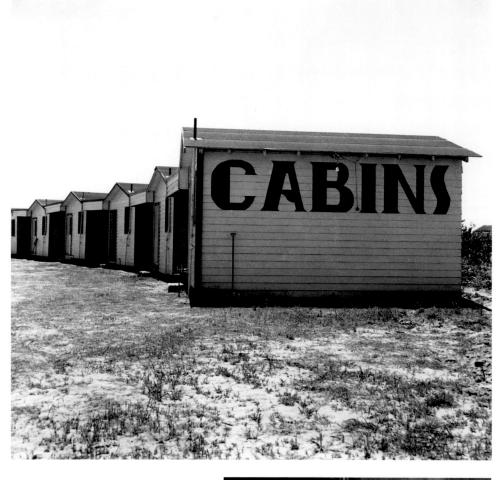

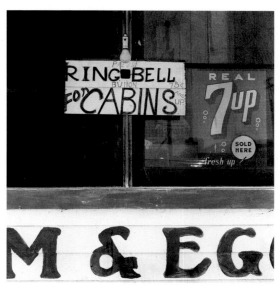

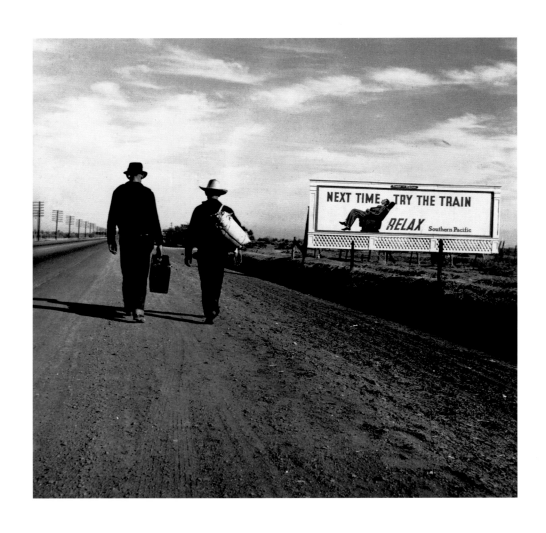

DOROTHEA LANGE

p. 25
Dorothea Lange, Resettlement
Administration photographer, in
California.
FEBRUARY 1936 00188

p. 26 top
Dust Bowl farm, Coldwater District,
north of Dalhart, Texas. This house
is occupied; most of the houses in
this district have been abandoned.
JUNE 1938 8b32396

p. 26 bottom
Refugee families near Holtville,
California.
FEBRUARY 1937 8b38619

p. 27 top
Family walking on highway, five chil-
dren. Started from Ioabel, Oklahoma.
Bound for Krebs, Oklahoma.
Pittsburg County, Oklahoma. In
1936 the father farmed on thirds
and fourths [paying the landlord
one-third or one-fourth of the crop]
at Eagleton, McCurtain County,
Oklahoma. Was taken sick with
pneumonia and lost farm. Unable
to get work on Works Progress
Administration and was refused
county relief in county of fifteen
years' residence because of
temporary residence in another
county after his illness.
JUNE 1938 8b38702

p. 27 bottom
Mississippi Delta, on Mississippi
Highway No. 1 between Greenville
and Clarksdale. Negro laborer's
family being moved from Arkansas
to Mississippi by white tenant.
JUNE 1938 8b33038

p. 28 top left
On U.S. 99 in Kern County on the
Tehachapi Ridge. Migrants travel
seasonally back and forth between
Imperial Valley and the San
Joaquin Valley over the ridge.
FEBRUARY 1939 8b33236

p. 28 top right
Southern California desert. Migrant
from Chickasaw, Oklahoma, stalled
on the desert in southern California
with no money. He and his ten
children are facing their future in
California.
MARCH 1937 8b31795

p. 28 center
The town of Caddo, Oklahoma.
Migrants leave the small towns as
well as the farms of the southwest.
This region is a source of many
emigrants to the Pacific Coast.
JUNE 1938 8b32354

p. 28 bottom
The windshield of a migratory
agricultural laborer's car, in a
squatter camp near Sacramento,
California.
NOVEMBER 1936 8a31317

p. 29 top
Once a Missouri farmer, now
a migratory farm laborer on
the Pacific Coast. California.
FEBRUARY 1936 8b27270

p. 29 bottom
Daughter of migrant Tennessee
coal miner. Living in the American
River Camp near Sacramento,
California.
NOVEMBER 1936 8b29876

p. 30 top
Billboard along U.S. 99 behind
which three destitute families of
migrants are camped. Kern County,
California.
NOVEMBER 1938 8b32706

p. 30 bottom
Rail car across tracks from pea-
packing plant. Twenty-five-year-old
itinerant, originally from Oregon.
"On the road eight years, all over
the country, every state in the
union, back and forth, pick up a job
here and there, traveling all the
time." Calipatria, Imperial Valley.
FEBRUARY 1939 8b33269

p. 31 top
Between Tulare and Fresno, on
U.S. 99. Many auto camps of this
kind are strewn along the highway.
MAY 1939 8b33590

p. 31 bottom
Between Tulare and Fresno on U.S.
99. The auto camp's office.
MAY 1939 8b33594

p. 32
Toward Los Angeles, California.
MARCH 1937 00235

DOROTHEA LANGE: PHOTOGRAPHIC ALBUM, "FIRST RURAL REHABILITATION COLONISTS, MAY 1, 1935"

In 1935 President Franklin Roosevelt offered 203 families from Minnesota, Michigan, and Wisconsin—three states severely affected by the agricultural crisis—the chance for a new start in life by offering them fertile land in Alaska's Matanuska Valley. In return these families were to adopt the spirit of modern-day pioneers and develop the land for future generations. The Matanuska Valley was chosen because its climate was similar to that of the states the so-called colonists were leaving. Roosevelt's New Deal launched similar "rehabilitation" projects in Florida, Arkansas, and Georgia. The relocations were accompanied by home-building and economic stimulus programs devised to provide work for the unemployed, along with hope for populations affected by the crisis and forced into frequently painful emigrations.

In San Francisco on May 1, 1935, photographer Dorothea Lange watched sixty-seven of these families board the *St. Mihiel,* a steamer bound for Alaska. They had recently arrived by train from northern Minnesota. At the time Lange was working for the California Division of Rural Rehabilitation, recording poignant images of families again relocating to a distant state and unknown living conditions. Lange selected nineteen photographs from her coverage of the events to create a personal photographic album, which she herself designed and for which she wrote the text and captions. In the summer of 1935 she gave the album to Roy Stryker, who in turn showed it to the photographers he had hired along with her, including Walker Evans and Ben Shahn. Their reactions were enthusiastic: "This was a revelation... what this woman was doing."[1]

The 22.2-by-20.5-inch album was conserved in the archives of the FSA (the negatives remained in Lange's possession) and is reproduced here in its entirety for the first time. It serves as an eloquent example of how Dorothea Lange wanted her work to be presented.

G.M.

1. Shahn in Meltzer, *Dorothea Lange,* p. 104.

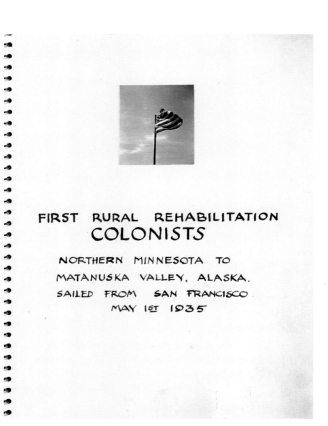

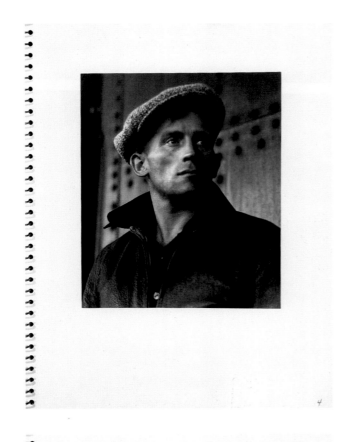

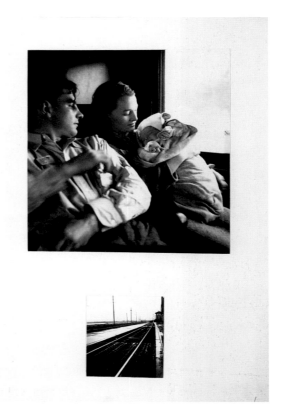

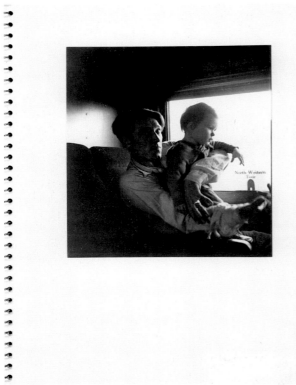

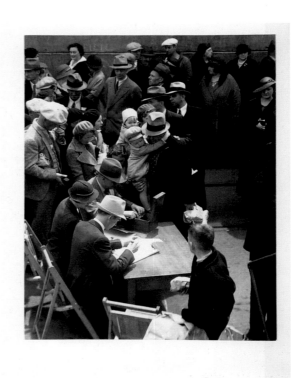

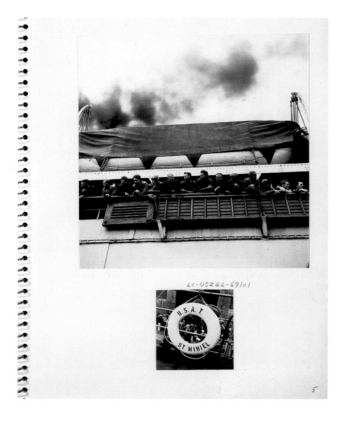

LC-USZ62-69101

5

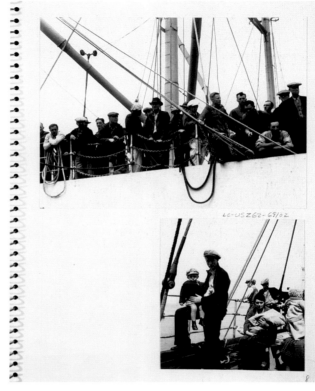

LC-USZ62-69102

8

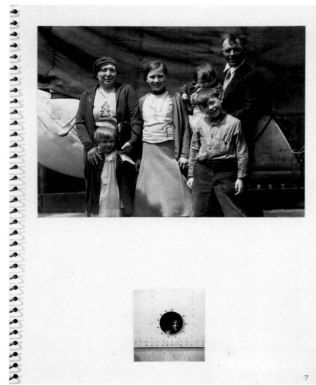

7

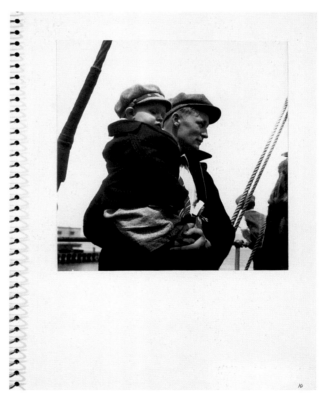

10

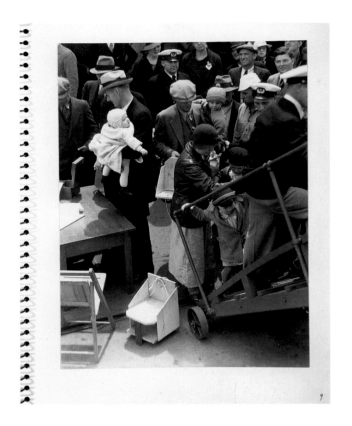

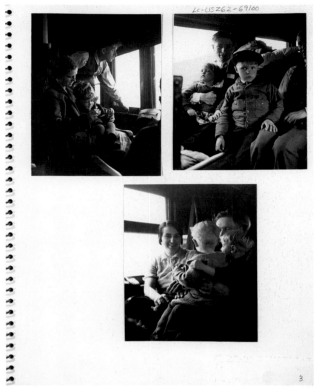

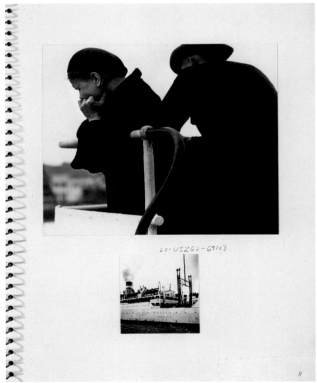

LC-USZ62-69103

The movement of colonists from northern Minnesota to
Alaska in the spring of 1935 is an attempt at ordered
resettlement of distressed people. As the initial
contingent of 67 families passed through San Francisco,
photographic documentation of this episode in the migra-
tion was made by Dorothea Lange, of the Division of Rural
Rehabilitation, California Emergency Relief Administration.

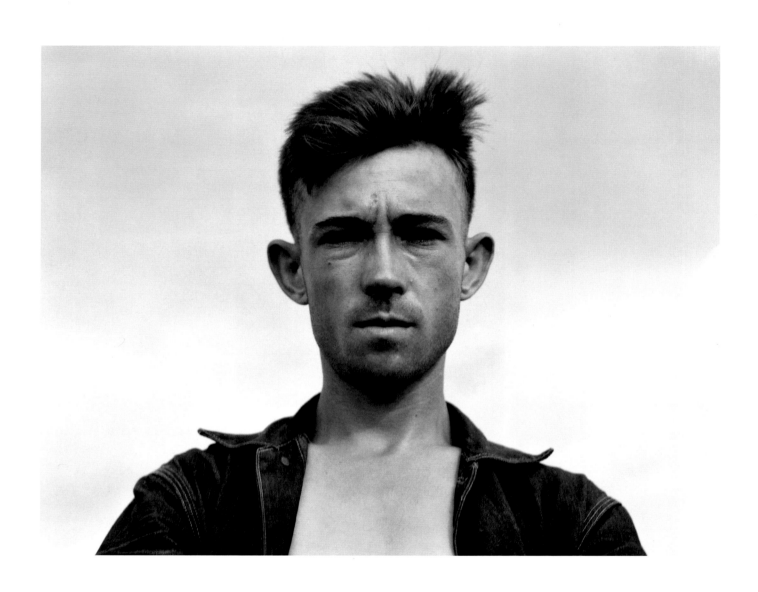

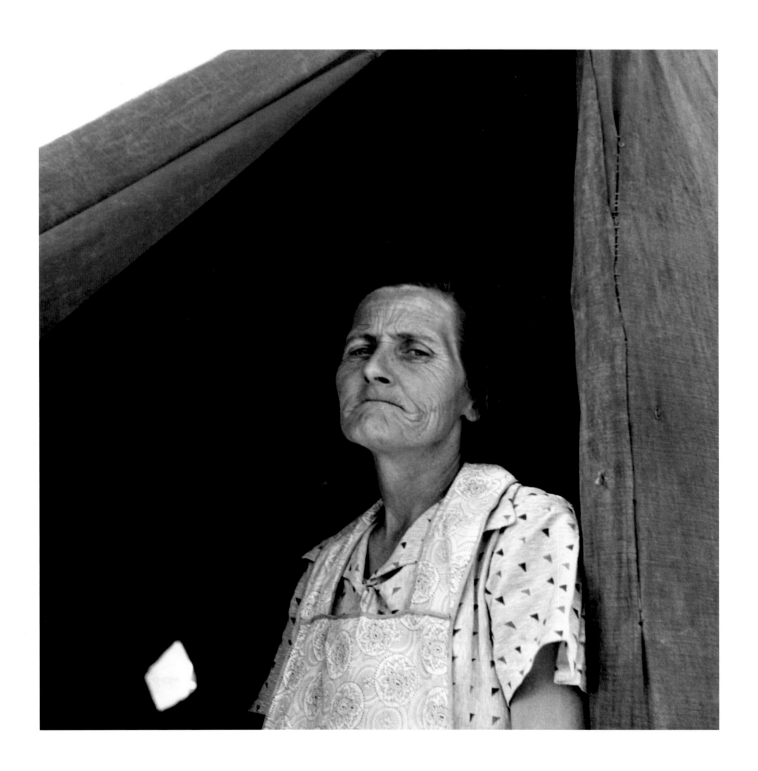

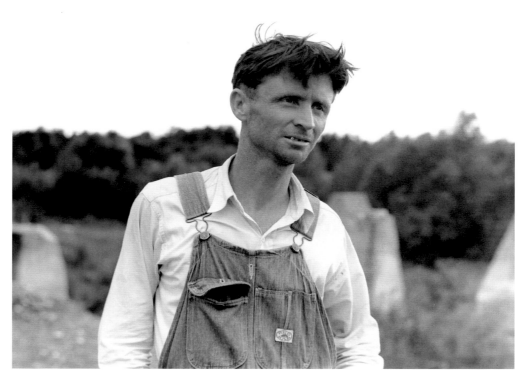

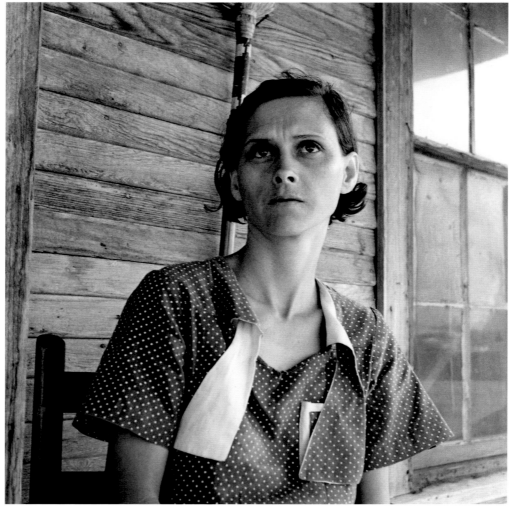

DOROTHEA LANGE

pp. 34–37

The relocation of families from northern Minnesota to Alaska in the spring of 1935 was a government attempt to resettle distressed people. As the initial contingent of sixty-seven families passed through San Francisco, Dorothea Lange documented the episode in photographs for the Division of Rural Rehabilitation, California State Emergency Relief Administration.

p. 38

Sharecropper. Receives five dollars a month "furnish" from the landowner. Macon County, Georgia.
JULY 1937 8b32268

p. 39

Migrant woman from Arkansas living in contractor's camp near Westley, California. She would prefer to live in a government camp, but the contractor system, which controls allocations of work, prevents it.
APRIL 1939 8b33509

p. 40 top

Kern County, California. Undernourished cotton picker's child listening to speeches of organizer at strike meeting to raise wages from seventy-five cents to ninety cents a hundred pounds. Strike unsuccessful.
NOVEMBER 1938 8b32810

p. 40 bottom

Child living in Oklahoma City shacktown.
AUGUST 1936 8b38490

p. 41 top

Young migrant mother has just finished washing. Merrill FSA (Farm Security Administration) camp, Klamath County, Oregon.
OCTOBER 1939 8b35575

p. 41 bottom

Cotton hoer near Clarksdale, Mississippi.
JUNE 1937 8b32071

p. 42 top

Man who worked in Fullerton, Louisiana, lumber mill for fifteen years. He is now left stranded in the cut-over area.
JULY 1937 8b32169

p. 42 bottom

Woman on relief. Memphis, Texas.
JUNE 1937 8b31993

Between 1932 and 1935 Ben Shahn took up photography with the help of Walker Evans. He began documenting his heritage, even while distancing himself from it emotionally, by photographing the Lower East Side of Manhattan (an enclave of Eastern European Jews like himself), learning to discern interesting faces, relationships, and juxtapositions. He studied works by other urban photographers in newspapers and books but developed his own visual language for expressing what he saw in the modern city.

Frequently out of work, Shahn developed friendships with other unemployed artists, as well as authors and newspaper reporters, including Bernarda Bryson, an artist, art reporter, and critic. Bryson's ancestors had left New Hampshire four generations earlier to be pioneers in Ohio. Her father published the Athens *Morning Journal,* and her mother and grandmother taught at the college level. Bryson herself was an accomplished artist and lithographer by the time she settled in New York City in 1933.

Early in 1935 Shahn abandoned his wife and two children; he took up with Bryson by autumn. In 1938 their family, which now included two-year-old Susie and two-week-old Jonathan, went to visit Bryson's recently widowed father in Ohio, and Roy Stryker suggested that Shahn photograph there. Leaving their children in the care of the Brysons' live-in housekeeper, "Ruthless Ruth,"[1] and their teenage niece, Jane Pope, the couple explored the farms, towns, and amusements within a fifty-mile radius of Columbus.[2]

While Bryson drove and acted as guide, Shahn observed the cycle of activities in the small towns of the Midwest. He photographed buildings less often than ordinary people going about their business.[3] He often used a right-angle lens so he could point the camera, usually at Bryson, while actually taking photographs that reflected his own image in windows or, more often, that fixed on someone completely unaware of being photographed. He emphasized individuals over

1. Nancy Einreinhofer, "Bernarda Bryson Shahn, A Selection of Drawings, Paintings, and Prints from 1928 through 1998," exhibition and catalogue, Ben Shahn Galleries, William Paterson University, Wayne, N.J., 2002.

2. Greenfeld, *Ben Shahn: An Artist's Life,* pp. 145–49.

3. Harry Bryson Pope, Bernarda Bryson's nephew, telephone interview with Beverly W. Brannan, August 17, 2003.

BEN SHAHN

OHIO

groups[4] and adapted his urban photographic language to express the remoteness of small towns from centers of intellectual culture, the loneliness of the empty train station, the familiarity of farmers socializing in town on Saturdays, the isolation of individuals among townspeople, the wretchedness of a Hooverville,[5] the mixed reactions to organized welfare, and the tenuous position of blacks.[6] As he had done in New York, Shahn took most of his photographs outdoors, but he ventured inside Circleville's Wonder Bar to capture on film a buck dancer (a kind of tap dancer) and a piano player whose posture Shahn later recalled in his painting of President Harry Truman playing piano for Lauren Bacall.[7]

Shahn called the summer's work "a nice job" and sent hundreds of photos to the FSA labs with the required general and specific captions. But instead of arranging his captions by roll and frame number as other photographers did, Shahn grouped them thematically. Some photo numbers appeared on several different caption sheets, associated sometimes with one location and sometimes with another. The multiple copies of captions on onion-skin paper, each mutilated by the excision of various captions, suggest that clerks tried to bring order to the geographic conundrum, but when Paul Vanderbilt took over the archive's organization in the 1940s he noted on the caption sheets: "It is impossible to sort this stuff out."

B.W.B.

4. Laura Katzman, "Ben Shahn's New York: Scenes from the Living Theater," in Kao, Katzman, and Webster, *Ben Shahn's New York,* p. 27.

5. One of the desolate camps for the homeless that appeared after the depression; Hoovervilles were named after President Herbert Hoover, who did not recognize the significance of the crisis.

6. Katzman, "Ben Shahn's New York," in Kao, Katzman, and Webster, *Ben Shahn's New York,* pp. 15–29.

7. Bernarda Bryson, interview with Beverly W. Brannan, Roosevelt, New Jersey, June 8, 2002.

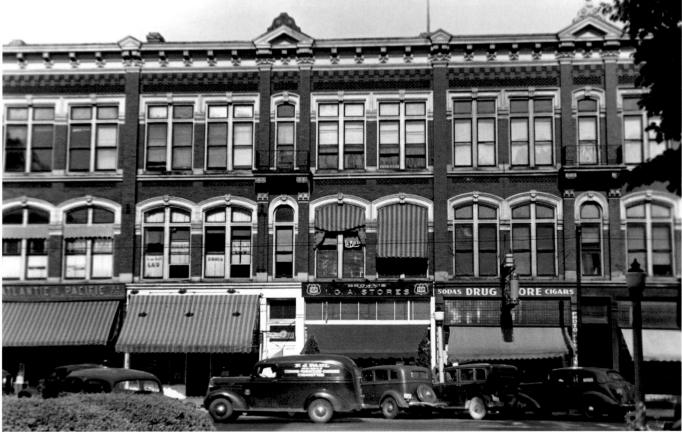

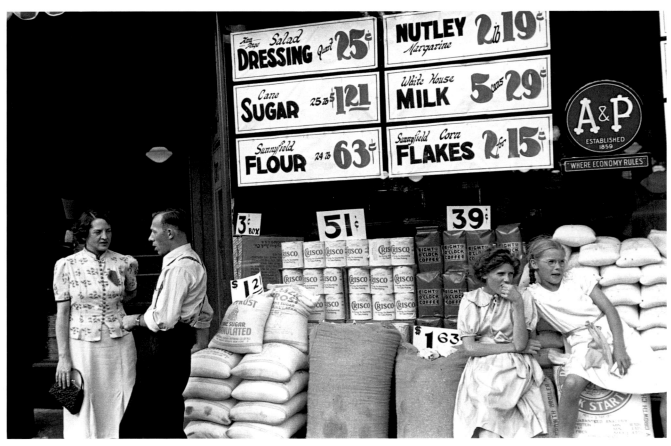

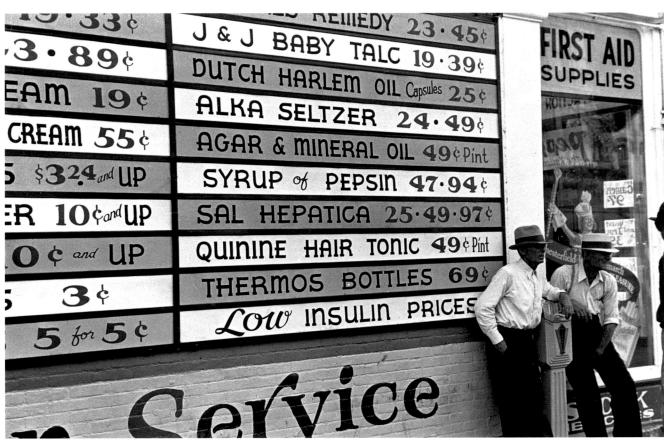

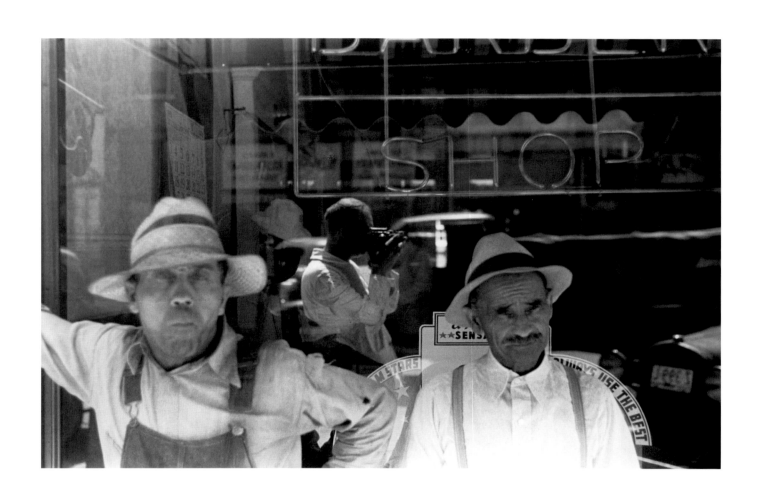

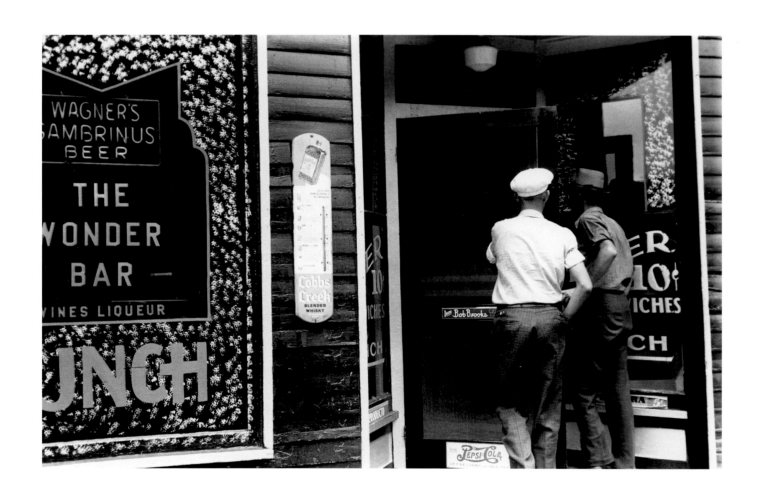

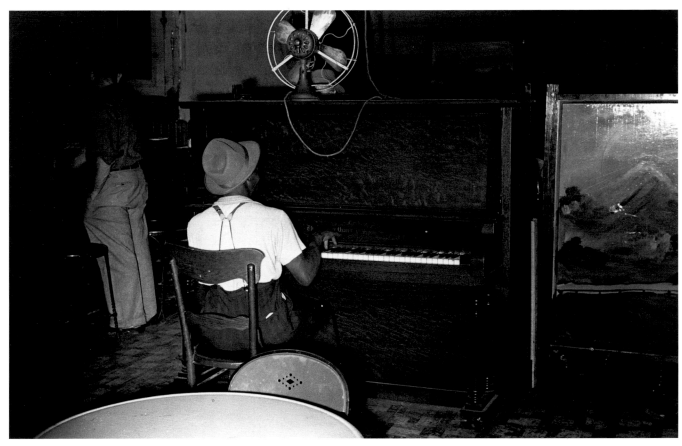

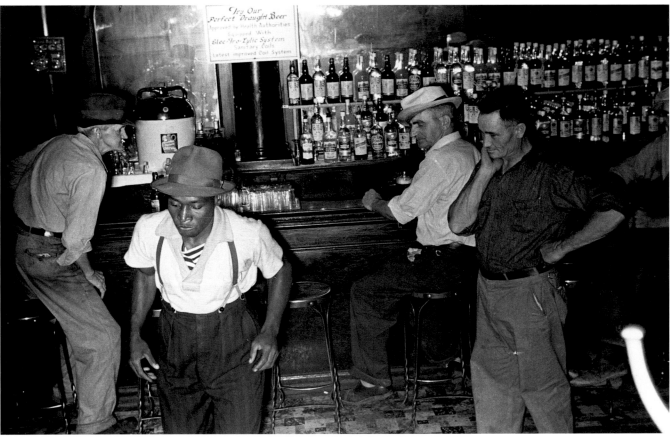

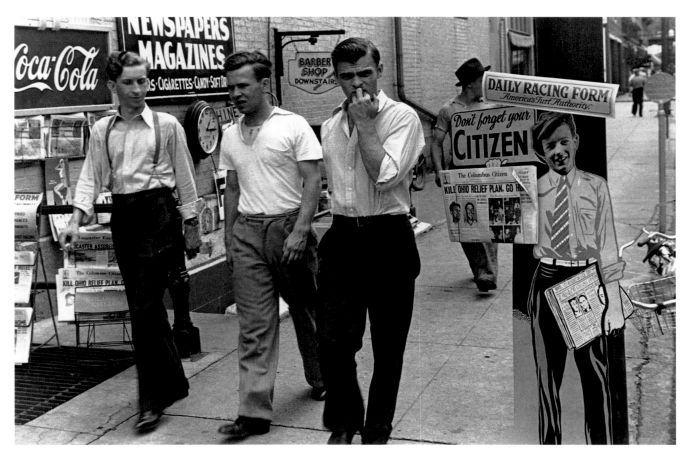

BEN SHAHN

p. 45
Ben Shahn, FSA photographer,
December 12, 1938

p. 46 top
Railroad station of Circleville, Ohio.
SUMMER 1938 8a18456

**General caption for this set
of images:**
Circleville, county seat of Pickaway
County. Average small Ohio city,
depending upon surrounding rich
farmlands for its livelihood.
Because of its nonindustrial
surroundings, retains much of old-
time flavor. Outstanding industries:
Eshelman's Feed Mill. Employs
150–200 men the year 'round. Pay
averages about eighty-five cents
an hour. Container Corporation of
America makes paper out of straw,
can absorb byproduct of all
neighboring farms. In addition,
a number of canneries and feed

mills. During depression many
farms of the district were
foreclosed. People who lost homes
naturally gravitated toward the
town. A town of its character is
unable to house new influx of
population. Consequently there
sprang up around it an extensive
Hooverville. Circleville got its name
through having been built in a
circle as a better protection against
the Indians.

p. 46 bottom
Ohio.
JULY–AUGUST 1938 8a18272

p. 47 top
Saturday afternoon in London,
Ohio, "the main street."
SUMMER 1938 8a18267

p. 47 bottom
SUMMER 1938 8a17568

p. 48 top
Main and Court Streets, Circleville,
Ohio.
SUMMER 1938 8a17552

p. 48 bottom
Street scene in central Ohio.
AUGUST 1938 8a17554

p. 49 top
London, Ohio.
SUMMER 1938 8a18238

p. 49 center
Saturday afternoon in London,
Ohio, "the main street."
SUMMER 1938 8a18239

p. 49 bottom
Saturday afternoon in London,
Ohio, "the main street."
SUMMER 1938 8a18240

p. 50 top
A&P store in Somerset, Ohio.
SUMMER 1938 8a18428

p. 50 bottom
Sign on drugstore, Newark, Ohio.
SUMMER 1938 8a18407

p. 51
Ohio.
SUMMER 1938 8a18768

p. 53
Wonder Bar, hot spot of Circleville,
Ohio.
SUMMER 1938 8a17544

p. 54 top
Wonder Bar, hot spot of Circleville,
Ohio.
SUMMER 1938 8a18708

p. 54 bottom
Wonder Bar, hot spot of Circleville,
Ohio.
SUMMER 1938 8a18707

p. 55 top
Main street, Lancaster, Ohio.
AUGUST 1938 8a17575

p. 55 bottom
Ohio.
SUMMER 1938 8a18235

p. 56
Waiting outside relief station,
Urbana, Ohio.
AUGUST 1938 8a18662

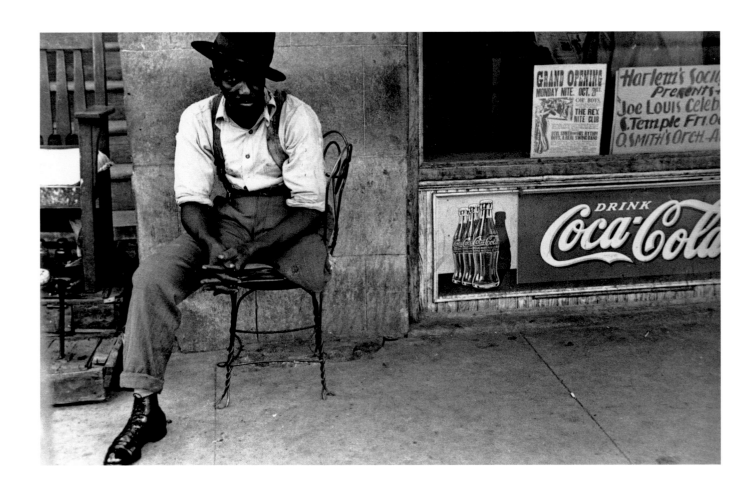

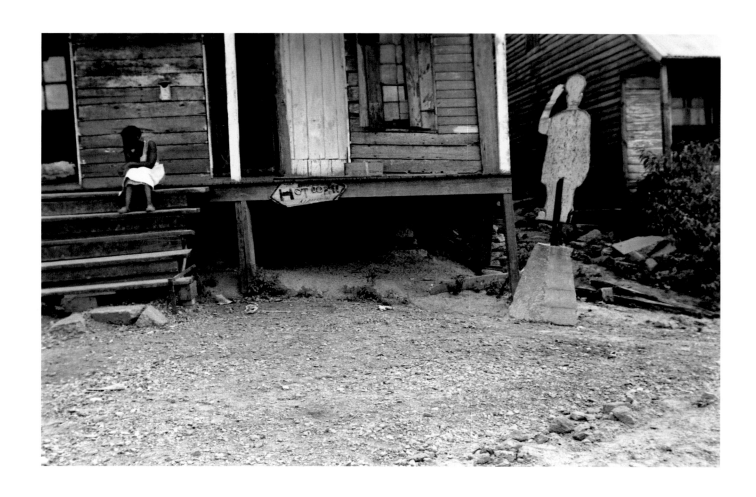

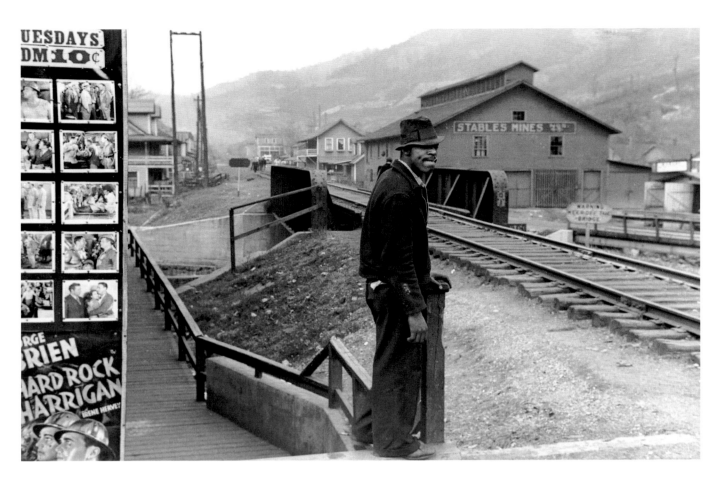

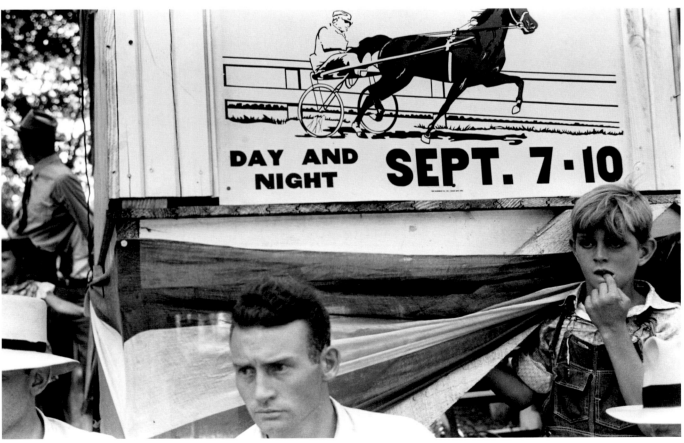

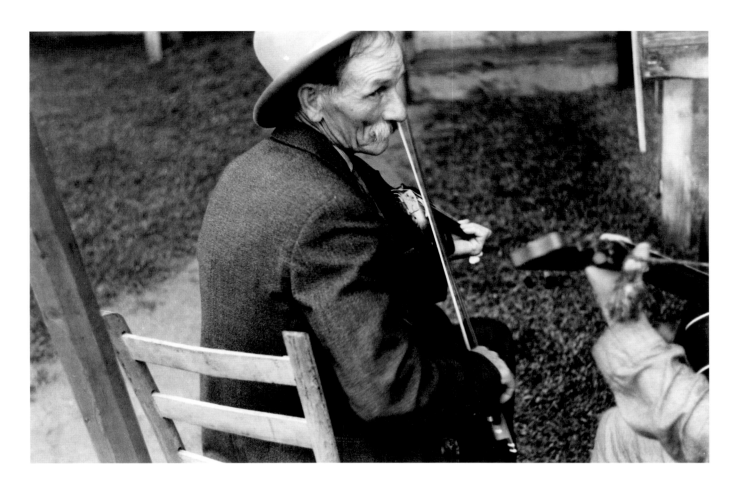

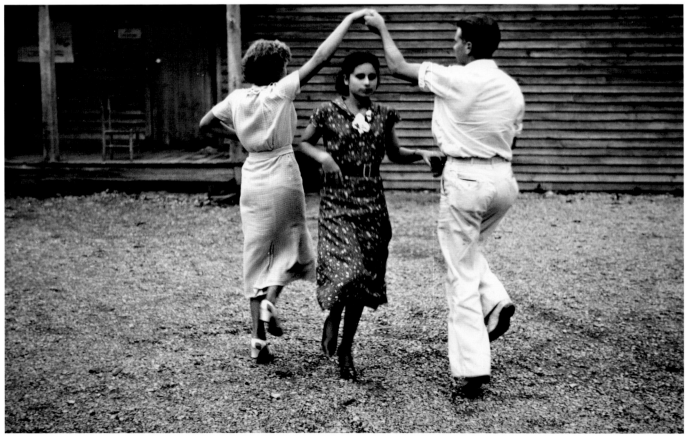

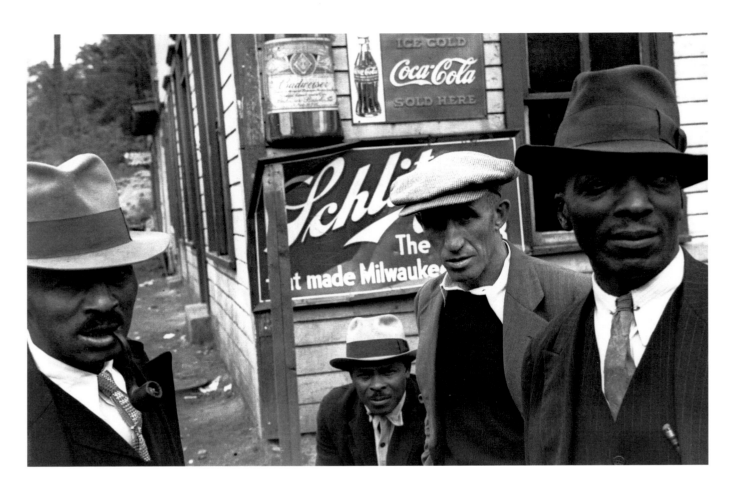

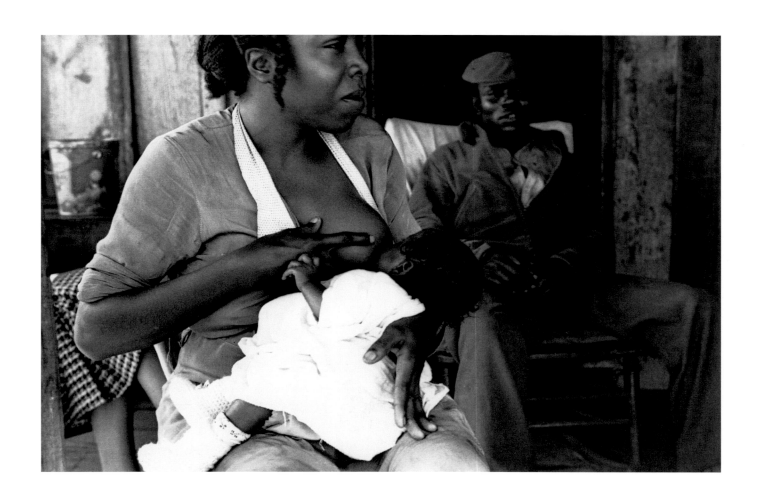

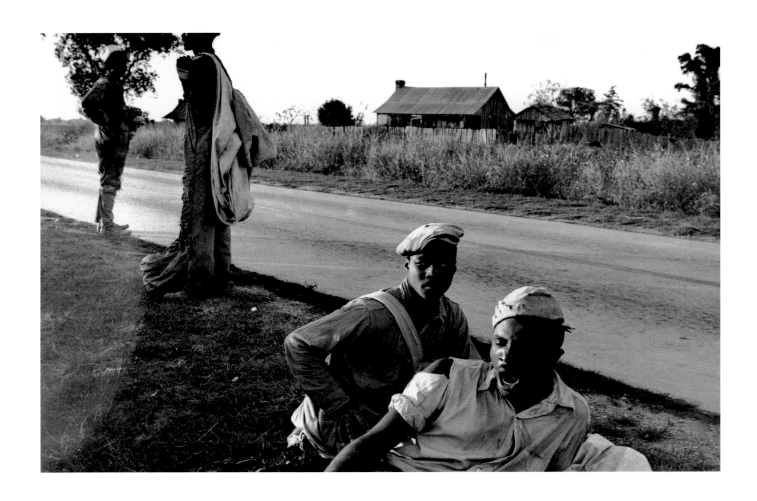

BEN SHAHN

p. 58
Child of Fortuna family, Hammond,
Louisiana.
OCTOBER 1935 8a16856

p. 59
A deputy with a gun on his hip
during the September 1935 strike
in Morgantown, West Virginia.
SEPTEMBER 1935 8a16611

p. 60
Scene in Natchez, Mississippi.
OCTOBER 1935 8a16484

p. 61
Natchez, Mississippi.
OCTOBER 1935 8a16488

p. 62 top
Omar, West Virginia.
OCTOBER 1935 8a16996

p. 62 bottom
Spectators at county fair, central
Ohio.
AUGUST 1938 8a18833

p. 63 top
Fiddlin' Bill Henseley, Asheville,
North Carolina.
1937 8a17157

p. 63 bottom
Dancers at Cumberland
Homesteads, Crossville,
Tennessee.
1937 8a17186

p. 64 top
Sunday in Scotts Run, West
Virginia.
OCTOBER 1935 8a16580

p. 64 bottom
Watching football game, Star City,
West Virginia.
OCTOBER 1935 8a16599

p. 65
Colored sharecropper family in
Little Rock, Arkansas.
OCTOBER 1935 8a16167

p. 66
Cotton pickers, Pulaski County,
Arkansas.
OCTOBER 1935 8a16163

The critic and filmmaker Jay Leyda probably provided the best description of his friend Walker Evans's feelings about his work with the FSA: "He was never active politically. He wouldn't do anything to commit himself to one party or the other, or to one cause. He had his own cause."[1]

Walker Evans's personal cause was, of course, his art. And throughout the periods he dedicated to assignments from Roy Stryker, on and off between June 1935 and 1937, Evans never lost sight of his art, though he produced relatively few negatives—about 540. Evans's agent, Ernestine Evans, had first put him in touch with John Franklin Carter, the director of the FSA's Information Division, who hired him on a trial basis—but from the beginning Evans was clear about his government work. He wrote in a note: "[I] mean never make photographic statements for the government or do photographic chores for gov, or anyone in gov, no matter how powerful—this is pure record not propaganda. The value and, if you like, even the propaganda value for the government lies in the record itself…

1. Quoted in Mellow, *Walker Evans,* p. 224.

WALKER EVANS
SIGNS AND MONUMENTS

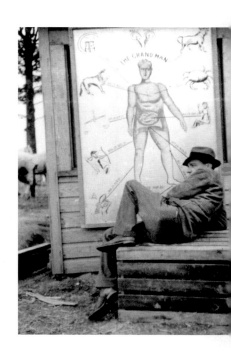

NO POLITICS whatever."[2] He was equally emphatic about his working methods, writing in a letter: "I hope you will agree with me that the only really satisfactory prints of a careful photographer's negative must be made by the original photographer."[3] Evans was the only FSA photographer to put forth what was, in his own words, an "egotistical" demand to make his own prints.[4]

With the exception of his 1935 visits to West Virginia and Pennsylvania, Evans's assignments were limited to the southeast of the country. He was generally accompanied by his Danish assistant, Peter Sekaer. Evans's interest in photographing signs of all shapes and sizes, which dated to 1929 and his earliest New York photographs, in the mid-1930s gave rise to a veritable obsession among government officials, who embraced the idea of using photography to catalogue traces of American vernacular culture. By recording signs, Evans affirmed his attraction to anonymous art and laid the foundations for a consideration of the symbols of mass marketing. Evans's work explored both the sign's semantic poverty and the occasionally poetic power of its unexpected appearance in the landscape.

G.M.

2. In Evans, *Walker Evans at Work*, p. 112.

3. Evans, letter to John Carter, August 17, 1935. Ibid.

4. "Please, be good enough to excuse the egotism of this letter...." Ibid.

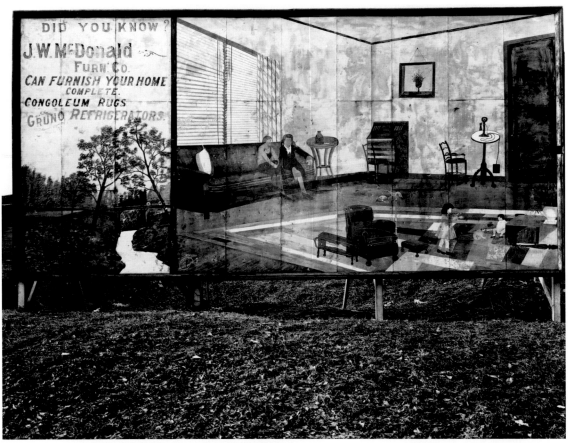

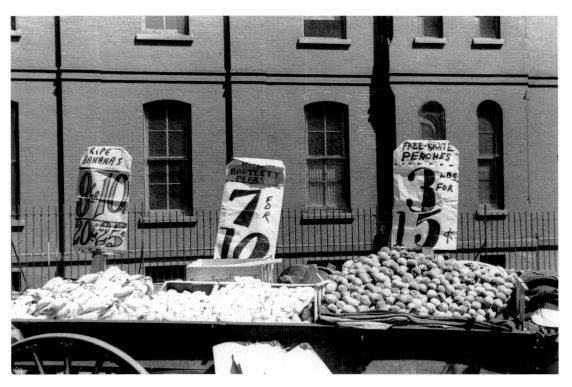

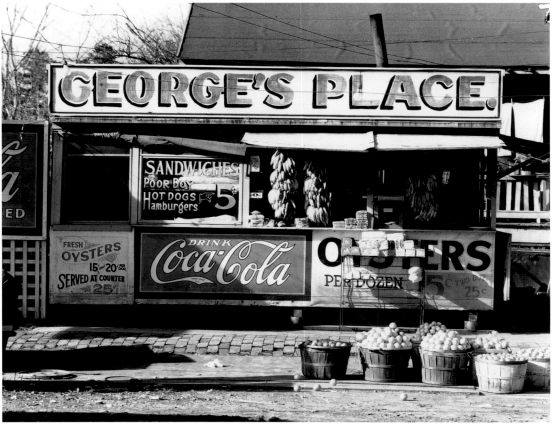

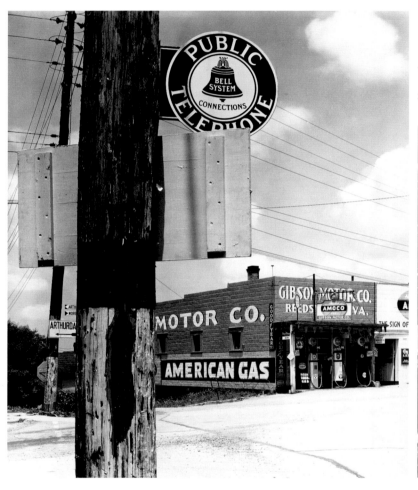

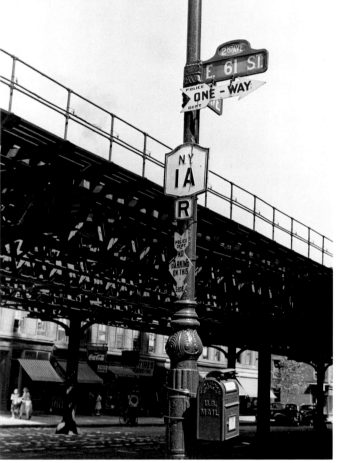

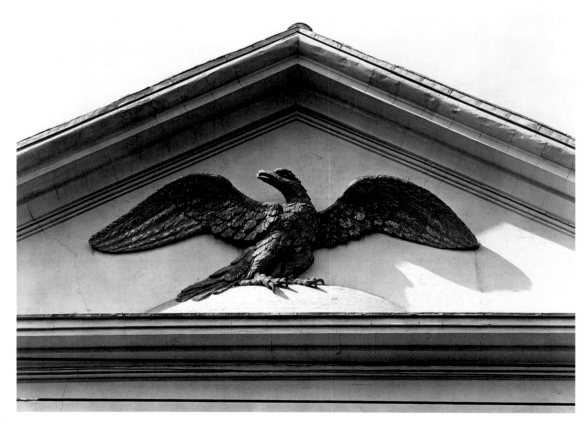

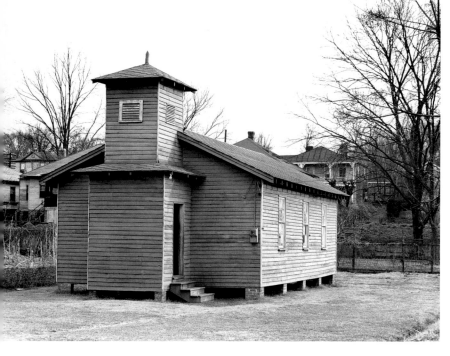

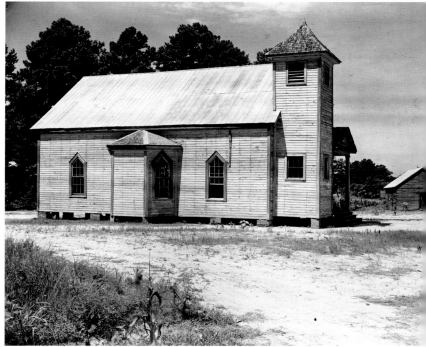

WALKER EVANS

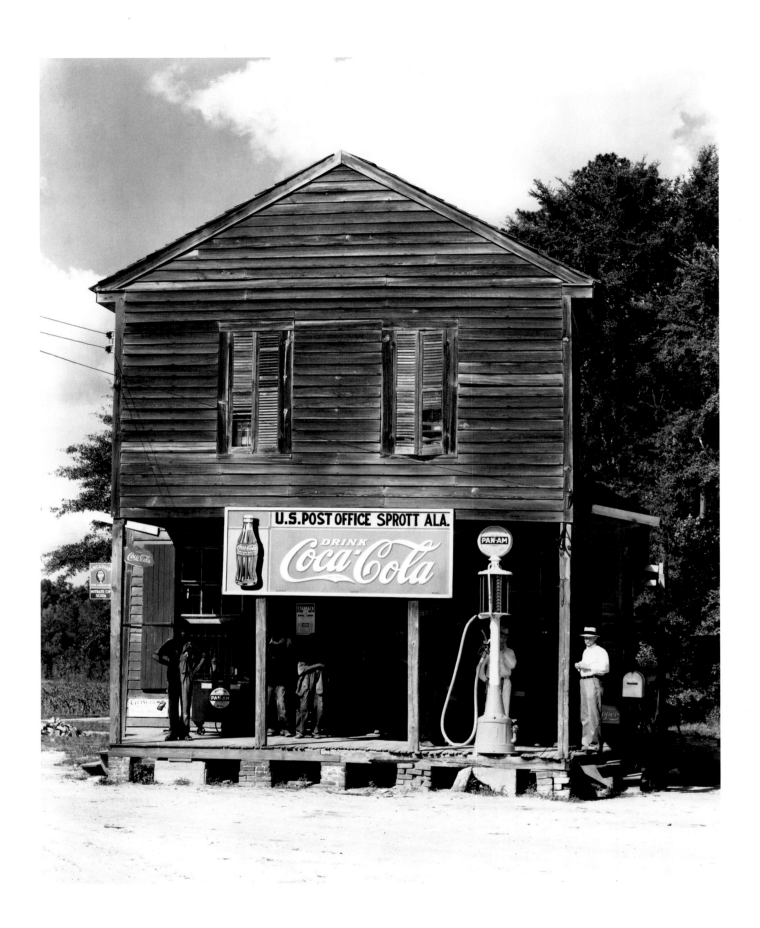

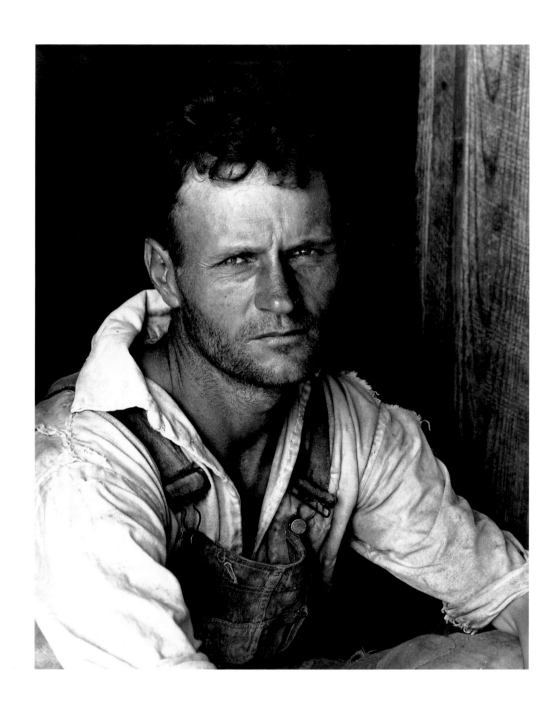

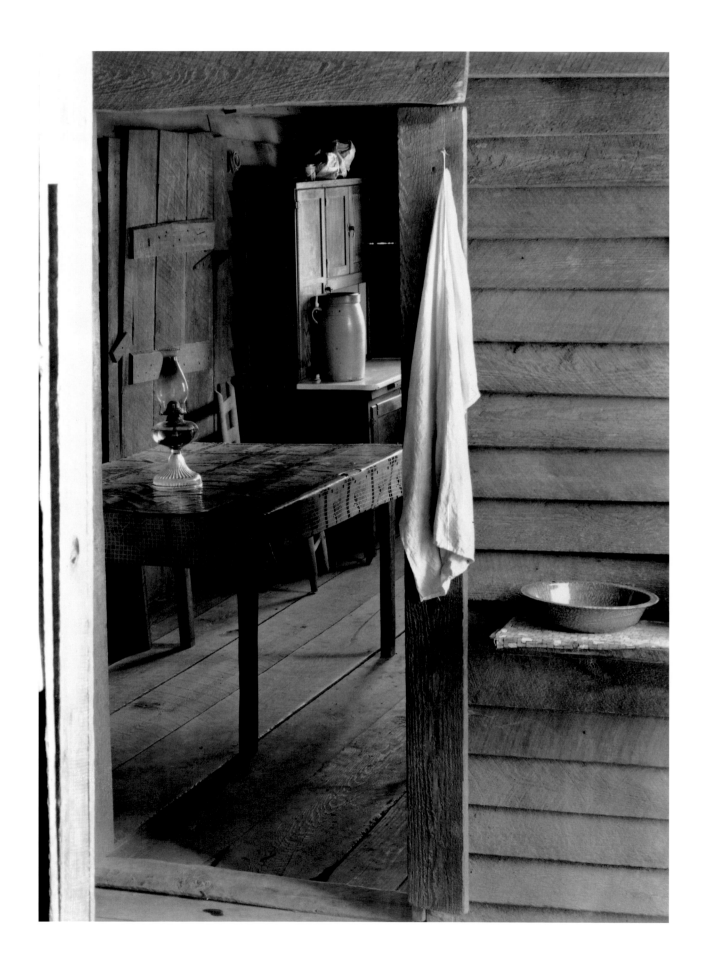

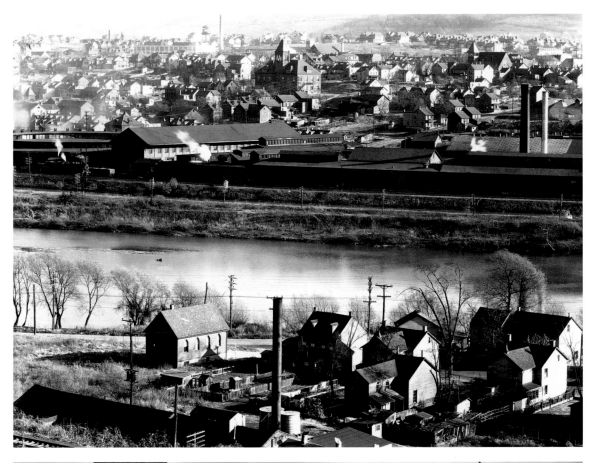

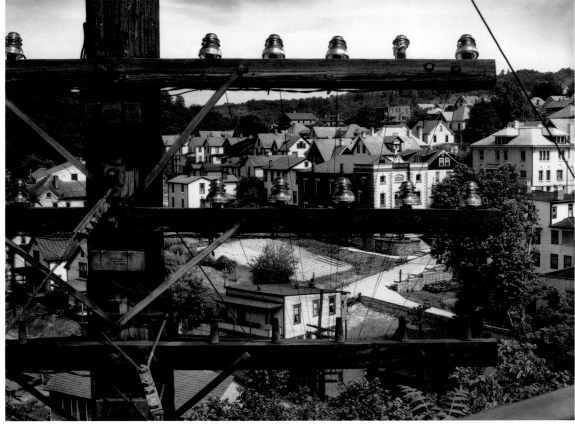

WALKER EVANS

The only member of the FSA team with an extensive background in the techniques of photojournalism, and an aficionado of the 35mm camera, Carl Mydans thought of himself not as a photographer but as a reporter. Before joining the staff of Roy Stryker's FSA division (where he was employed for just one year, from late 1935 to 1936), Mydans had already completed several photo assignments on housing for the Resettlement Administration. Those early works dealt with the new "greenbelt towns," government-sponsored planned communities developed in the suburbs to relieve urban housing shortages and meant to balance residential and commercial development with landscaping and public parks.

When Mydans was transferred to Stryker's team of photographers, he reacted to his new assignments as an objective observer confronted with an unfamiliar rural world he found difficult to grasp. He carried out two projects for the FSA: The first, in late 1935, took him to the southeastern states to

CARL MYDANS
HOUSING PROJECTS

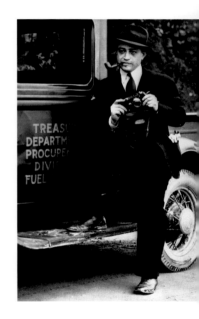

document cotton production, and the second, in spring 1936, to New England. Mydans photographed impoverished dwellings primarily, from the hovels of the Old South to the slums in small cities and in Washington, D.C. He also documented the numerous building projects the Roosevelt administration initiated to provide homes for the displaced and jobs for the construction industry, even as he underscored the architectural monotony that resulted from the government's effort.

Mydans followed Jacob Riis's pioneering lead in recording the foul conditions of slums and focusing on the "significant detail" to reveal as much as possible about the lives of those inhabiting the environments he photographed. But he also mastered a formal visual language reminiscent of the era's European modernity, particularly in its use of symmetry, details, and unusual angles. No subject seemed trivial to Mydans, as can be gathered from the veritable typology of public and private bathrooms he created.

G.M.

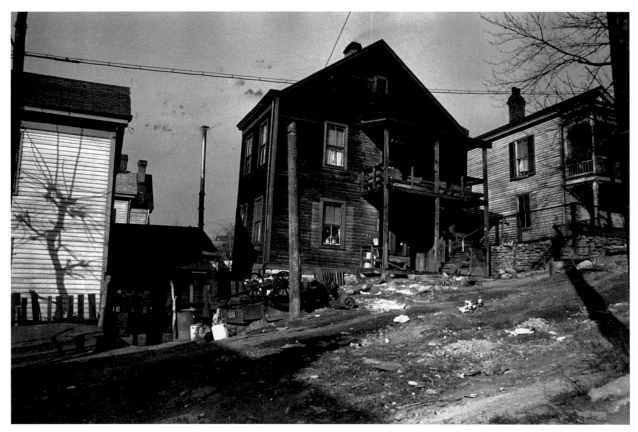

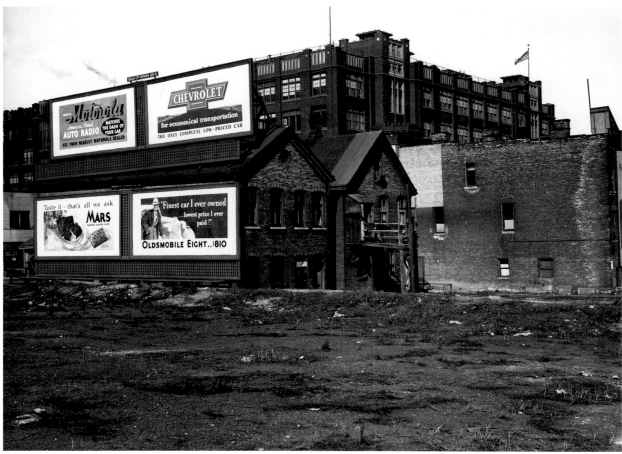

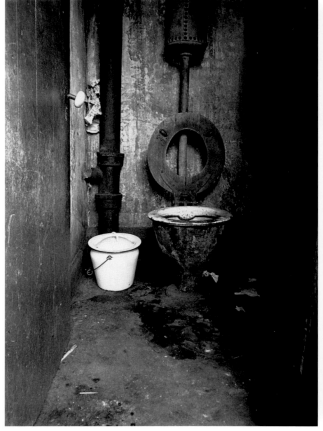

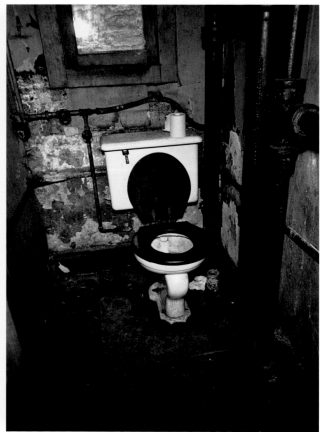

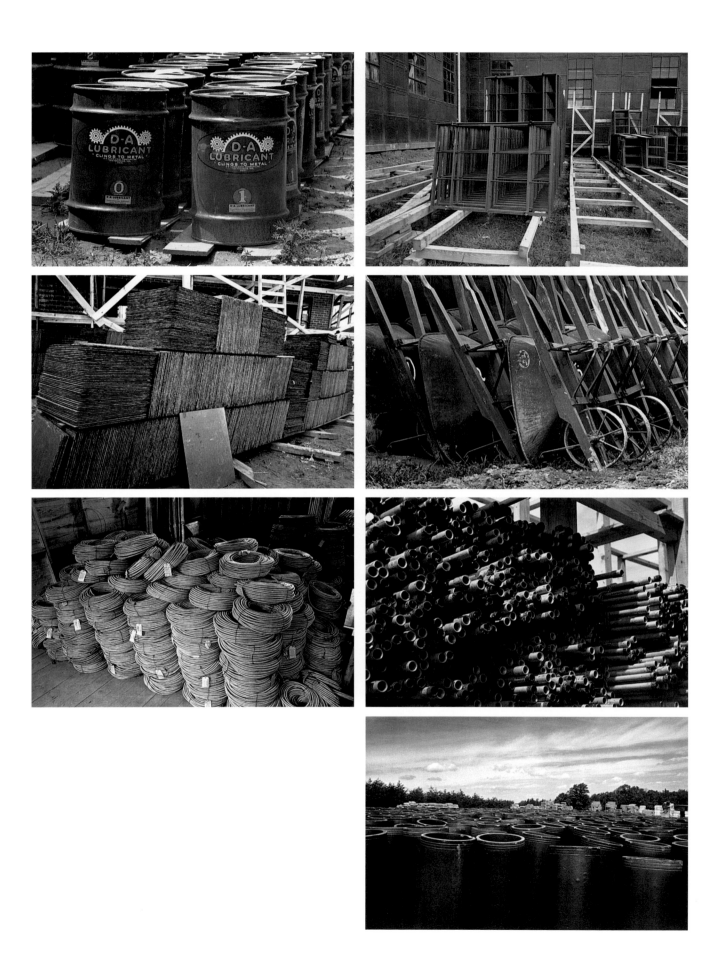

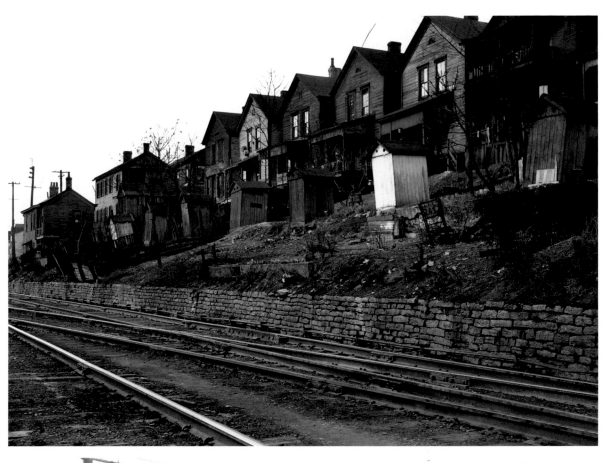

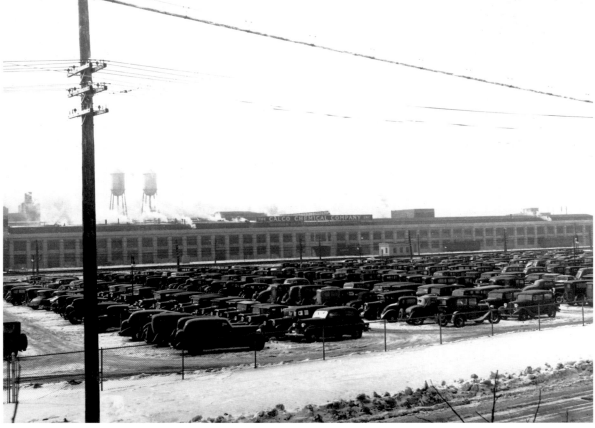

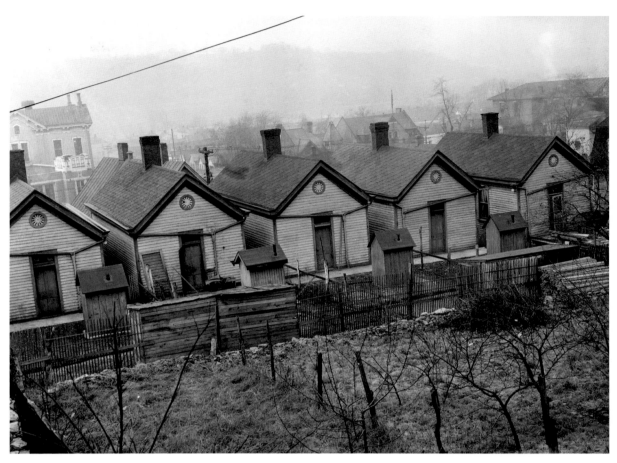

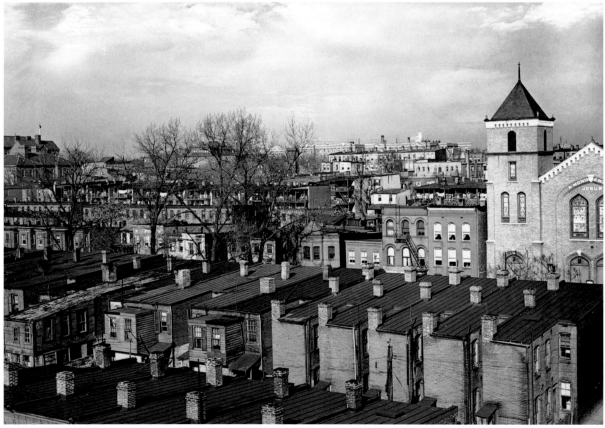

CARL MYDANS

p. 91
Carl Mydans, Farm Security Administration photographer, full-length self-portrait, holding camera, standing with his foot on the running board of a Treasury Department Procurement Division Fuel Yard truck, Washington, D.C.
C. 1935 00271

p. 93 top
Backyard, Hamilton, Ohio.
DECEMBER 1935 8a00772

p. 93 bottom
Rear of houses at 711 West State Street. Milwaukee Vocational School in background. Milwaukee, Wisconsin.
APRIL 1936 8b28638

p. 94 top
Kitchen and bedroom, Hamilton County, Ohio.
DECEMBER 1935 8900823

p. 94 bottom
Kitchen of Ozarks cabin purchased for Lake of the Ozarks project. Missouri.
MAY 1936 8b26565

p. 95 top left
Typical slum privy. The only available water supply is usually nearby, Washington, D.C.
SEPTEMBER 1935 8a00701

p. 95 center left
Tenement backyard and privy, Hamilton County, Ohio.
DECEMBER 1935 8a00701

p. 95 bottom left
Privy along Front Street, Hamilton County, Ohio.
DECEMBER 1935 8a00788

p. 95 top right
Privy off Amwell Road, West New Brunswick Township, New Jersey.
FEBRUARY 1936 8a01206

p. 95 bottom right
Three-family toilet, Hamilton County, Ohio.
DECEMBER 1935 8a00804

p. 96 left
Hod carriers at Greenbelt, Maryland.
1936 JULY 8a01984

p. 96 top right
Construction at Greenbelt, Maryland.
JULY 1936 8a01920

p. 96 center right
Dam construction, Prince George's County, Maryland.
NOVEMBER 1935 8a00625

p. 96 bottom right
Playtime, Radburn, New Jersey.
NOVEMBER 1935 8a00665

p. 97 top left
Lubricating oil, Greenbelt, Maryland.
AUGUST 1936 8a02069

p. 97 top right
Steel window frames, Greenbelt, Maryland.
AUGUST 1936 8a02079

p. 97 center left
Slate for roofing, Greenbelt, Maryland.
AUGUST 1936 8a02083

p. 97 center right
Wheelbarrows used at Greenbelt, Maryland.
AUGUST 1936 8a02087

p. 97 bottom left
Armored cable for wiring, Greenbelt, Maryland.
AUGUST 1936 8a02091

p. 97 lower center right
Pipe storage at Greenbelt, Maryland.
AUGUST 1936 8a02103

p. 97 bottom right
Tile pipe, Greenbelt, Maryland.
AUGUST 1936 8a02116

p. 98 top
Cincinnati, Ohio.
DECEMBER 1935 8b26564

p. 98 bottom
The Calco Chemical Company near Bound Brook, New Jersey, which employs many people.
FEBRUARY 1936 8b26916

p. 99 top
Row of identical houses off Eastern Avenue, in Cincinnati, Ohio, showing backyard outhouses. Ohio River Valley is in the distance.
DECEMBER 1935 8b38169

p. 99 bottom
Housing in the vicinity of Pierce Street, L Street, First Street, and North Capitol. Washington, D.C.
NOVEMBER 1935 8b26584

p. 100
Manville, New Jersey, showing series of identical houses.
FEBRUARY 1936 8b26919

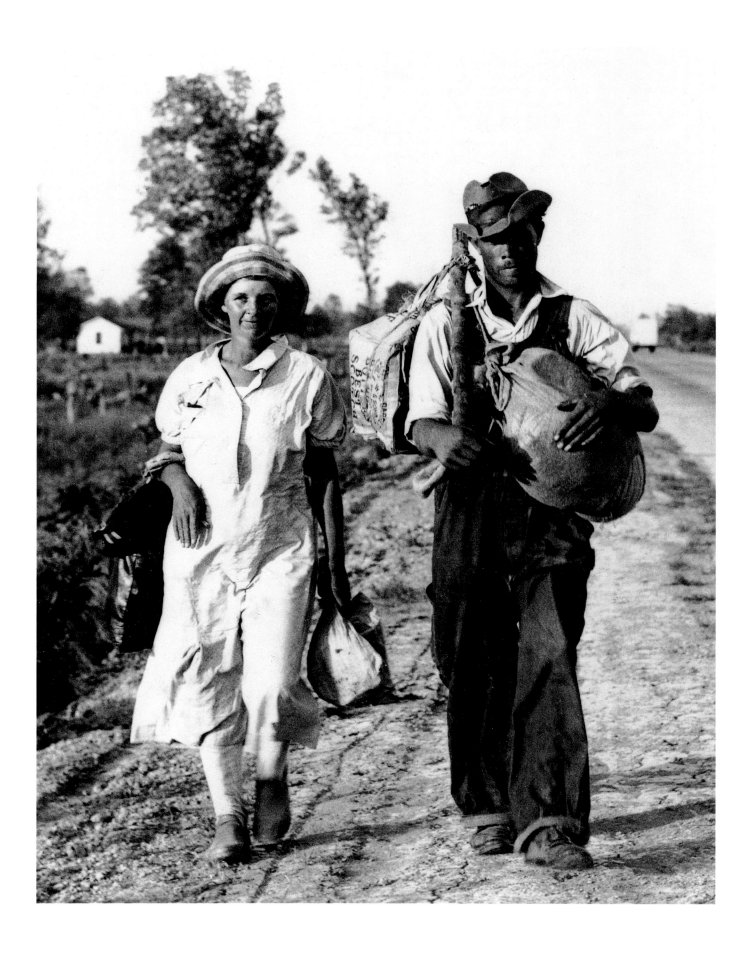

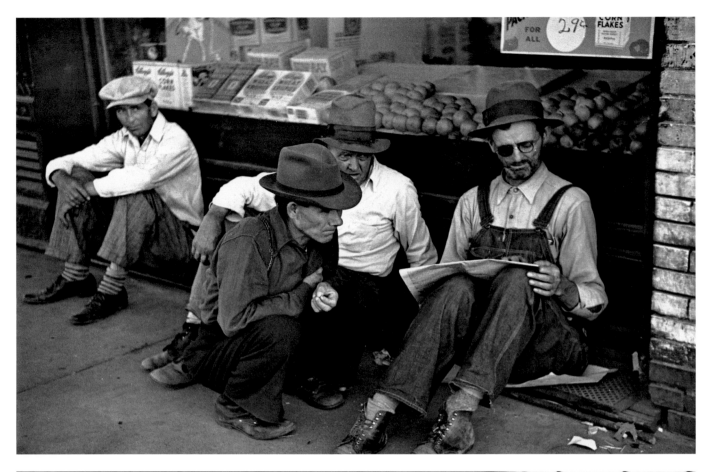

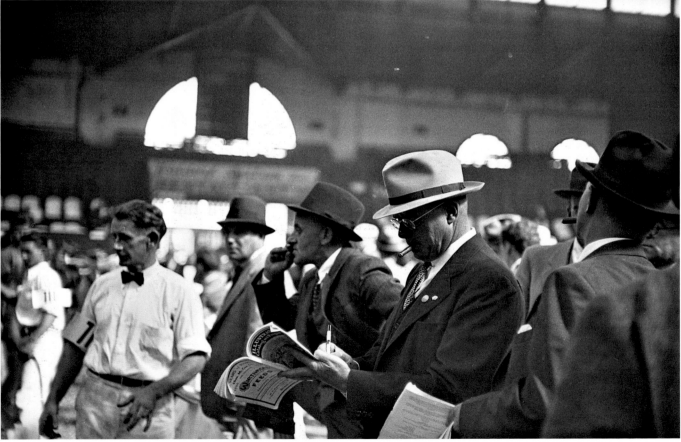

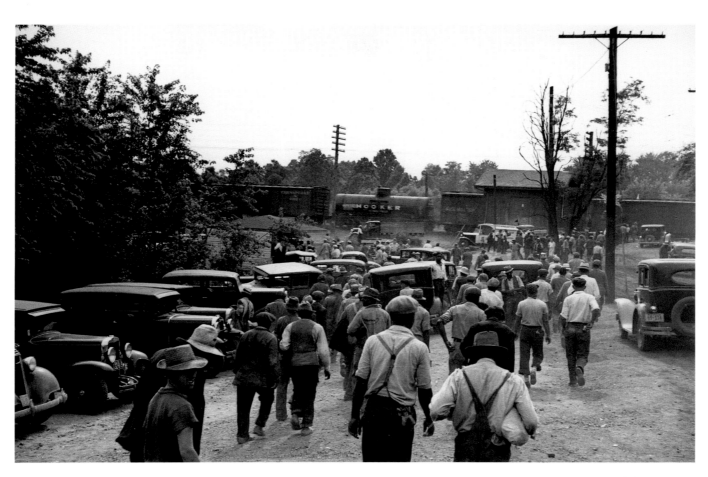

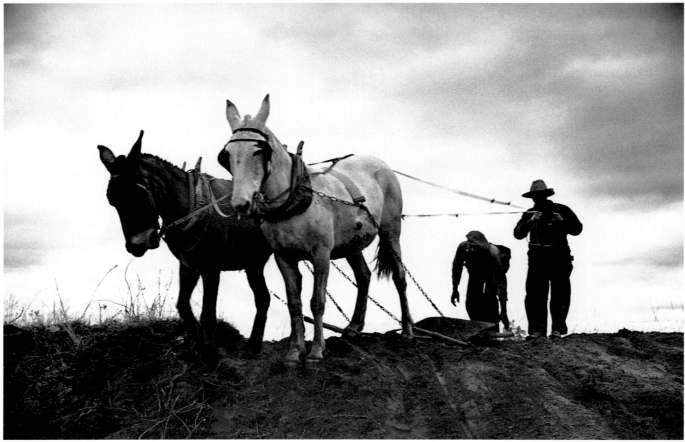

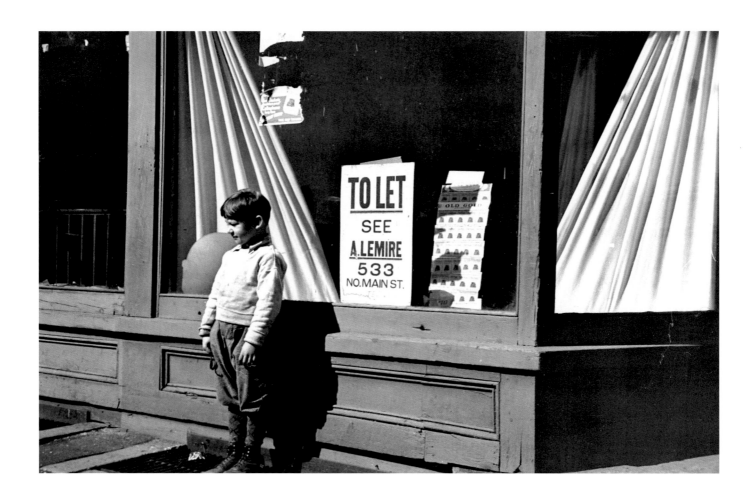

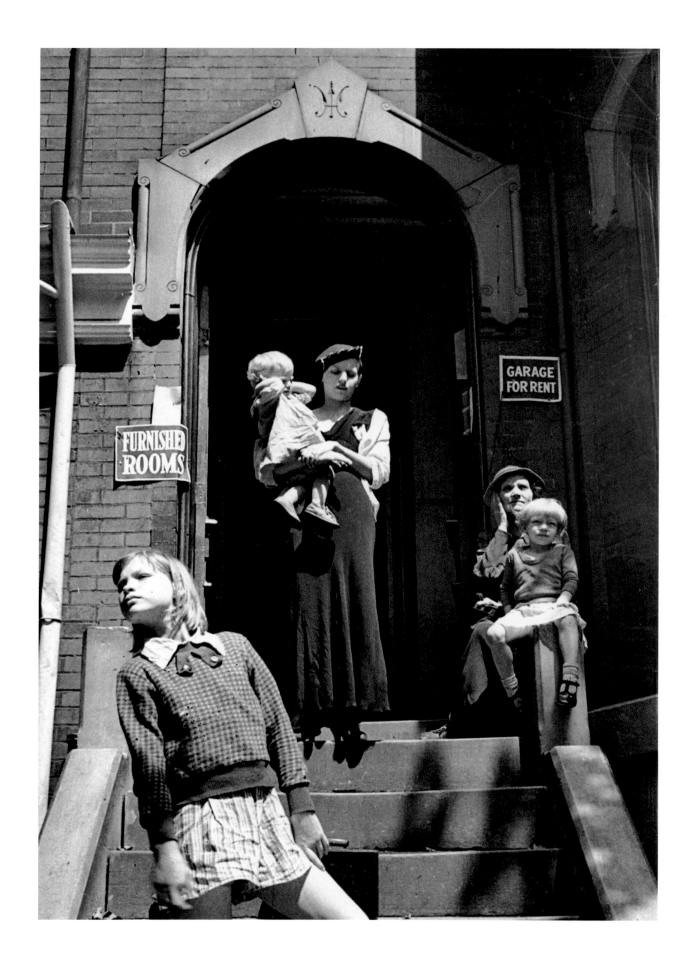

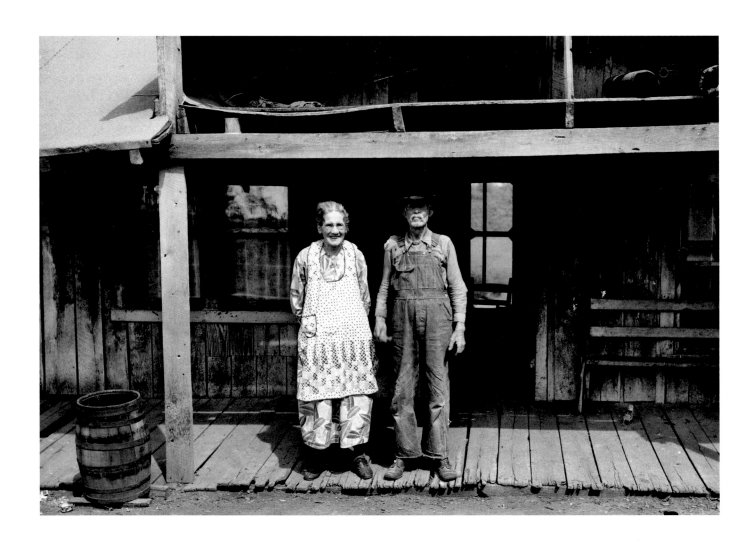

CARL MYDANS

The artistic evolution of Austrian-born photographer Theodor Jung was that of an autodidact who initially took up photography as a pastime. Born in Vienna, Jung immigrated to the United States at age six in 1912. In 1933 he returned to his birthplace for a yearlong training course in graphic design, then moved back to the United States the following year.

In February 1934 friends found Jung a job with the Federal Emergency Relief Administration, the Works Progress Administration's predecessor, where he was charged with preparing pictorial charts of unemployment statistics using the method invented by Austrian sociologist Otto Neurath. In September 1935 Jung showed Roy Stryker some pictures he had taken in Washington's poor neighborhoods. Stryker hired him on the spot, both as a photographer and as a graphic designer for the publications and exhibits that would be organized by what was about to become the FSA.

THEODOR JUNG
JACKSON COUNTY, OHIO

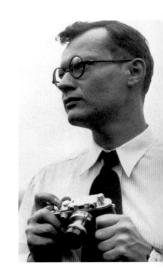

As a member of Roy Stryker's first team of photographers, Theo Jung took a limited number of photographs (about 150 are in the Library of Congress archives), which he shot over the course of three assignments. His first was to Maryland, in September 1935, and his second, in October of the same year, to Indiana.

Jung's last assignment was to Jackson County, Ohio, in April 1936. The influence of Jung's close friend and colleague, the painter-photographer Ben Shahn, is fully apparent in the Ohio pictures. Working exclusively in 35mm and almost never photographing his subjects frontally, Jung took pictures in a style more intuitive than composed and refused to immerse himself in the study of sociogeographic conditions that Stryker espoused. He defended his novel approach by stating that it allowed him "an attitude and an eye free of any prejudice."[1] Conceptual differences and the relative paucity of Jung's output led Roy Stryker to fire him, in May 1936, under the pretense of budget restrictions.

1. Quoted in O'Neal, *A Vision Shared,* p. 26.

G.M.

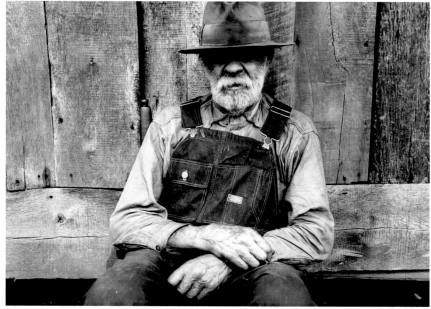

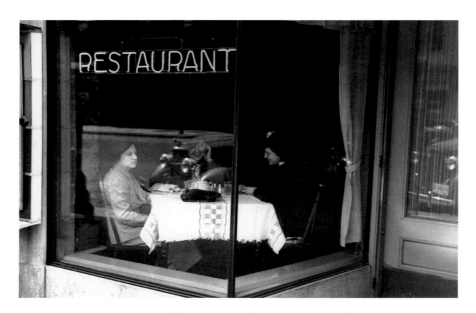

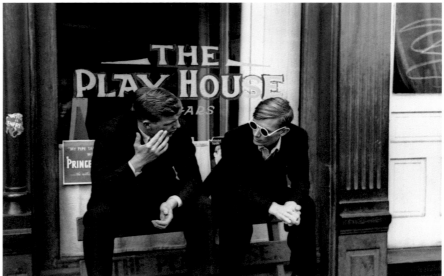

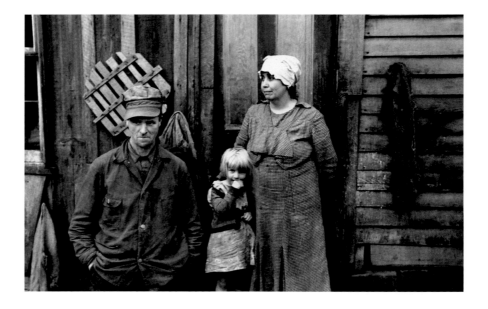

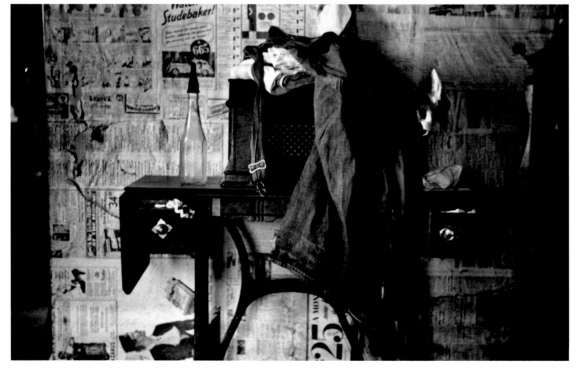

THEODOR JUNG

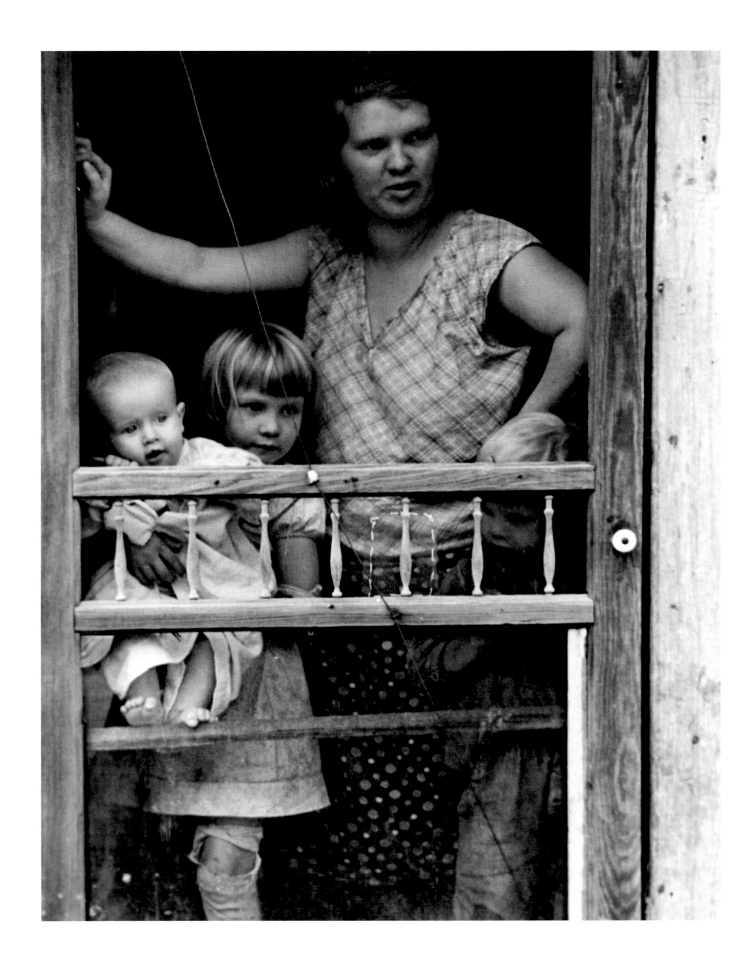

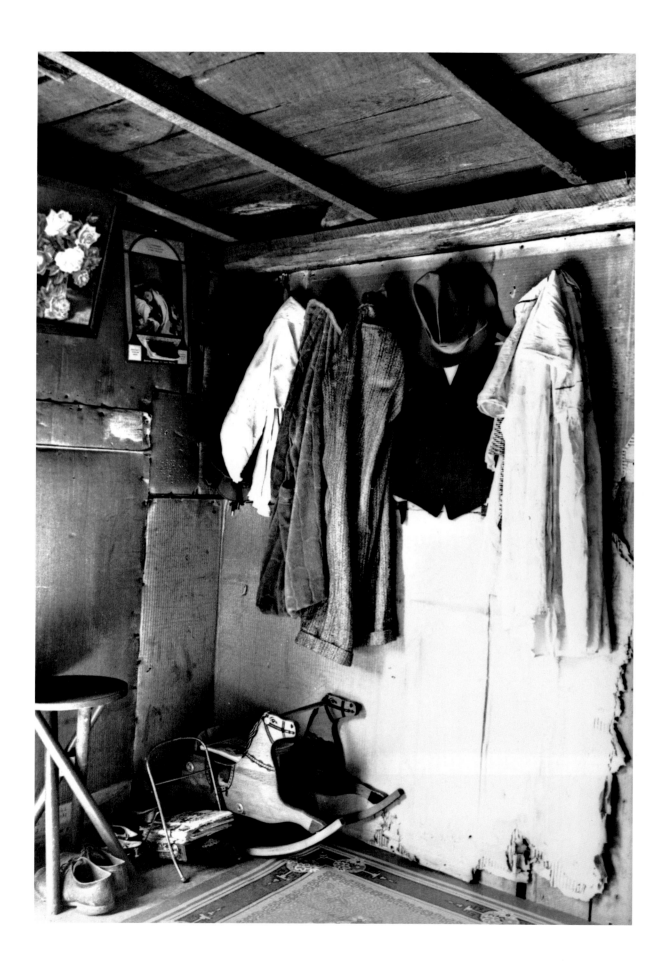

THEODOR JUNG

On March 17, 1936, five months shy of his twenty-first birthday. Rothstein set out from Washington, D.C., on a picture-taking trip that expanded as he drove. Roy Stryker's undergraduate assistant only the year before, Rothstein relied on his enormous social and scientific curiosity, as well as his youthful bravado, to get him through. Coming just a couple of weeks after a well-received White House screening of *The Plow That Broke the Plains,*[1] Rothstein's initial assignment called for him to "explore dust storms and drought in the west and the agency's attempts at relief,"[2] but Roy Stryker steadily revised his directions for the remainder of that presidential election year.

Rothstein's early photographs most resemble the movie, with weed-tangled plows abandoned in arid, sandy Oklahoma soil, including one captioned "The plow that broke the plains; look at it now."[3] There's also his famous Cimarron County, Oklahoma, photograph of a farmer and his sons walking in the face of a dust storm on April 23, and (by May 16 or 17, according to his biographer) a steer's skull against "dry and parched earth in the badlands of South Dakota."[4] Thereafter his assignments changed with the agency's needs, what and whom he found along the way, and late-breaking political events and expectations.

Rothstein visited rehabilitation projects in Kansas and Nebraska in May. He spent June and early July exploring agricultural areas in Oregon and along the Yakima River in Washington State, wheat harvests in Washington and North Dakota, and migrant farmers in South Dakota. He backtracked to Oregon to photograph Native Americans at the Molalla Buckaroo, and in late July and early August surveyed Texas, where he photographed abandoned farms and almost entirely depleted human endurance. With word that Rexford Tugwell, the agency director, would lead a committee to study the drought in the West, Stryker sent Rothstein to join Tugwell in Amarillo, Texas, and to continue on with him to Colorado and Oklahoma for the Great Plains Drought Committee meetings with farmers.[5]

Rothstein was with the committee in Bismarck, North Dakota, on August 27, when candidate Franklin D. Roosevelt made a whistle-stop, greeting the public from the platform at the rear of his train and conferring with candidates for resettlement from his open-top automobile (see p. 136). The newspaper headlines confronting them at the Bismarck station accused the New Deal Democrats of fraud and Rothstein with moving a steer's skull from site to site to exaggerate drought damage for political advantage. Stryker was vacationing in Vermont "when this skull business cracked," he said.[6] Edwin Locke, the Historical Section's in-

1. Pare Lorentz's documentary film on soil erosion caused by overuse.—Ed.

2. Peterson, forthcoming Arthur Rothstein biography, draft from 1998.

3. Official caption for FSA-OWI negative number LC-USF34-004380.

4. Peterson, forthcoming Rothstein biography.

5. Ibid.

6. Transcript of a conversation among former FSA staff members at Vachon's New York apartment, 1952, p. 29, John Vachon Papers.

formation officer, was in Washington, D.C., "and he hadn't much experience with the press, and he gave them a clue when he said, 'I guess it is a case of skull-duggery....' [Locke] said afterwards he learned his lesson."[7]

Through Locke, Stryker told Rothstein to get rid of the skull, drop from sight, and drive as quickly as possible to Itasca State Park, in northern Minnesota, to photograph the sign "Home of Mississippi Headwaters," for Pare Lorentz's upcoming film, *The River.* Rothstein took the picture immediately, relaxed briefly in Minnesota, then drove for two days to reach Washington, D.C. He left the next

ARTHUR ROTHSTEIN
DROUGHT

day for a week's stay in New York, his first visit home that year, before returning to RA headquarters.

At a dinner Roy Stryker had with FSA photographers Dorothea Lange, Arthur Rothstein, and John Vachon at Vachon's New York apartment in 1952, Rothstein asked the group to assess the impact of their photographs on the 1936 presidential campaign. Stryker immediately cited Ben Shahn's display of RA news photos at the Democratic National Convention, which brought the agency's free photo service to the attention of the national press.[8] Rothstein then asked specifically about the skull incident; Stryker initially dismissed it as an internal public relations mistake and expressed greater concern over a now forgotten incident involving Russell Lee, where "[t]hat same kind of thing got us into trouble again, that same kind."[9]

After reflection, Stryker attributed the skull mess to "fancy writing." As he recalled, "There were two captions written by our own caption writers. Arch Mercey [writer for the Information Section] in his desire to get out some publicity wrote the caption.... They asked [the Historical Section] to do captions.... Th[at] caption was printed at the bottom of the page exactly as supplied." But, he said, the caption that was written up in the newspapers was Mercey's.[10]

All in all, the significance of the incident that had haunted Rothstein and tainted his FSA legacy seems barely to have registered for his boss.

B.W.B.

7. Ibid.
8. Ibid., p. 28.
9. Ibid.
10. Ibid.

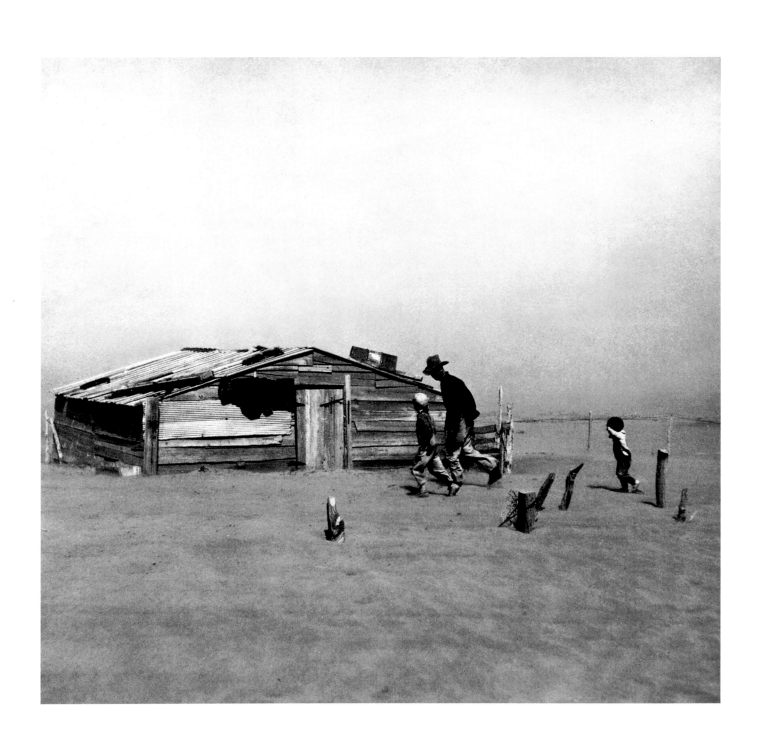

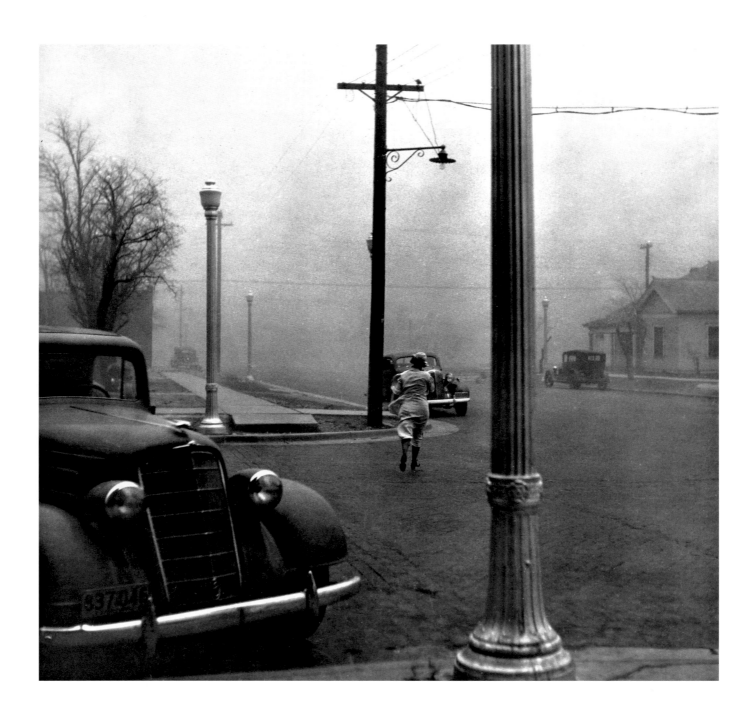

ARTHUR ROTHSTEIN

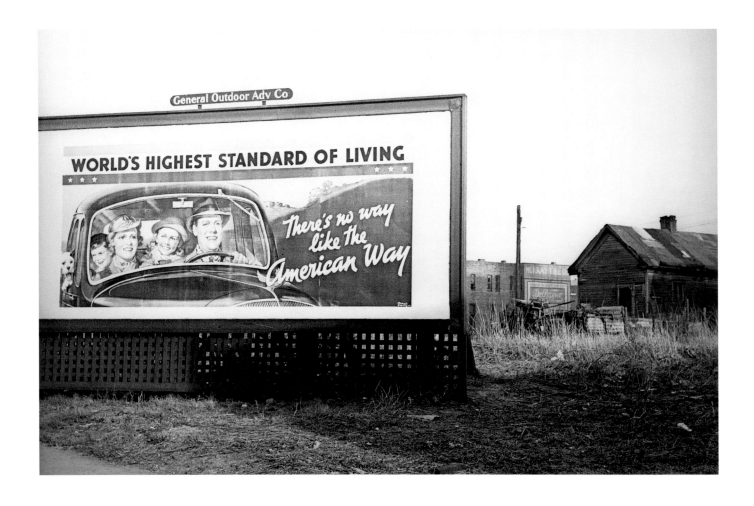

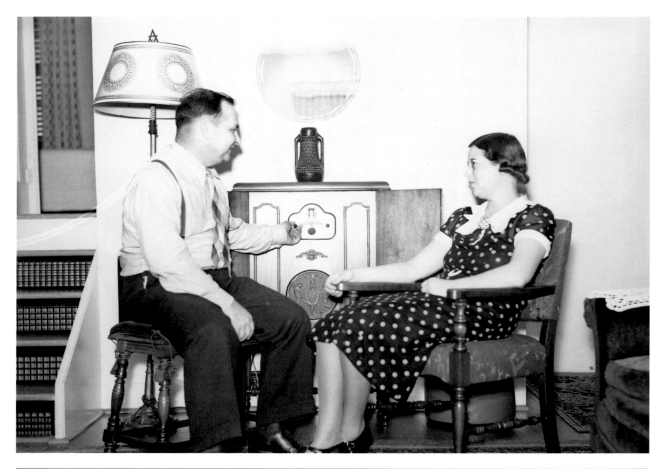

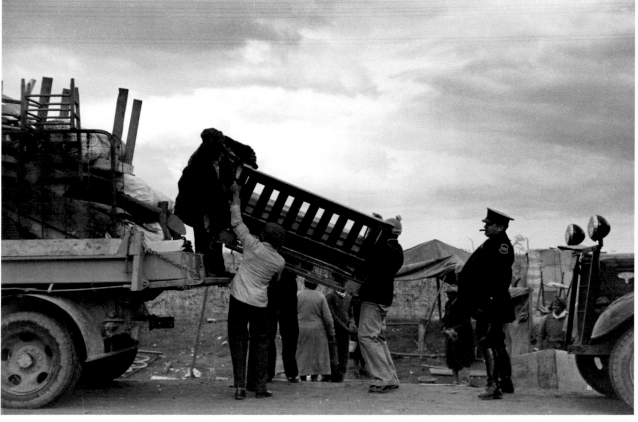

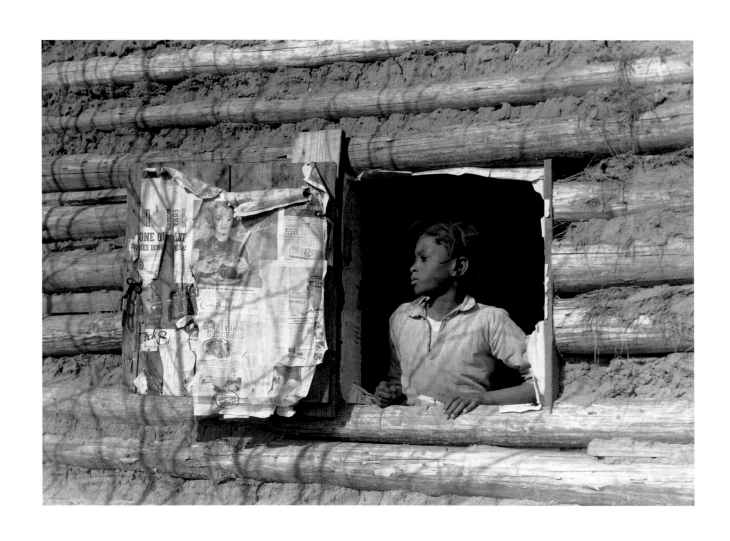

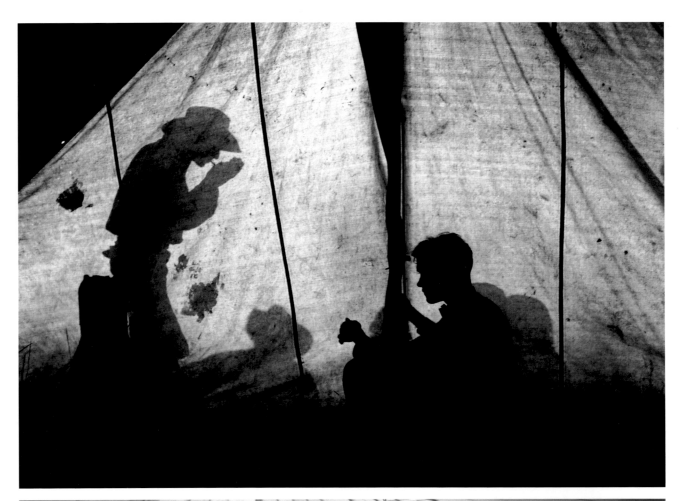

ARTHUR ROTHSTEIN

THE MIDDLE PERIOD
(1937–42)

EDWIN AND LOUISE ROSSKAM

MARION POST WOLCOTT

JACK DELANO

JOHN VACHON

RUSSELL LEE

From the beginning of their marriage, in late 1936, the Rosskams worked as a team. Edwin Rosskam provided the ideas, saw the big picture, made the public presentations, and operated the camera. Louise acted as his assistant, identifying the gaps in the ideas, providing whatever was missing, setting up the lights, and developing the film. The first year their work was published, only Edwin's name was listed in the photo credits, as the newspapers didn't acknowledge Louise's role, but thereafter most of their credits read "The Rosskams." They worked together trying to perfect their project, not to garner individual recognition.

The Rosskams spent most of 1937 creating series of local photos for the rotogravure section of the *Philadelphia Record.* After living close to their relatives for a year, Edwin sought an assignment in Puerto Rico from the newly launched *Life* magazine. *Life* sent the Rosskams to cover the trial of young Puerto Rican nationalists who had staged a political uprising on the island, a U.S. territory.[1]

An outgoing couple, the Rosskams began their research well before the trial. They started in New York, contacting Puerto Ricans living there; then they traveled to Puerto Rico to learn about it firsthand. Local contacts expedited their cultural immersion by taking them to a cockfight, a Christmas party in a rural village, a candlelit memorial service, and employment and education programs the American government and businesses had established for residents. Their *Life* credentials gained them entrée to the island's North American governor and to the trial itself, which began in 1938, just after New Year celebrations.

The chief defendant, Pedro Albizu Compos, was in a federal prison in Georgia, so the Rosskams' focus during the trial was on the families of the young men the police had killed during the protest. They photographed the families outdoors and set up lights in the courtroom to document the trial, judge, and jury. The Rosskams' usual practice was for Louise to let Edwin know she had completed her preparations and the camera's flash was ready to go off by calling, "Shoot!" However, the use of that word during an assassination trial got them hustled out of the courtroom; only after considerable persuasion were they readmitted.

1. L. Rosskam, interview with Saretzky.

EDWIN AND LOUISE ROSSKAM

PUERTO RICO

The Rosskams honed their skills as teammates on that assignment, and they also identified their life's work. They responded so deeply to the people of Puerto Rico that they determined to return to the island to work at improving living standards for its poorest inhabitants.

When World War II prevented their immediate return, they prepared photodocumentary books about the cities of San Francisco and Washington, D.C., work that led them to the FSA file and thus to Roy Stryker. Stryker hired Edwin as an editor and packager of photos, exhibitions, public statements, and books. Louise, who had trained as a scientist, relinquished the microscope for the camera, supplying photographs to magazines. She documented in FSA style the lives of the rich and poor around her, immersing herself in disparate cultures—from small farm towns in Vermont to the mixed-race Washington neighborhood where she and Edwin lived.

Their FSA experience was followed by several years' work with Stryker on a promotional photo project for Standard Oil of New Jersey—ideal preparation for the call the Rosskams received in 1945: Rex Tugwell, who had been Stryker's mentor and was then governor of Puerto Rico, wanted to establish an FSA-style project on the island. Edwin, who was appointed director, hired Louise and former OWI photographer Jack Delano as project photographers.

B.W.B

EDWIN AND LOUISE ROSSKAM

p. 149
Edwin Rosskam preparing prints publicizing the sale of war bonds, Washington, D.C., 1941. Photograph by John Collier

p. 151 top
Villa of the owner of a sugar plantation and refinery and sugar workers' shacks. Ponce, Puerto Rico.
DECEMBER 1937 8b30529

p. 151 bottom
Hoeing a tobacco slope. No matter how steep, all of the hills in the picture are under cultivation. Puerto Rico.
JANUARY 1938 8b30540

p. 152 top left
Sugar cane being loaded onto a train for transportation to the refinery. Near Ponce, Puerto Rico.
JANUARY 1938 8b30535

p. 152 top right
Longshoreman. San Juan, Puerto Rico.
JANUARY 1938 8b30665

p. 152 bottom left
Jibaro women and children preparing tobacco leaves for the drying barn. Puerto Rico.
JANUARY 1938 8b30684

p. 152 bottom right
Cutting cane on a sugar plantation near Ponce, Puerto Rico.
JANUARY 1938 8b30647

p. 153 top
Girl carrying water in gasoline can. Ponce, Puerto Rico.
JANUARY 1938 8b30568

p. 153 bottom
Ponce (vicinity), Puerto Rico. Sugar worker taking a drink of water on a plantation.
JANUARY 1938 8b30504

p. 154 top
Jibaro hurricane shelter. The rags are freshly washed laundry drying. Puerto Rico.
JANUARY 1938 8b30569

p. 154 bottom
Woman suffering from malaria in the workers' quarter of Puerta de Tierra. San Juan, Puerto Rico.
JANUARY 1938 8b30521

p. 155 top
Families of Nationalist demonstrators who were killed in the Ponce massacre, standing before the Nationalist headquarters. Note machine gun bullets in wall. Ponce, Puerto Rico.
DECEMBER 1937 8b30694

p. 155 bottom
Governor Winship on the staircase of the governor's palace. Puerto Rico.
JANUARY 1938 8b30719

p. 156 top
Exterior of country store in the hills. Puerto Rico.
JANUARY 1938 8b30516

p. 156 bottom
Homework in the so-called needlework industry. Ponce, Puerto Rico.
JANUARY 1938 8b30531

p. 157 top
Itinerant barber at work in the worker's quarter of La Perla. San Juan, Puerto Rico.
JANUARY 1938 8b30716

p. 157 bottom
Guitar player above the swamp water. The workers' quarter of Puerta de Tierra. San Juan, Puerto Rico.
JANUARY 1938 8b30726

p. 158 top
Musicians (local farmers) at a "rosario," a semireligious ceremony used for "cures" among the jibaros. Near Cidra, Puerto Rico.
JANUARY 1938 8b30618

p. 158 bottom
A cockfighting ring near San Juan, Puerto Rico.
DECEMBER 1937 8b30674

p. 159 top left
The beginning of the cockfight. When the man in the center raises the cloth, the birds will see each other and begin to fight. Puerto Rico.
DECEMBER 1937 8b30549

p. 159 top right
Rosario, a religious ceremony purported to have medicinal properties. A small altar is erected in the hut; all the neighbors come to visit and help in prayer and the singing of hymns. Puerto Rico.
JANUARY 1938 8b30660

p. 159 bottom left
Trainer washing the head of a fighting cock before the fight. Puerto Rico.
DECEMBER 1937 8b30673

p. 159 bottom right
Birds in the training arena. Puerto Rico.
DECEMBER 1937 8b30734

p. 160 top
Demonstration in support of the Spanish loyalists in the workers' quarter of Puerta de Tierra. San Juan, Puerto Rico.
JANUARY 1938 8b30470

p. 160 bottom
Demonstration in support of the Spanish loyalists in the workers' quarter of Puerta de Tierra. San Juan, Puerto Rico.
JANUARY 1938 8b30476

p. 161 top
Toy sellers in the municipal plaza. San Juan, Puerto Rico.
DECEMBER 1937 8b30597

p. 161 bottom
Pushcart vendors in front of a five-and-ten store. San Juan, Puerto Rico.
DECEMBER 1937 8b30602

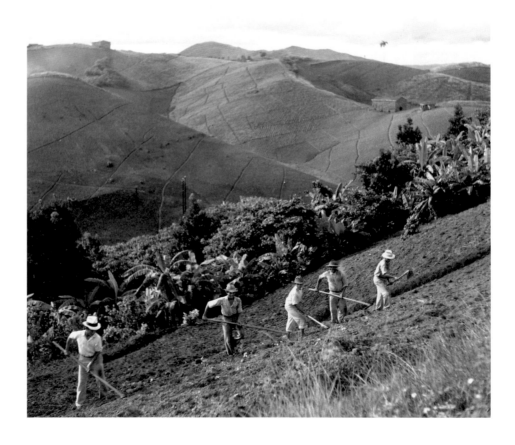

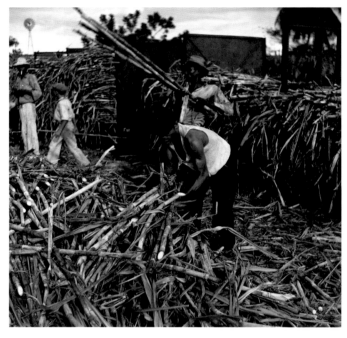
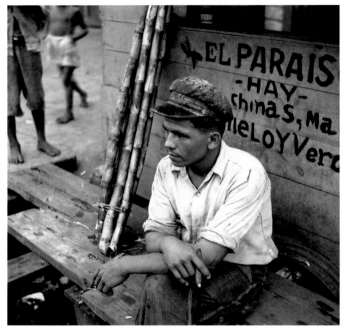
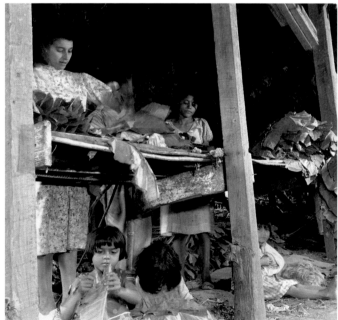
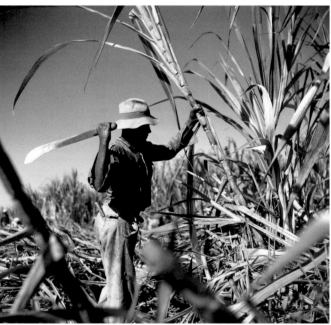

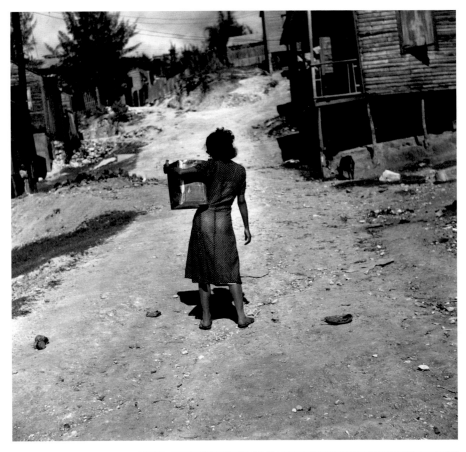

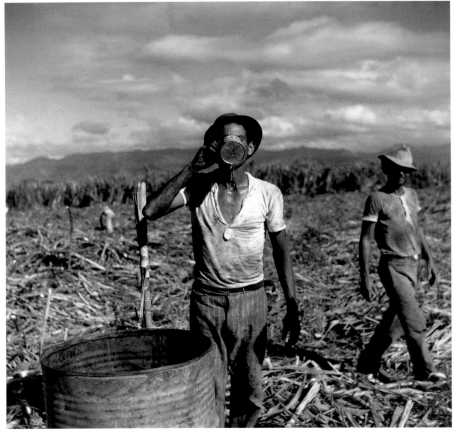

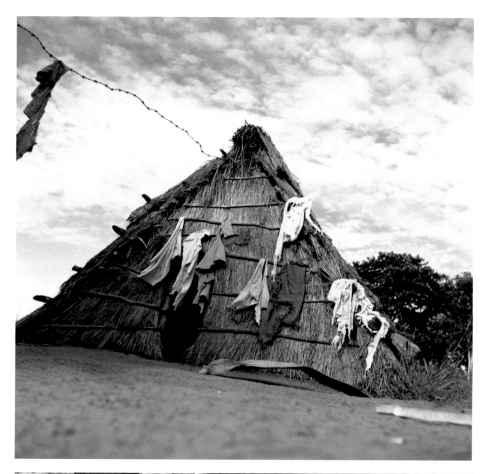

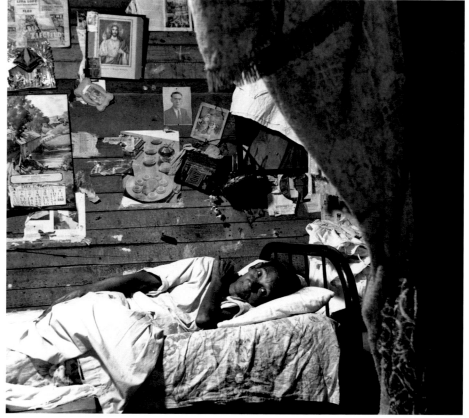

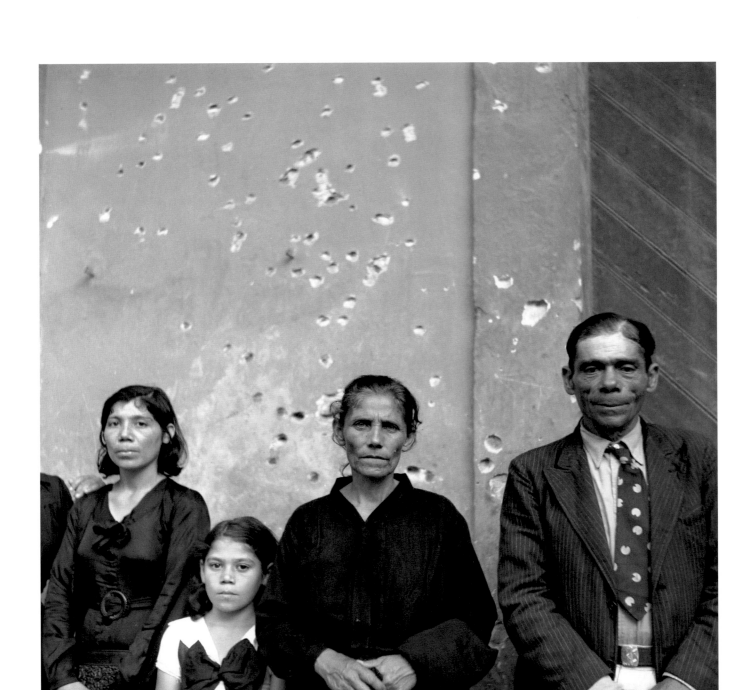

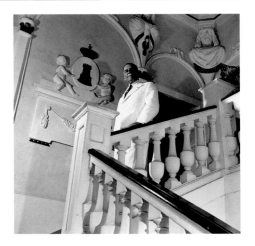

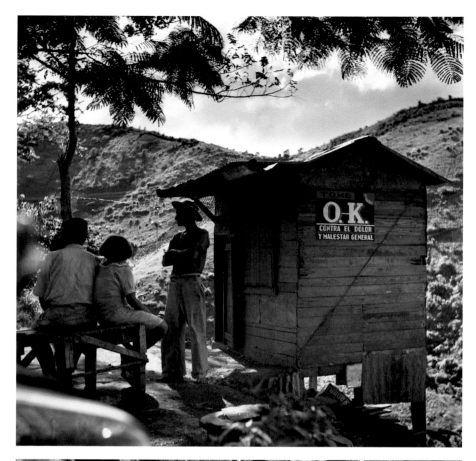

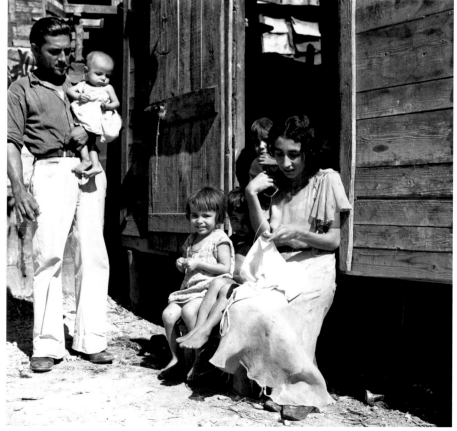

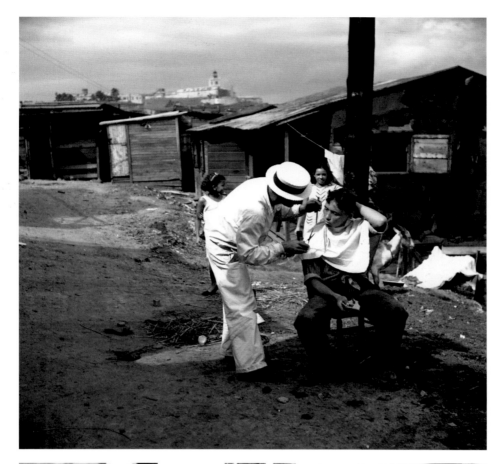

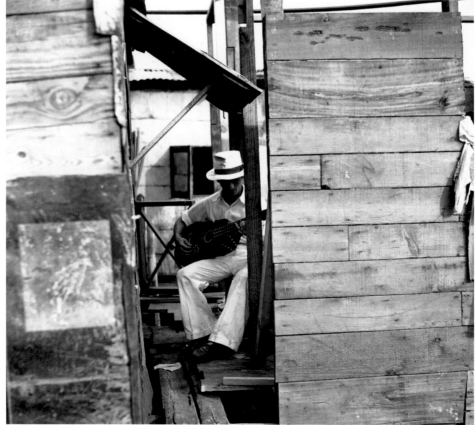

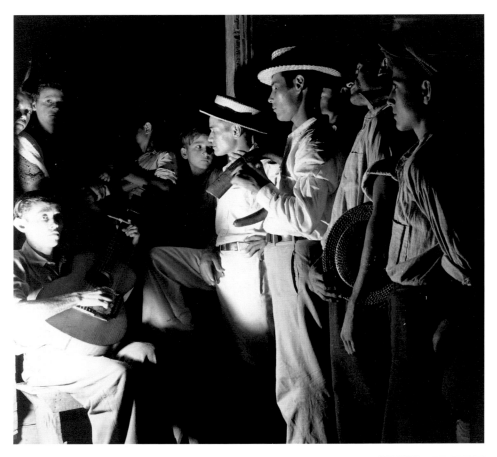

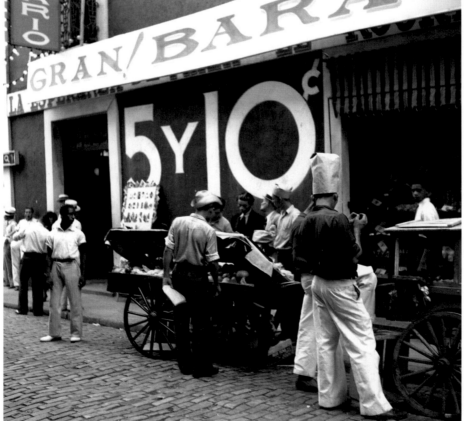

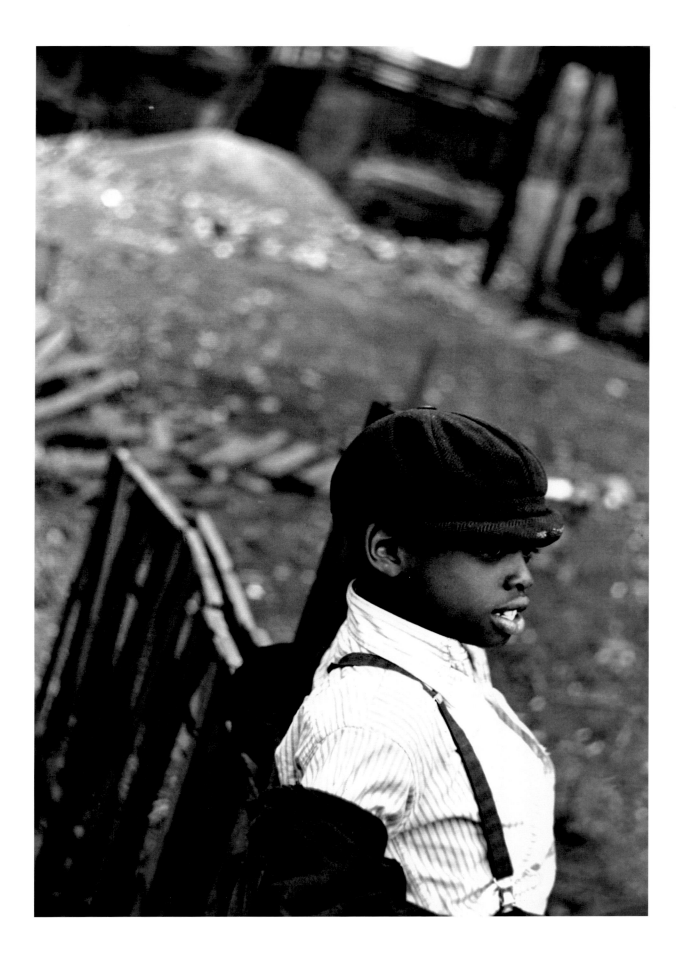

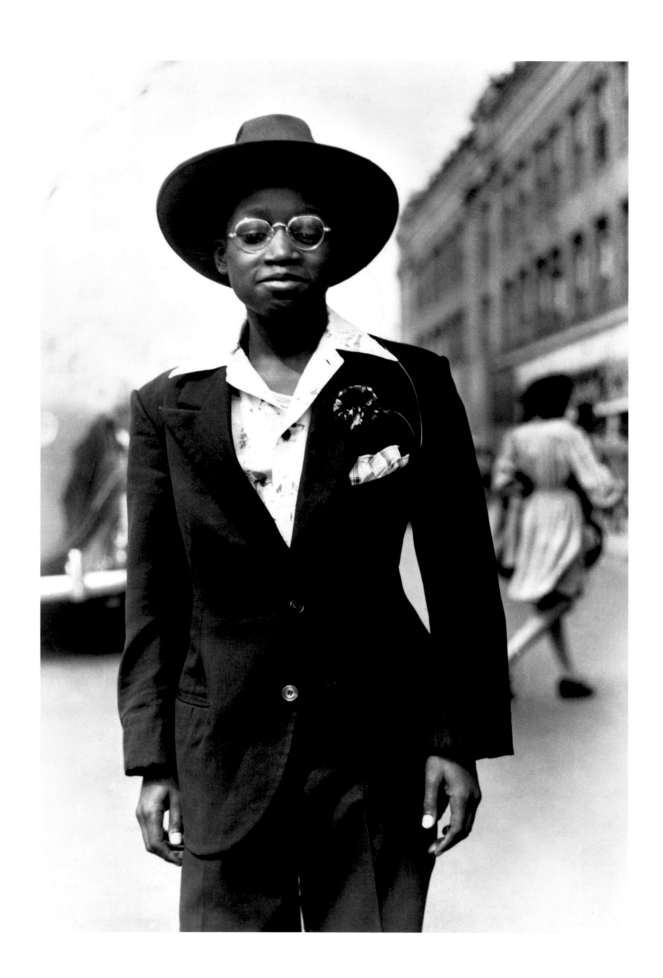

EDWIN AND LOUISE ROSSKAM | 163

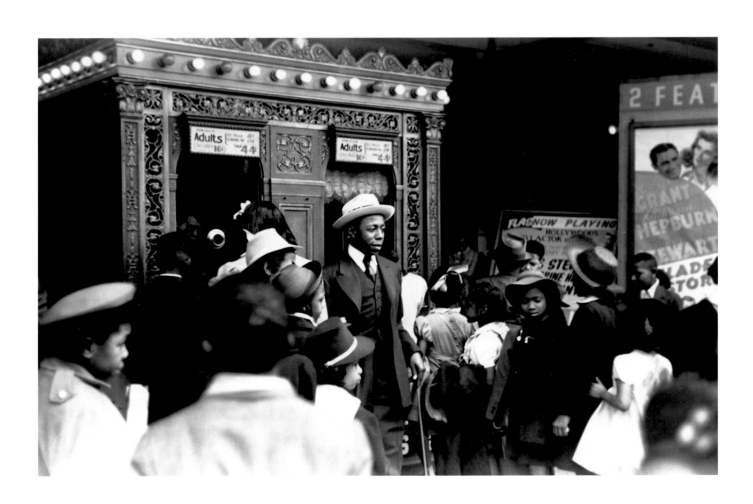

EDWIN AND LOUISE ROSSKAM

p. 162
Negro boy in an empty lot which is
his playground, Chicago, Illinois.
APRIL 1941 8a15897

p. 163
Adolescent boy dressed up for the
Easter parade, Chicago, Illinois.
APRIL 1941 01594

p. 164
Children in front of moving-picture
theater, Easter Sunday matinee,
Black Belt, Chicago, Illinois.
APRIL 1941 8a15698

p. 165 top
Boys on the Fourth of July, State
College, Pennsylvania.
JULY 1941 8a15962

p. 165 bottom
Negro children on the street,
Chicago, Illinois.
APRIL 1941 8a15660

p. 166
Employees of a wrecking company
eating lunch. New York.
DECEMBER 1941 8b14692

Something about Marion Post Wolcott drew people to her, and they remembered experiences with her as high points of their lives. Nearly fifty years after spending a night in 1939 squiring the FSA photographer to North Carolina tobacco auctions, Leonard Rapport was still absorbed by the memory. As a field worker for the Works Progress Administration, he interviewed and transcribed the words of farmers, tenant farmers, sharecroppers, and auctioneers, oral histories later collected in "The Tobacco People."[1] Working with Post Wolcott, he fell under her spell. During a lengthy telephone interview in 1987, Rapport repeated again and again, "Aw, shucks, I was just a kid."[2]

Tobacco was then North Carolina's principal cash crop.[3] The extractive industries of agriculture, mining, logging, and quarrying were the leading sources of income in the southeastern United States, which was regarded as the most economically backward part of the rapidly industrializing nation. The FSA organized several projects there to try to raise the population's standard of living. Post Wolcott bore a heavy load as the photographer solely responsible for documenting such a large, needy region.

She had already established her own contacts through her many previous assignments in North Carolina, but Post Wolcott needed young Rapport's network, as well as his male presence, on the night in November 1939 she spent documenting tobacco auctions. The bulk of the series reproduced here shows grading and tying tobacco, delivering it to market, preparing it for sale, safeguarding its condition prior to auction, displaying it for auctioneers to examine, waiting for the final sale, the various phases of the auction itself, paying for the goods, and transferring the sold tobacco to its buyers. After completing the assignment, Post Wolcott asked to return to the Southeast to really "do tobacco culture," but she was able to add to the archive only a few photographs on growing and storing the crop in the fall of 1940.[4]

Wolcott's style was to be a "sociologist with a camera," to paraphrase Ansel Adams.[5] She was adept at teasing out the nuances of social interaction in her photographic choices, as seen in her depiction of Titus Oakley's entire family— even his eight-year-old daughter (see p. 171)—helping prepare tobacco for market; the racial segregation during the tobacco auction; and the social and service

1. Leonard Rapport, "The Tobacco People," in Ann Banks, ed., *First Person America* (New York: Knopf; distributed by Random House, 1980), pp. 137–59.

2. Leonard Rapport, telephone interview with Beverly Brannan, summer 1987.

3. The Federal Writers Project of the Federal Works Agency, Works Projects Administration for the State of North Carolina WPA, *North Carolina, a Guide to the Old North State* (Chapel Hill: University of North Carolina Press, 1939), p. 61.

4. Post Wolcott letter to Stryker, November 4, 1940, *Roy Stryker Papers.*

5. In Stryker and Wood, *In This Proud Land*, p. 8.

MARION POST WOLCOTT

TOBACCO LAND

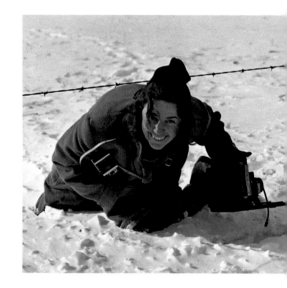

industries that swirl around the auction, giving it the semblance of a medieval market fair.[6] As a North Carolina native who had also done painstaking fieldwork, Rapport made Post Wolcott aware of the buyer's complete price control, within company guidelines; favoritism for long-term customers or farmers accompanied by pretty daughters at auction; "pinhooking," or blending the best of the already sold piles and placing them back on the market for a higher bid;[7] and the pitchmen waiting to sell the just-paid farmers everything from shoes to Armenian shawls to ten-dollar cars that had been outlawed in northern states mandating automobile inspections.[8]

In the days before videotape, Post Wolcott and Rapport created a detailed time capsule of an era that was coming to an end, recording in words and still photographs tobacco auction culture as it existed in North Carolina and much of the southeastern United States before World War II. Tobacco auctioning began to be regulated in 1940, and rural America was changing: The military built training camps, mostly on the outskirts of small towns, as America entered the war, and the ratio of farms to urban residences reversed within a few years.

Wolcott became so disillusioned by the inadequacies of government relief programs that she left her job and devoted herself to her family. She never resumed full-time use of her camera.

<p style="text-align:right;">B.W.B.</p>

6. Paul Hendrickson, writing about Post Wolcott's photo of the stairs to the movie theater in Belzoni, Mississippi (see p. 179), and Sally Stein, deconstructing her images of black field workers having their pickings weighed and being paid at a barred window and of black maids caring for white infants, have analyzed her sensibility in this regard. See Bibliography.

7. Leonard Rapport, interview with Pete Daniel, Washington, D.C., 1986. Notes in Daniel's possession.

8. Ibid.

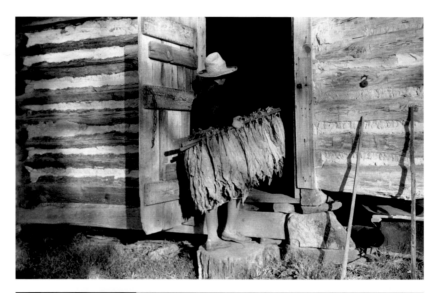

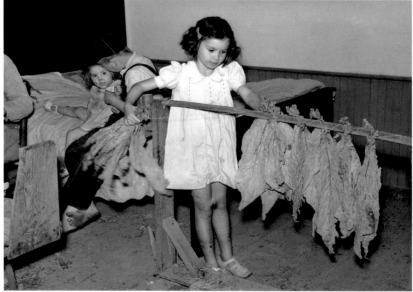

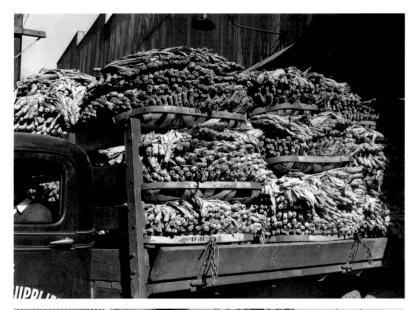

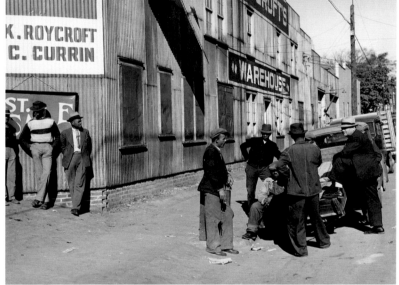

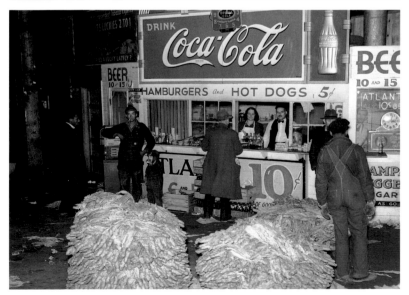

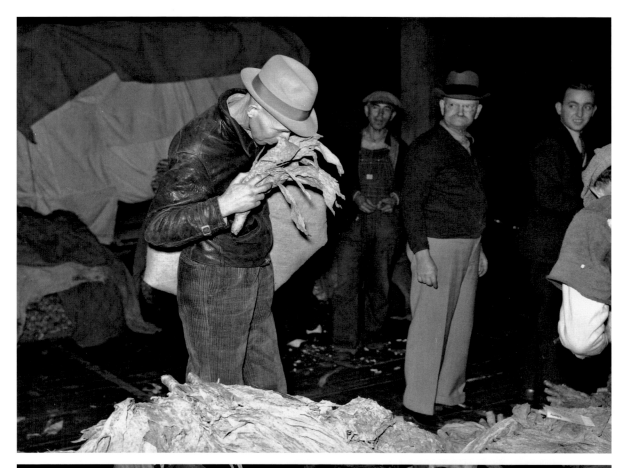

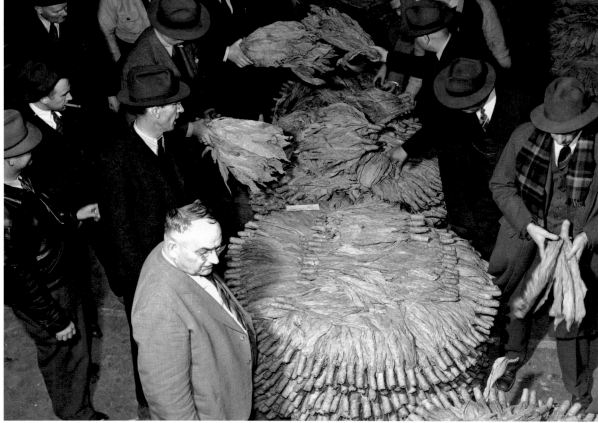

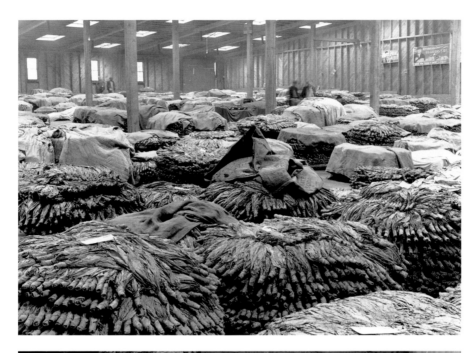

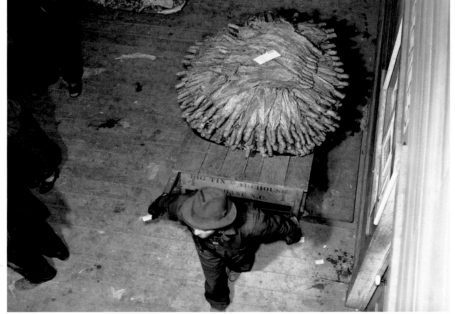

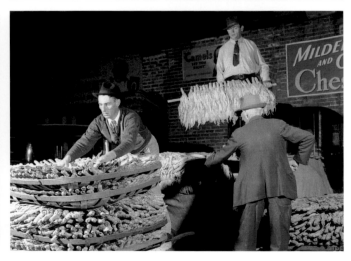

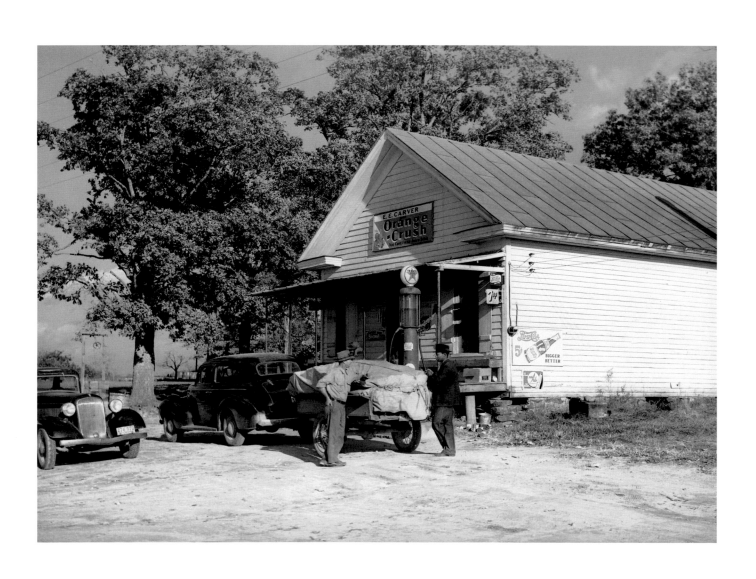

MARION POST WOLCOTT

p. 169
Marion Post Wolcott, 1940.
Photograph by Arthur Rothstein

p. 170 top
Sticks used in stripping tobacco in
front of strip house on Emery
Hooper's farm in Corbett Ridge
section near Prospect Hill. Caswell
County, North Carolina.
SEPTEMBER 1940 8c14065

p. 170 bottom
Tobacco barns and cigarette
advertisements on country road in
Prospect Hill section. Caswell
County, North Carolina.
OCTOBER 1940 8c14027

p. 171 top
Mrs. Fred Wilkins bringing in
tobacco to strip house for stripping.
Tally Ho, near Stem, Granville
County, North Carolina.
NOVEMBER 1939? 8a41790

p. 171 bottom
Titus Oakley's daughter helping in
the grading and tying of tobacco in
their bedroom as it had gotten too
cold to work in the strip house. She
is eight years old and is "taking off"
the tobacco. Shoofly, Granville
County, North Carolina.
NOVEMBER 1939 8c11091

p. 172 top
Durham, North Carolina. A truck
loaded with baskets of tobacco
being taken to a cigarette factory.
NOVEMBER 1939 8c11298

p. 172 center
Buyer talking to Negro outside
tobacco warehouse during auction
sales. Durham, North Carolina.
NOVEMBER 1939 8c10844

p. 172 bottom
Lunch stand and tobacco inside
entrance to warehouse at end of
auction sale. Durham, North
Carolina.
NOVEMBER 1939 8c11271

p. 173 top
Farmer smelling tobacco while
waiting for auction sale in
warehouse. Durham, North
Carolina.
NOVEMBER 1939 8c10793

p. 173 bottom
Auctioneer, buyers, and farmers
during tobacco auction sale.
Warehouse, Durham, North
Carolina.
NOVEMBER 1939 8c11320

p. 174 top
Baskets of tobacco on warehouse
floor before auction sale. Durham,
North Carolina.
NOVEMBER 1939 8c11246

p. 174 bottom
Basket of tobacco being taken
from the scales to the floor after
weighing before auction sale in
warehouse. Mebane, Orange
County, North Carolina.
NOVEMBER 1939 8c11267

p. 175 top left
Farmers sleeping in white camp
room in warehouse. They often
must remain overnight or several
days before their tobacco is
auctioned. Durham, North Carolina.
NOVEMBER 1939 8c11209

p. 175 top right
Farmers must often wait overnight
or for several days before their
tobacco is sold at auction. They
sometimes hang around in cafes or
pool rooms, sleeping most
anywheres. Durham, North
Carolina.
NOVEMBER 1939 8c11243

p. 175 center left
Tobacco auctioneer who "bet
on Carolina" and lost, pays off
the wager by pushing the
warehouseman in a wheelbarrow
from the warehouse to the
courthouse. Durham, North
Carolina.
NOVEMBER 1939 8a41879

p. 175 center right
Tobacco buyers playing at pinball
machine during lunch hour on day
of tobacco auctions. Durham, North
Carolina.
NOVEMBER 1939 8c11201

p. 175 bottom left
Farmers listening to sales talk of
patent medicine vendor in
warehouse during tobacco
auctions. Durham, North Carolina.
NOVEMBER 1939 8c11208

p. 175 bottom right
Farmers unloading their tobacco
from their trailer in the baskets the
night before auction sale in
Hughes warehouse. Danville,
Virginia.
OCTOBER 1940 8c13995

p. 176 top left
Farmers listening to shoe salesman
in warehouse during tobacco
auctions. Durham, North Carolina.
NOVEMBER 1939 8c11248

p. 176 top right
Farmers in warehouse getting their
checks after tobacco auction sale.
Durham, North Carolina.
NOVEMBER 1939 8c11204

p. 176 bottom
Farmers getting their checks in
warehouse office after their
tobacco has been sold at auction.
Durham, North Carolina.
NOVEMBER 1939 8c11282

p. 177
Untitled.
C. 1935–42 8c14111

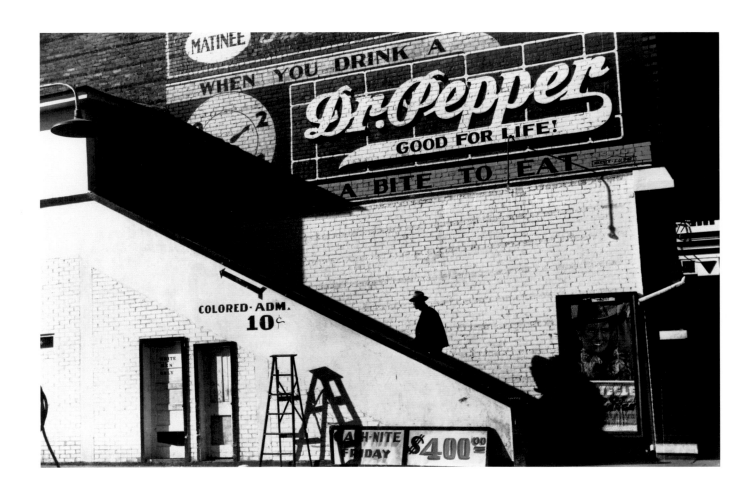

MARION POST WOLCOTT

p. 179
Negro going in colored entrance of
movie house on Saturday
afternoon, Belzoni, Mississippi
Delta, Mississippi.
OCTOBER 1939 8a41115

p. 180
County judge in front of mortuary,
main street of Leadville, old mining
town. Colorado.
SEPTEMBER 1941 8c31626

p. 181 top
Mountain child shooting slingshot
from porch of his home. Near
Buckhorn, Kentucky.
SEPTEMBER 1940 8a43535

p. 181 bottom
Horse races, Hialeah Park, Miami,
Florida.
FEBRUARY 1939 8a40626

p. 182
Lyman Brewster of Quarter Circle
U Ranch at rodeo in Ashland,
Montana.
SEPTEMBER 1941 8c31583

p. 183
Judge at the horse races.
Warrenton, Virginia.
MAY 1941 8c31182

p. 184
Negro day laborers brought in by
truck from nearby towns waiting to
be paid off for cotton picking and
to buy supplies inside plantation
store. Friday night, Marcella
Plantation, Mileston, Mississipi
Delta, Mississipi.
OCTOBER 1939 8c30355

p. 185
Juke joint and bar in the Belle
Glade area, vegetable section of
south-central Florida.
FEBRUARY 1941 8c14746

p. 186
Entrance to one of Miami Beach's
better hotels. Miami Beach, Florida.
APRIL 1939 8c09805

In 1938 Jack Delano successfully completed a project, funded by the WPA Federal Arts Project, documenting unemployed anthracite coal miners in Schuykill County, Pennsylvania. His work was mounted in a large exhibition at the Pennsylvania Railroad Station in Philadelphia, the reviews of which drew New York art photographer Paul Strand to the show. On the basis of what he saw there, Strand recommended Delano to FSA project director Roy Stryker, who had already heard his staffers Edwin Rosskam and Marion Post Wolcott (who had worked as photojournalists in Philadelphia) praise the young photographer's work.[1] After interviewing Delano in Washington in October 1939, an impressed Stryker wrote that he hoped to hire him at the very next opportunity.[2] The opportunity came unexpectedly soon, in May 1940, when Arthur Rothstein left the staff for *Look* magazine.

Much of Delano's work was informed by an interest in people who performed necessary but thankless work; he approached the subject as a fine artist, searching for the quintessential image to convey the dignity of their labor. Roy Stryker referred to this sensibility when he recalled Delano's effort to capture the essence of Vermont in a single photo while his colleagues tried to document as many scenes and activities as they could.[3]

Trained at the Pennsylvania Academy of Fine Arts, Delano spent four months, funded by the Cresson Traveling Scholarship, studying art in Western Europe's major churches, museums, and galleries. He found himself drawn to depictions of ordinary people in the works of Van Gogh, Daumier, Brueghel, Goya, and Hogarth, and in Persian and Indian miniatures and Japanese prints.[4] Their similarity to the published photographs by Stryker's Historical Section that documented farmers and sharecroppers suffering from the depression and the drought

1. WPA–Federal Art Project photographs of Pennsylvania coal miners and coal mining communities, 1938 or 1939. LOT 13323, Prints and Photographs Division, Library of Congress.

2. Stryker, letter to Delano, November 1, 1939, Jack Delano Papers.

3. Transcript of a conversation among former FSA staff members at Vachon's New York apartment, 1952, p. 40, John Vachon Papers.

4. Jack Delano, *Puerto Rico Mio: Four Decades of Change* (Washington, D.C.: Smithsonian Institution Press, 1990), p. 19.

JACK DELANO
ORDINARY PEOPLE

that had ruined their farms inspired Delano to think that someday he himself would work for Stryker.

The opening of a position at FSA-OWI, so fortuitously timed, allowed the then unemployed photographer to pursue his passion for celebrating the common people. Delano spent more than three years with the FSA-OWI project, bringing his artistic training to bear when he judged it appropriate. Delano was gifted in many expressive ways—he would later be an artist, composer, musician, conductor, and filmmaker—but his portraits figure among his most significant accomplishments. His son later remarked on how, when his father took photographs of people, a look of pure communication passed between them, with nothing to impede one human baring its soul to another.[5]

Delano may not have known he had that special skill at age twenty-six, when he began working at the FSA, but he certainly recognized it later. At the conclusion of his autobiography, *Photographic Memories,* published only days before his death in 1997, he wrote, "my lifelong concern for the common people and appreciation of their value… have been the driving force behind everything I have done."[6] Without a doubt, he fulfilled his life's ambition to "make ordinary people important."[7]

<div align="right">B.W.B.</div>

5. Pablo Delano, telephone interview with Beverly Brannan, September 2003.

6. Delano, *Photographic Memories,* p. 216.

7. Idem, *Puerto Rico Mio,* p. 33.

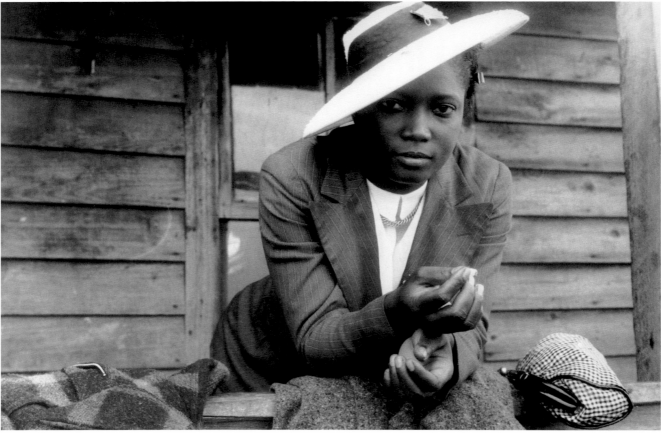

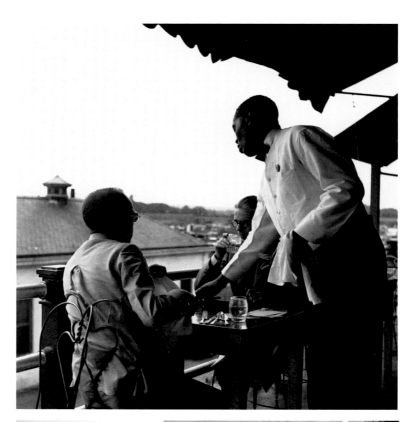

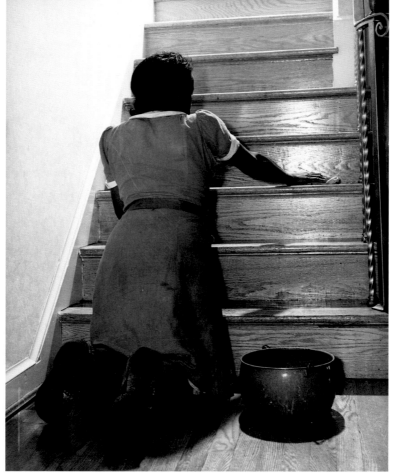

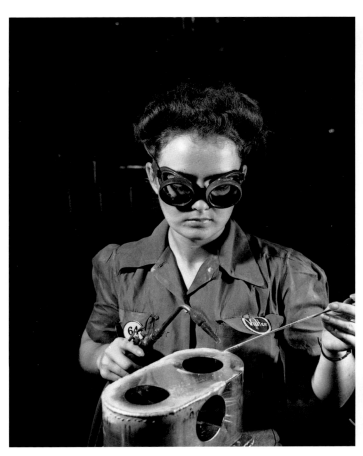

JACK DELANO | 193

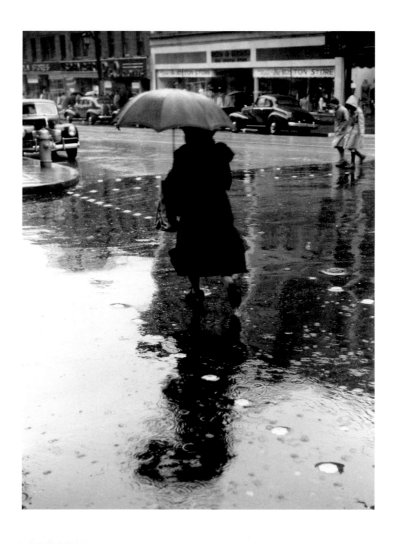

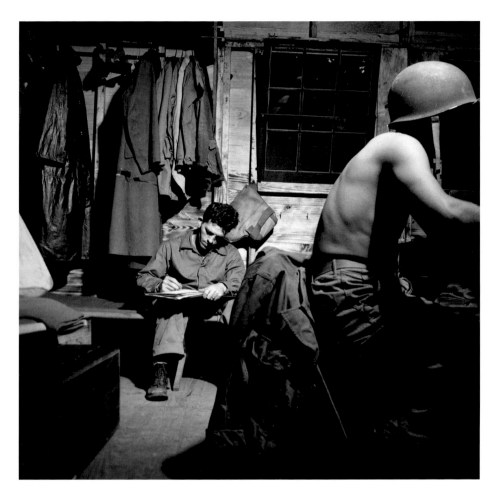

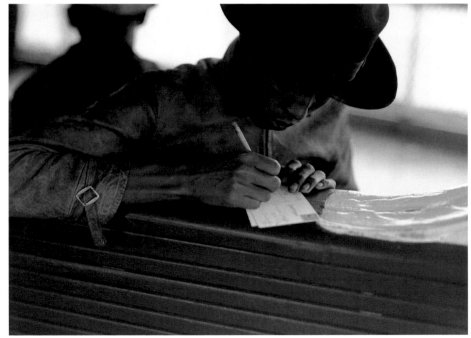

JACK DELANO

p. 189
Jack Delano, Farm Security Administration/Office of War Information photographer, full-length portrait, holding camera, standing on front of locomotive.
C. 1943 00186

p. 191 top
In town on a Saturday afternoon, Franklin, Heard County, Georgia.
APRIL–MAY 1941 8a35326

p. 191 bottom
Migratory agricultural worker from Florida waiting to leave Belcross, North Carolina, for another job at Onley, Virginia. It is Sunday and she is wearing her best clothes.
JULY 1940 8a34278

p. 192 top
Negro waiter in Hertzog's, seafood restaurant along the waterfront. Washington, D.C.
JULY 1941 8c29089

p. 192 bottom
Negro maid. Washington, D.C.
JULY 1941 8c06134

p. 193 left
Nashville, Tennessee. Welding parts for fuel pumps. Vultee Aircraft Corporation plant.
AUGUST 1942 8d07167

p. 193 right
Decatur, Alabama. Ingalls Shipbuilding Company. Worker carrying air hose.
JULY 1942 8d06323

p. 194 top
Baltimore, Maryland. Sargeant Franklin Williams, home on leave from army duty, posing for family portrait with his mother and father beside him and his nephew on his lap.
MARCH 1942 8d03321

p. 194 bottom
Group of Florida migrants on their way to Cranberry, New Jersey, to pick potatoes. Near Shawboro, North Carolina.
JULY 1940 8c02701

p. 195 top
Interior of general store and pool room at Stem, Granville County, North Carolina.
MAY 1940 8c02551

p. 195 bottom
Having a beer in Art's Sportsman's Tavern on a rainy day in Colchester, Connecticut.
NOVEMBER 1940 8c03777

p. 196
CIO pickets jeering at a few workers who were entering a mill in Greensboro, Greene County, Georgia.
MAY 1941 8a35773

p. 197 top
On a rainy day in Norwich, Connecticut.
NOVEMBER 1940 8a34693

p. 197 bottom
Passengers boarding a plane on a rainy day at the municipal airport in Washington, D.C.
JULY 1941 8a36318

p. 198
Spectators at the barrel-rolling contest in Presque Isle, Maine.
OCTOBER 1940 8c03332

p. 199 top
Granville Clarke, Florida, migratory agricultural worker studying road map before leaving Elizabeth City with his crew. They are going to Bridgeville, Delaware, to work in a cannery. North Carolina.
JULY 1940 8a34042

p. 199 bottom
Wrestlers at the "World's Fair" in Tunbridge, Vermont.
SEPTEMBER 1941 8a37054

p. 200 top
Greenville, South Carolina. Air Service Command. Writing a letter home.
JULY 1943 8d32071

p. 200 bottom
Migratory worker on the Norfolk–Cape Charles Ferry, writing a postcard home to his parents.
JULY 1940 8c02742

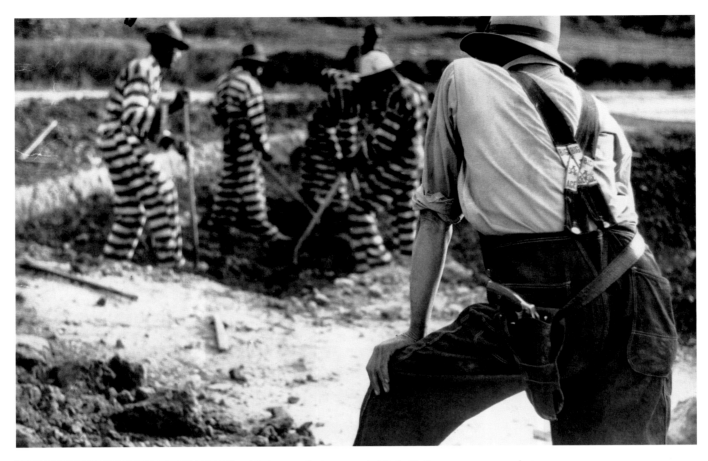

JACK DELANO

John Vachon was initially hired by Roy Stryker of the RA to do "rather dull work,"[1] copying photo captions onto the back of prints by Stryker's team of photographers. Twenty-one at the time, Vachon had no intention of becoming a photographer, but Stryker soon made a life-changing suggestion: "When you do the filing, why don't you look at the pictures?"[2] Vachon would later confess that, though some of the photographers were already quite famous, he had "never heard of any of these names."[3]

His study of his colleagues' work was fruitful. In late 1937, and with their encouragement, Vachon began to express a desire to take his own photographs. In the fall of 1938 Stryker gave him his first photographic assignments, sending him to Nebraska. Even Vachon's earliest work, his November 1938 story on Omaha, displayed a distinctive style, influenced principally by Walker Evans. Until 1941 Vachon would divide his time between doing field photography and classifying the increasingly abundant FSA archive.

1. Quoted in Orvell, ed., *John Vachon's America*, p. 3: "Mr. Stryker told me kindly that it was rather dull work."

2. Quoted in Fleischhauer and Brannan, eds., *Documenting America*, p. 90.

3. Ibid., p. 3.

JOHN VACHON
MONTANA AND MINNESOTA

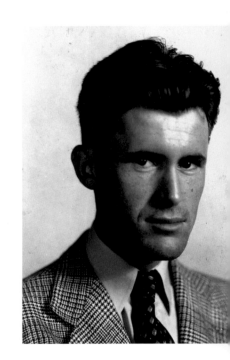

A Minnesota native, Vachon felt most comfortable photographing in the central and northwestern states. He often traveled alone, keeping a diary and regularly corresponding with his wife.[4] Vachon took photographs in an inspired, intuitive manner. He was sensitive to vernacular elements of American civilization, giving rise to an occasionally lyric, intimate approach similar to travel photography. Vachon's visual language assimilated the vocabulary of modernist photography, combining geometric rigor with spontaneous attentiveness to the human environment. The assignment that best expressed Vachon's quintessential style was the one that took him to Montana and Minnesota in the spring of 1942.

Vachon adamantly maintained a distinction between his approach and the FSA's, disparaging the agency's modus operandi for producing photographs that served purely as functional, informational documents. In his opinion, FSA dictates could trap photographers into creating "just formula pictures, they look like Farm Security stuff."[5]

G.M.

4. Vachon's diary and correspondence were published in *John Vachon's America*.

5. Orvell, ed., *John Vachon's America,* p. 193. Letter to his wife, March 3, 1942: "I guess the main trouble is that 'the pictures' are all just formula pictures, they look like Farm Security stuff."

JOHN VACHON

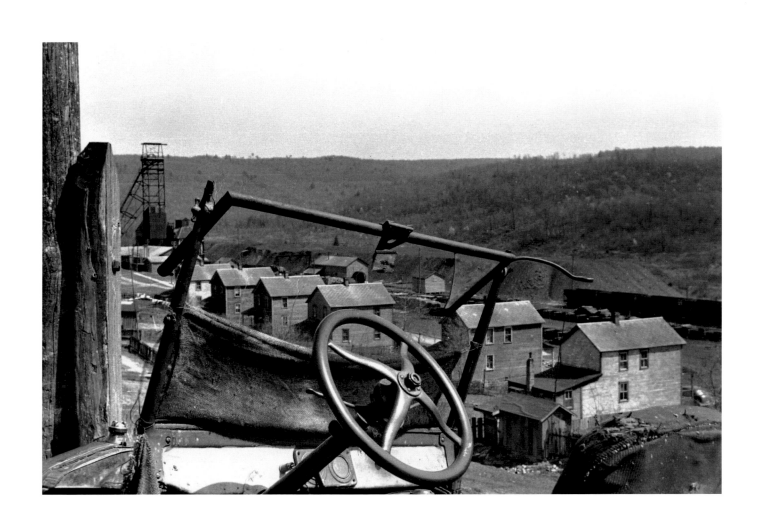

JOHN VACHON

Discussing the FSA in 1952, Stryker described Russell Lee's style: "Never forget that Russ was an engineer and an analyzer, a thorough, fast operator, and he turned in quality and he turned in detail, and when he hit a thing he went through it from all phases and analyzed it and took it apart for you and laid it on the table."[1] No wonder Stryker essentially gave him carte blanche, allowing him to shoot when and where he wanted, and at his own speed. Traveling with his wife, Jean, a former journalist, Lee was able to submit his photos with publication-ready captions attached at exceptional speed. Also, though there is little mention of it in the FSA-OWI public records available for research today, Lee had inherited a personal fortune that eased the cares most other photographers faced on the road.

The Lees were in Redding, California, on Sunday, December 7, when the Japanese bombed Pearl Harbor. They went into action immediately, telegraphing Stryker for special instructions and photographing newsboys on the streets hawking the latest editions of the local papers (see p. 236). They had just finished working at Shasta Dam in California, where Russell took a photo of a dam worker reading the final morning edition of the December 9 *San Francisco Chronicle,* which was headlined "U.S. AT WAR!"

In his message to Stryker, Lee rededicated himself to the FSA-OWI project: "In view of the war with Japan I do not know whether the direction of our work will change materially or not but at this time I wish to reaffirm my willingness to do whatever work you may consider that I can best perform. Please let me know about this just as soon as possible."[2]

He reminded Stryker that all the staff photographers would soon need additional credentials and identification and offered to be fingerprinted by the Department of Justice as soon as he arrived in San Francisco, where he was heading to visit former RA-FSA photographer Dorothea Lange and her husband, an agricultural economist at the University of California at Berkeley.

On December 19 Lee went to the American Rubber Company in Salinas, California, to begin a set of photographs about its experiments cultivating guayule, a source of rubber that would be needed for the war. Jean planned to research guayule at the library for an essay to accompany Russell's photos; they expected

1. Transcript of a conversation among former Farm Security Administration staff at Vachon's New York apartment, 1952, p. 39, John Vachon Papers.

2. Lee, letter to Stryker, December 8, 1941, *Roy Stryker Papers.*

RUSSELL LEE
CALIFORNIA FOOD INDUSTRY

to produce a story of national interest. He also planned to investigate several other agricultural subjects in California, including chicken and egg farming in Petaluma; wine in Napa, Sonoma, and Livermore counties; and the use of Japanese laborers for at least thirty percent of the area's vegetable production.

With characteristic attention to process, he covered producing, growing, harvesting, processing, and marketing local products. He went on to document what earlier would have been a coup for the FSA—improvements in camps for migrant agricultural workers. Lee noted, however, that times had changed. In the tense wartime atmosphere, any association with the camps prevented laborers from being hired for defense activities. Labor contractors looked down on people staying in FSA camps, an indication of a growing breach between the FSA and California employment services. Lee went on to shoot an especially photogenic camp at Woodville, California, on January 26, 1942, but it proved to be one of his last reports on the subject, as stories about war preparations overtook those on the nation's recovery from the Great Depression. In April and May Lee joined Lange and other California photographers in documenting how the U.S. government herded approximately one hundred thousand Japanese Americans out of their homes and sent them to guarded internment camps for so-called enemy aliens at desolate inland sites in the West.

B.W.B.

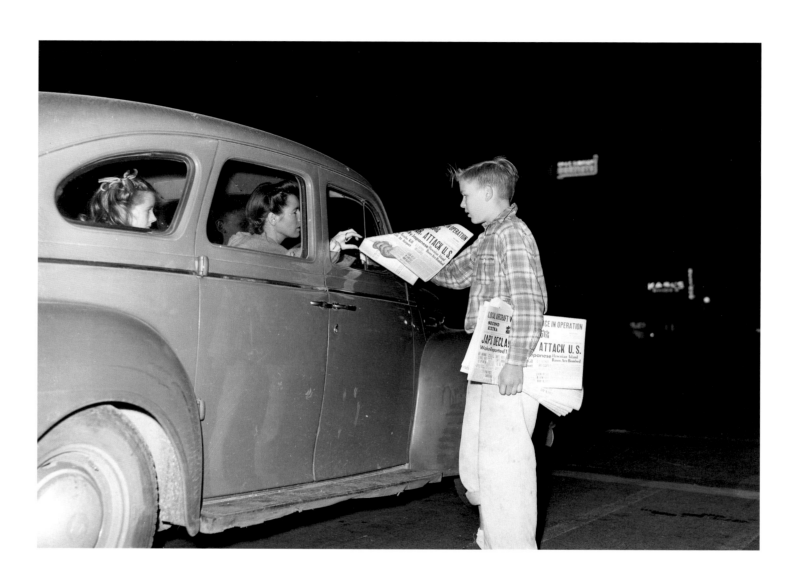

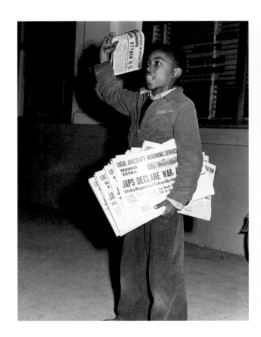

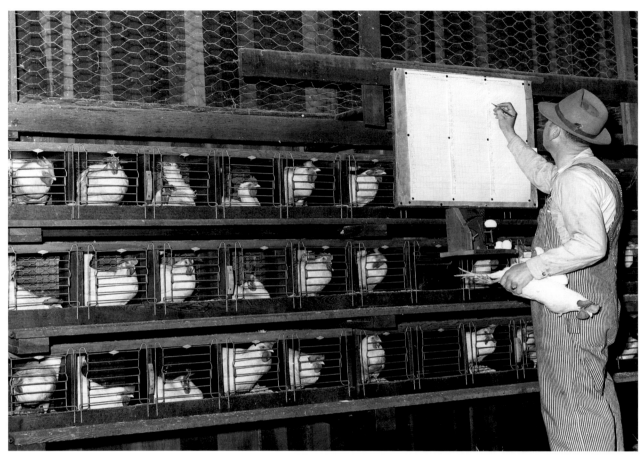

RUSSELL LEE

p. 235
Russell Lee, Farm Security
Administration photographer,
Woodstock, New York, 1936

p. 236
Newspaper extra, December 7,
1941. Redding, California.
DECEMBER 1941 8c23248

p. 237 left
Newspaper extra, December 7,
1941. Redding, California.
DECEMBER 1941 8c23357

p. 237 center
Workman at Shasta Dam reads war
extra. Shasta County, California.
DECEMBER 1941 8c23366

p. 237 right
Newspaper extra, December 7,
1941. Redding, California.
DECEMBER 1941 8c23359

p. 238 top
Sonoma County, California.
Chickens in yard.
JANUARY 1942 8c23470

p. 238 bottom
Petaluma, Sonoma County,
California. Warehouse of a poultry
cooperative that handles feed and
packs and ships the eggs.
JANUARY 1942 8c23477

p. 239 top
Sonoma County, California. Trap-
nests on a chicken ranch. The
rancher is noting the weight of an
egg just laid. He keeps check on
the quantity and quality of each
hen's eggs, thus producing high-
quality pedigreed eggs for
breeding purposes.
JANUARY 1942 8c23507

p. 239 bottom
Petaluma, Sonoma County,
California. Boxes of baby chicks
are ready for shipment from a
hatchery.
JANUARY 1942 8c23466

p. 240 top
Petaluma, Sonoma County,
California. Sign on a hatchery. One
hatchery in Petaluma produces as
many as 1,800,000 baby chicks
annually.
JANUARY 1942 8c23505

p. 240 bottom
Petaluma, Sonoma County,
California. Sign on a chicken
pharmacy. Petaluma, a town of
8,000 persons, is built around the
production of eggs and baby
chicks. All of its industries, such as
the feed mills, warehouses,
transportation, and trucking
concerns, are part of egg
production.
JANUARY 1942 8c23522

p. 241
Sonoma County, California.
Unpruned grapevines. Vines are
pruned during January and
February.
JANUARY 1942 8c23559

p. 242 top
Sonoma County, California.
Coopers fitting head of wine cask.
JANUARY 1942 8c23574

p. 242 bottom left
Sonoma County, California.
Champagne fermenting in the
bottle is shaken daily at the winery.
JANUARY 1942 8c23585

p. 242 bottom right
Sonoma County, California.
Labeling bottle of wine at winery.
JANUARY 1942 8c23592

p. 243 top
Sonoma County, California. Bottling
wine and corking bottles of wine at
the winery.
JANUARY 1942 8c23604

p. 243 bottom
Sonoma County, California.
Winemaster examing red wine for
clarity at the winery.
JANUARY 1942 8c23633

p. 244 top
Cold drinks on the Fourth of July.
Vale, Oregon.
JULY 1941 8a30311

p. 244 bottom
Soda jerker flipping ice cream into
malted milkshakes. Corpus Christi,
Texas.
FEBRUARY 1939 8b37302

p. 245 top
Woodville, California. FSA (Farm
Security Administration) farm
workers' community. The women's
club sells hamburgers at the
Saturday-night dances.
JANUARY 1942 8c23709

p. 245 bottom
Boy living in camp near Mays
Avenue making sandwich. This
food is distributed by Saint
Anthony's Hospital after patients
have been fed. This is the only food
line left in Oklahoma City,
Oklahoma.
JULY 1939 8b22554

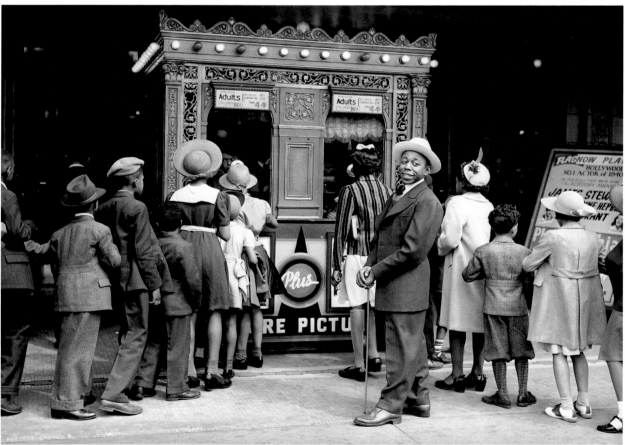

RUSSELL LEE

p. 247
Watching the Fourth of July
parade. Vale, Oregon.
JULY 1941 8a30343

p. 248
Interlude, after watching the Fourth
of July parade, Vale, Oregon.
JULY 1941 8a30301

p. 249
Radiator cap, Laurel, Mississippi.
NOVEMBER 1938 8a25299

p. 250
Fortune teller, state fair,
Donaldsonville, Louisiana.
NOVEMBER 1938 8a24308

p. 251
Ice for sale. Harlingen, Texas.
FEBRUARY 1939 8b37254

p. 252 top
Tenant purchase clients at home.
Hidalgo County, Texas.
FEBRUARY 1939 8b37079

p. 252 bottom
In front of the movie theater.
Chicago, Illinois.
APRIL 1941 8c00905

GILLES MORA

THE FSA'S DOCUMENTARY STYLE:
FROM REPORTAGE TO VISION

The most accurate approach to understanding the FSA[1] photographs' aesthetic is to consider the pictures in groups of unpolished proofs, without touch-ups, editorial context, or any information beyond the most basic facts. Thanks to the Internet, one can also view the FSA photographs on a computer screen, digitized at a level of resolution that thwarts a flattering presentation.

Looking at the pictures in this manner properly conveys their neutrality and total lack of affectation. Paradoxically, it is in this stripped-down mode that the visual strengths and informational legibility of many FSA pictures shine through, free of the flourishes associated with overdone, embellished prints that the photographers themselves never dreamed of. The workers hired by Roy Stryker, the guiding spirit of the FSA's prestigious Historical Section, retrieved their pictures from the labs in the crudest form: as simple proofs meant to indicate a photograph's illustrative effectiveness and whether it should be rejected, archived, or used for a vast array of editorial purposes (in print media or exhibits) somewhere along the spectrum between propaganda and news.

Neutrality characterizes the bulk of the FSA photographs.[2] Though aesthetics did occasionally surface through the paradox of the "documentary style,"[3] in general the FSA photographers voluntarily set aside aesthetic concerns. (Roy Stryker settled the matter in a famous outburst by stating, "I don't care about the damn aesthetics: Is it a good picture or not?")[4] Yet the neutrality of the FSA's still photographs is nowhere to be seen in its propaganda films of the era. (Edwin Rosskam called the films "epic productions," distinct from the FSA's fact-based photography.)[5] In *The Plow That Broke the Plains,* a 1936 film for the Resettlement Administration (RA) directed by Pare Lorentz and shot by Ralph Steiner, Paul Strand, and Paul Ivano, aesthetic concerns seem to dominate the cinematography and the editing. Though certain sequences inspired Arthur Rothstein's Dust Bowl photographs,[6] every shot seems to be forced from reality to attain a cumbersome lyrical abstraction, which is reinforced by voiceovers and musical accompaniment.

Studied in their rawest form—undoubtedly the way they were available in Washington's administrative archives during the FSA's heyday[7]—simply arranged by geographic area or subject, with explanatory texts limited to the photographers' captions, the FSA pictures could hardly seem more different from their motion-picture counterparts. The extensive recontextualization to which the photographs were subjected[8]—in publications ranging from illustrated volumes[9] to tourist guides,[10] in exhibits commissioned by the Roosevelt administration, as well as in a 1962 retrospective[11]—accounts for their eventually being interpreted as ideological or propagandistic rather than purely documentary, the approach to which they most closely adhered. Limited public presentation of the FSA photographs, often restricted to a few recurrent canonic images, also hampered a thorough understanding of the work. In the mid-1960s Ed Rosskam estimated that only ten percent of the FSA's photographs had been exhibited or published, while the rest of the section's output was known only to the photographers and others working under Roy Stryker.[12]

1. By "FSA" I refer throughout to the Historical Section for which Roy Stryker hired photographers during its three distinct periods. Its original purpose was to document the results of Roosevelt's agricultural policies. The Historical Section began in 1935 as a division of the Resettlement Administration, which was renamed the Farm Security Administration in 1937. The section was absorbed by the Office of War Information and served as its photographic division from 1942 to 1943.

2. The FSA-OWI archive, which is housed in the Library of Congress and from which the pictures in this volume were selected, contains 164,000 black-and-white negatives, 1,610 color positives, 107,000 photographic prints, and related documents.

3. The expression was coined by Walker Evans in defining his own photographic style: "Documentary: that's a very sophisticated and misleading word…. The term should be 'documentary style.' You see, a document has use, whereas art is really useless. Therefore art is never a document, although it can adopt that style." Leslie Katz, "Interview with W. Evans," *Art in America* (March–April 1971).

4. Stryker and Wood, *In This Proud Land,* p. 13.

5. E. Rosskam, interview with Doud.

6. See photos on pp. 127–35.

7. E. Rosskam, interview with Doud. He describes the archives' extreme disorganization before the FSA's absorption by the OWI in 1942. Then archivist Paul Vanderbilt reorganized the pictures, allowing them to be accessed either individually or as part of a group or series.

8. The FSA photographs were featured in newspaper articles and other periodicals, books, and exhibits Ed Rosskam and others curated for the FSA. For details of ways the photos were used, see Rosskam's interview with Doud.

9. The most famous of these were commissioned from noted writers during the FSA years. These include *Land of the Free* by Archibald MacLeish (1938), *Forty Acres and Steel Mules* by Herman Clarence Nixon (1938), *Home Town* by Sherwood Anderson (1940), and *Twelve Million Black Voices* by Richard Wright (1941). See Bibliography.

10. A series of state guides was published by the Federal Writers' Project of the Works Progress Administration, with occasional illustrations from the FSA files.

11. "The Bitter Years," the FSA retrospective Edward Steichen organized at the Museum of Modern Art in New York, durably established an exclusively humanist view of Stryker's team.

12. E. Rosskam, interview with Doud.

It is equally important to reject any notion of the FSA photographs as mere nostalgia, illustrations of a decade and a country then in crisis but now considered a paradise lost.[13] We must forget the idealistic and consensual photographic hagiography that for so long and so exclusively measured the work, which was stifled by conceptions of compassion and empathy, to assess it afresh. Roy Stryker wrote, "In the light of what's happened since, it's clear that what we did at FSA constitutes a unique episode in the history of photography."[14] Indeed, a careful study of the FSA photographs reveals the profound change in methodology they initiated; the lineage that allowed for that radical change; their relation to the subsequent development of street photography in the 1950s and 1960s and the documentary style's rise to prominence; and the extent to which they retrained our eyes. Finally, a serious study of the FSA photos should attempt to assess the new experiences to which the photographers were exposed by their increased social consciousness, their confrontation with an unfamiliar American territory, and their attraction to new subjects and original points of view.

A NEW AND EXHAUSTIVE DOCUMENTARY FIELD

The expression of a purely American art by artists active during the depression has often been conflated with their political engagement and commitment to the New Deal—although some (including the painter Stuart Davis and the photographer Walker Evans) joined government agencies solely to put bread on the table. The social consciousness President Roosevelt defined for the participants in the arts programs that were part of his economic recovery effort certainly contrasted with the elitist, detached attitudes associated with art in previous decades. The Social Realist painter Raphaël Soyer, who was instrumental during the depression in popularizing subjects drawn from everyday American life, summed up his immediate predecessors, artists of the 1920s, as follows:

> Hopper, O'Keeffe, Demuth, Sheeler: I call them the aristocrats of the so-called indigenous American art.... There was not one human being in those pictures. They also were so kind of, it seemed to me, so cold, so aristocratic, so, so devoid of interest in humanity. Everything was so prophylactic, so clear, [in] those pictures.[15]

The aesthetic abstraction and disregard for historical and social concerns characteristic of that first phase of American modernism would be supplanted by a wholly different approach in the 1930s.

The economic and social crisis that shook an anxious United States throughout that decade also introduced the notion that art could be used advantageously for both its aesthetic *and* its documentary qualities. With the onset of the depression, America's visual arts, theater, dance, literature, and, especially, photography quickly refocused on the concept of documenting and bearing witness. Every artist and artistic endeavor either represented the current state of things or sifted the past in a pragmatic attempt to gain perspective on progress and a transcendent national conscience. Supported by new techniques of audio and visual recording, what took shape was an unprecedented effort to systematically archive the American way of life and heritage through such projects as *The Index of American*

13. Even Roy Stryker was quick to acknowledge the potential weight of nostalgia in every FSA photo. Writing about a Walker Evans photo ("Railroad Station, Edwards, Mississippi," January 1936), Stryker declared: "I look at these pictures and I regret that time when the world was safer, and more peaceful.... That's the kind of nostalgia inspired in me by these photographs of small towns." Stryker and Wood, *In this Proud Land,* p. 15.

14. Ibid., p. 8.

15. Raphaël Soyer, interview with Milton Brown, May 13, 1981, Archives of American Art, Smithsonian Institution, Washington, D.C.

Design.[16] It was as if the economic disaster had exposed American culture's perishability even while reinforcing its perennial importance in binding the nation together. The New Deal administration hired hundreds of researchers from the art world and beyond to crisscross the nation recording music, sounds, stories, and pictures.[17] Roosevelt's artist recruitment programs launched writers, filmmakers, photographers, painters, and musicologists on an almost obsessive pursuit of documentary recordings to assist Americans in the grip of an identity crisis; *Land of the Free,* one of the central works produced, eloquently expressed the country's self-doubt.[18] The government-funded arts projects sought to reassure the public about America's roots and way of life and, by deepening the public's understanding, to help safeguard them.

The Historical Section Roy Stryker ran as a division of the RA from 1935 (and of the FSA from 1937) must therefore be seen in the context of documentary concepts that had begun taking shape in American photography in the early 1930s and were reinforced by the enveloping social crisis. The period's approach to documentary photography can be boiled down to three general tendencies: the nascent photojournalism featured in mass-market magazines such as *Fortune* (1930), *Life* (1936), and *Look* (1937), which consisted of "picture stories" (illustrated text with obvious editorial, narrative, or commercial agendas); the socially useful "photodocument," in the great reformist tradition of Jacob Riis and Lewis Hine, which the New York Photo League, particularly under the guidance of Sid Grossman and Aaron Siskind, devoted considerable pedagogic efforts to establishing; and, beginning in the early 1930s and championed by the critic Lincoln Kirstein, a new aesthetic current that Walker Evans eventually named the "documentary style." (Kirstein made particular use of Berenice Abbot's work as well as Walker Evans's in advocating for this style. Evans's 1938 MoMA retrospective, "American Photographs," and its exhibition catalogue, with a preface by Kirstein, served as manifestos for this school of thought.) The FSA photographers found themselves (without always knowing it) at the intersection of those three distinct approaches, which shared little more than the use of photography's inherent qualities to bear witness to reality. They would submit to the ambiguities and enjoy the advantages of each.

The novel aspect of the assignments Roy Stryker gave his photographers was the field he asked them to investigate. The nation's economic crisis was reaching catastrophic proportions in the mid-1930s, but the FSA was not bound by photojournalism's obligation to provide immediate and regular coverage of the latest news. In fact, of all the photographers who worked in the Historical Section, only Carl Mydans had training as a journalist.[19] The thousands of negatives Stryker stockpiled between 1935 and 1942 are practically devoid of any content comparable to that seen in the newsreels of the day.[20] The many government agencies[21] assigned to photographing the tangible effects of Roosevelt's economic and social policies produced in-depth work on subjects far removed from the spectacular tabloid articles and news headlines of the day. Photojournalism had been trying since the late 1920s to establish itself as a genre, but at that point it usually amounted to little more than a depiction of lurid news items and high-society events. Stryker differentiated that journalistic practice of "going to the dogfight" from the FSA's approach: The former produced strictly descriptive photos of a specific

16. Founded as part of the WPA's Federal Arts Project (FAP) in 1935, the project employed hundreds of artists affected by the depression to create an index of thousands of objects in museums or private collections, compiling photos or sketches to catalogue American utilitarian and decorative arts.

17. See *These Are Our Lives,* an extraordinary collection of interviews by reporters investigating the full spectrum of Southern society.

18. MacLeish, *Land of the Free.* MacLeish described his text—a poem—as the soundtrack to the photographs (most of them FSA works) it accompanies. Recurring phrases such as "We can't say," "We don't know," "We wonder" accentuate book's overall pessimism.

19. In a 1964 interview with Richard Doud, Arthur Rothstein described Carl Mydans's approach: "He was a reporter from the very beginning. He used the photograph only as an adjunct to his writing."

20. The only bona fide news coverage in the thousands of FSA negatives is Arthur Rothstein's photos of Roosevelt's visit to drought victims near Bismarck, North Dakota, in August 1936.

21. The number of government agencies with photographic sections documenting New Deal policy was legion. Besides the Resettlement Administration (later the FSA), they included the Civil Works Administration, the Civilian Conservation Corps, the Federal Emergency Relief Administration, the Rural Electrification Administration, the Tennessee Valley Authority (which employed Lewis Hine in the early 1930s), and the Works Progress Administration (WPA), whose photographic section, directed by William Pryor, was active and effective but not as famous as the FSA's.

event, whereas the FSA produced in-depth analysis and commentary, closer in spirit to "the adjective and adverb"[22] than to the unadorned noun and verb. He added:

> The news picture is a single frame; ours a subject viewed in series. The news picture is dramatic, all subject and action. Ours shows what is behind the action. It is a broader statement—frequently a mood, an accent, but more frequently a sketch, and not infrequently a story.[23]

In its final years, 1942–43, after its absorption by the Office of War Information (OWI), the FSA did allow staff photographers like John Collier, Marjory Collins, Esther Bubley, and Gordon Parks to refine their photographic series; unlike their predecessors (Ben Shahn, Dorothea Lange, Arthur Rothstein, and Theo Jung), they could rigorously compose their work. By the early 1940s the success of *Life* and *Look,* which published the work of former FSA photographers such as Carl Mydans, Arthur Rothstein, and John Vachon, had established their style as the dominant photojournalistic model, with written reportage illustrated by a set of photographs.

It's important to keep in mind all those distinctions to appreciate the FSA photographers' complex explicative work, which was far removed from the era's superficial and frequently brutal photojournalism.[24] Some fifteen years would pass before the photojournalist W. Eugene Smith would confer on his profession a richer and more profound status by perfecting the photo essay as an honest tool for analyzing reality. For the FSA photographers, in the meantime, the concept of syntactic construction crucial to Smith's form of photo essay was totally foreign. The Library of Congress's FSA archive contains only three collections of photographs conceived and designed by photographers themselves, the albums by Dorothea Lange, Walker Evans, and Jack Delano.[25] Stryker's visual policies meant to push his photographers to strive for the single shot that would best synthesize information. Such an image would, of course, be obtained by taking multiple shots, which would then be honed down in the editorial process; pictures deemed insufficiently pertinent were destroyed; Stryker was famous for "killing" rejected negatives with a hole punch. Though photos in the FSA archives are filed individually, some were gathered in narrative combinations long after they were shot to compose artificial "series" such as those found in *Documenting America, 1935–1943* (Fleischhauer and Brannan, eds.) and, to a certain extent, the present volume. While Stryker did encourage his photographers to explore specific themes or geographic areas, their work rarely was conceived as the full-fledged, rationally constructed "series" the Photo League, among others, then advocated. (Indeed, until the arrival in 1942 of archivist Paul Vanderbilt, FSA photos were catalogued only by location—where they were shot—not by subject, rendering systematic consultation of the archive impractical, if not downright impossible.)[26]

According to Aaron Siskind, who taught in the Photo League's Feature Group from 1936 to 1941,[27] "picture stories" recontextualized individual images in a specific historical context, giving them an authentic construction of meaning by grouping and pacing them. In Siskind's view, a photo's meaning was not necessarily limited to a literal representation of its subject and certainly surpassed the basic naturalism of the isolated documentary photo. The FSA photog-

22. Stryker and Wood, *In this Proud Land,* pp. 7–8.

23. Ibid., p. 8.

24. In an interview with Doud, Delano recounted that the people of an area he had been sent to photograph had turned hostile to all photography after being subjected to the cavalier, vulgar methods of *Look* photojournalists.

25. These are "The First Rural Rehabilitation Colonists" album by Lange, reproduced here for the first time (pp. 34–37), Evans's albums of photographs taken in Alabama in 1936, and Delano's Pennsylvania coal miners, c. 1938–39.

26. E. Rosskam, interview with Doud. Rosskam stated: "The filing system was impossibly bad. It was something geographic and so you couldn't find anything, unless you knew every picture in the file."

27. See Deborah Martin Kao and Charles A. Meyer, eds., *Aaron Siskind: A Personal Vision, 1935–1955,* exhibition catalogue (Boston: Boston College Museum of Art, 1994).

raphers by and large did not acknowledge those standards, primarily because their negatives and the fate of their pictures were out of their control. In fact, no clear editorial policy for publications and exhibits was defined until Ed Rosskam's arrival at the FSA in 1939. Rosskam's policy provided Stryker's photographers with a better understanding of the uses to which their photos would be put but still kept them out of the decision-making process. The standard working procedure at the FSA was generally to accumulate sufficient quantities of photographs of a single subject to allow for the greatest editorial choice.

The photographic section of the RA (and then the FSA) was initially charged with documenting the Roosevelt administration's efforts on behalf of agriculture and, later, its employment initiatives. Another objective was soon added to the original assignment, and eventually came to replace it. With the backing of the agency's director, Rex Tugwell, Stryker endowed the FSA with a personal vision that would give the project the monumental scale for which it is famous: "To introduce America to Americans."[28] While undertaking their original tasks, the FSA photographers were also to compose a historical record, which they soon recognized as a far more important mission.[29] Stryker later described their new focus this way: "We know now that we helped open up a brand new territory of American life and manners as a legitimate subject for visual commentary."[30]

According to the photographers as well as Stryker himself, that transcendence of the FSA's original goals by a concerted effort to archive America imposed itself from the first.[31] The FSA photographers were not reporters but more like general researchers; most important, they were endowed with tremendous cultural curiosity constantly stoked by Stryker's own probing nature and infectious energy. The FSA's field of investigation spanned the vast breadth of the United States's geography, economy, and society. In 1937, shortly after he was hired as the FSA's clerk, John Vachon wrote Roy Stryker a memo, "Standards of the Documentary Files," in which he recommended that the FSA produce "a monumental document, comparable to the tombs of Egyptian pharaohs, or to the Greek temples, but far more accurate."[32]

The transition from factually recording specific events to investigating in depth the subjects Stryker assigned in his celebrated (but perhaps overrated)[33] shooting scripts was unquestionably advantageous for the FSA photographers. They became engaged in scrutinizing an unexplored American geographic and cultural territory in wholly original ways and on an unprecedented scale. Straying far from New York and the East Coast, the photographers delved into underexposed regions of the Southeast, the West, and the Southwest,[34] initially for demonstrative reasons—to illustrate the national scale of the crisis—and then for archival ones, as belief in the need to archive grew. They recorded urban centers such as Chicago, Washington, D.C., and New Orleans and took an overdue interest in midsize cities. They focused especially on small towns and rural areas—Stryker's favorite subjects[35]—which had been passed over while photographic modernism emphasized urban motifs. Russell Lee, who joined Stryker's team early on, in 1936, saw his role in exactly these terms: "I am a photographer hired by a democratic government to take pictures of its land and its people. The idea is to show New York to Texans, and Texas to New Yorkers."[36]

For most of the FSA photographers, that didactic dimension surpassed any aesthetic or

28. Opinions vary regarding who was responsible for this historic decision. Though the photographers took quickly to their new goal (as they expressed in mid-1960s interviews with Richard Doud for the Archives of American Art, many of which can be consulted online; see Bibliography), Ed Rosskam maintained that the shift in the FSA's objective from providing information about the depression's effects on agriculture to an unprecedented investigation of the state of the nation at a specific point in its history was largely due to the far-reaching vision of Rex Tugwell. In his interview with Doud, Rosskam said Tugwell initiated the project and charged his faithful deputy, Roy Stryker, with putting it in place.

29. Rothstein noted, in his 1964 interview with Doud, that he and his colleagues quickly understood that many of their photographs dealt not specifically with RA activities but with a way of life, and started focusing on segments of America in distress. He said, "As it went on over the years, Roy [Stryker] became more and more fascinated with making a pictorial record of life in the United States.... He wanted to photograph everything."

30. Stryker and Wood, *In This Proud Land*, p. 7.

31. In Richard Doud's interviews, the FSA photographers are virtually unanimous in affirming this.

32. This document is reproduced in its entirety in Orvell, ed., *John Vachon's America*, pp. 282–85.

33. In a 1965 interview with Doud, Post Wolcott echoed many other FSA photographers in saying that, in retrospect, the scripts "were not the most important thing.... You weren't bound by them at all." Yet the scripts' importance increased as of 1939, once Stryker regularly had to justify the Historical Section's existence through its results.

34. In a January 1936 note to Lange asking her to photograph the slums around San Francisco, Stryker wrote: "We need to vary the diet in some of our exhibits here by showing some western poverty instead of all south and east." Hurley, *Portrait of a Decade*, pp. 70–71.

35. Stryker: "Through the pictures, the small town emerged as a thing possessing emotional and aesthetic advantages: kinship with nature and seasons, neighborliness,... plus some certain disadvantages:... lack of economic and cultural freedom." Stryker and Wood, *In This Proud Land*, p. 15.

36. In *US Camera* 1, 1941.

political impulse. It opened to them new photographic territory that touched on the most banal aspects of everyday life, "infra" or "micro" subjects unknown to a field that had been dominated throughout the 1920s by the superficiality of fashion and commercial photography, exemplified by Edward Steichen's work. The photographers were now assigned to document broad themes that recurred in the "scripts" Stryker drew up for them: food, home, leisure, religion, transportation, commerce, the work environment, vernacular art, and so forth. The seemingly far-flung range of subjects the FSA team covered from 1935 to 1943 actually reduces to a few fields of social, economic, and cultural activity that together reflect the life of the nation. Though some of the photographers discounted the FSA's importance—Ed Rosskam, for one, severely criticized the FSA's amateurishness and regretted that his efforts were restricted to the still camera[37]—the scope of its documentary ambitions was unprecedented and has not been replicated since. It follows that the participants would have had to develop new artistic responses and photographic methods.

SOCIOLOGICAL OR TRAVEL PHOTOGRAPHY?

The publication of John Vachon's FSA journals and correspondence,[38] providing unparalleled insight into the daily life of a photographer on assignment for Roy Stryker, confirmed that the FSA photographer was, first and foremost, a dedicated multitasker. The FSA operative had to be a versatile photographer, of course, but was also a fledgling sociologist responsible for collecting notes in the field. He or she had to be capable of facing the unexpected and navigating the human relationships intrinsic to the diverse social contacts required by the work. The FSA photographer had to be able to repair a car, to handle the ups and downs of assignments for which no one could ever be fully prepared, and, in the FSA's early days, to develop his film in the bathrooms of frequently Spartan hotels. Stryker selected members of his team on the basis of their professional skills (Lange, Rothstein, Evans, Mydans); their background in the art world (Shahn); their promising though often limited experience with photography (Jung, Vachon, Delano, Post Wolcott, Parks, and Bubley); but mostly for their inquiring minds.[39] Even so, he sometimes hired staff members on a part-time basis; for example, John Vachon, who joined the FSA in 1936, was hired full time only in 1941. And any staff member was confronted by an administrative culture that ran counter to attitudes typical of artists engaged in individualistic activities. Walker Evans was famously reluctant to bend to the requirements of a commission; other FSA photographers' responses to being a hired hand rather than a free agent acting on his or her own aesthetic decisions varied in proportion to their previous experience in the worlds of art and photography. Rothstein, Lee, Delano, Post Wolcott, and Vachon considered themselves faithful soldiers of the Roosevelt administration but maintained that they were free to make their own decisions.[40] Evans, by contrast, sustained a cynicism to provide himself with the illusion—and the means—of his artistic freedom: "I was just in a sense taking advantage of the FSA and using the government job as a chance for a wonderful individual job. I didn't give a damn about the office in Washington or about the New Deal, really."[41]

Stryker probably preferred to hire photographers without a well-defined professional or creative background (the case for everyone but Dorothea Lange, Walker Evans, and Ben Shahn)

37. See E. Rosskam's interview with Doud.

38. Orvell, ed., *John Vachon's America.*

39. See Stryker, interview with Doud, 1963: "It was curiosity, it was a desire to know...."

40. In interviews with Doud, the photographers corroborate this view. They all said that, once Stryker made his recommendations, he left his photographers to choose their subjects and how to treat them.

41. In Stott, *Documentary Expression,* p. 281.

to create a versatile team unencumbered by preconceptions. He needed them all to adapt easily to a broad range of subjects, including portraits,[42] landscapes, architecture, objects, and "mood pieces," while mastering a variety of photographic materials and formats. In addition to taking pictures, photographers had to write substantive captions. Arthur Rothstein regretted in retrospect that each photographer was not accompanied by a writer, which would have allowed for a more thorough and efficient documentary effort.[43] As it was, Dorothea Lange and Russell Lee were the only FSA photographers to benefit from teamwork with a professional writer; their spouses, economist Paul Taylor and reporter Jean Lee, devoted themselves to the task. Training took place on the job and even in the field (as was clearly the case for Rothstein, Post Wolcott, and Delano), and there was little creative exchange among the FSA photographers; all but Evans rued that isolation.[44] Therefore, the photographers generally developed their craft by responding pragmatically to the assignment's circumstances rather than by making stylistic choices in the service of a given aesthetic. For example, when documenting standardized housing or mass manufacturing, Carl Mydans (pp. 93–108) and Russell Lee (pp. 236–52) composed their images using formal symmetry to suggest the repetitive monotony of industrial design. Stryker later recalled Ansel Adams's disdainful view of the FSA photographers, which was typical of the period's "art" photographers: "What you've got are not photographers. They're a bunch of sociologists with cameras."[45]

This much was true: The FSA team did not fit the elitist image American modernism and Alfred Stieglitz had, after successfully associating photography with fine art, conferred upon the photographer. The day-to-day reality of FSA photographers toiling in the field could not have been more removed from art photography per se. Material and human problems naturally arose over the course of assignments that frequently lasted weeks, in surroundings with which many of them were utterly unfamiliar.[46] It's hard to imagine what inveterate city slickers like Evans, Shahn, Delano, Wolcott, and Rothstein made of the underdeveloped farming states of the Southeast. Dorothea Lange joked that, on joining the FSA, she "didn't know a mule from a tractor,"[47] and Ben Shahn confessed that, when he accepted his first assignments for Stryker's division in 1935, his "knowledge of the U.S.A. came via New York and mostly through Union Square."[48]

Despite Roy Stryker's generous advice and reading recommendations, his photographers' discomfort upon confronting rural areas went beyond a geographic unfamiliarity to a far more powerful experience of sociological or cultural alienation. Yet, as was to be expected from agencies charged with assisting impoverished farmers, rural areas were the primary regions of activity for the RA and the FSA until 1941, when the threat of war and Ed Rosskam's influence convinced Stryker to redirect his photographic researchers toward cities and industrial areas;[49] even so, those latter subjects account for only twenty-five percent of the FSA negatives. Stryker sought to capitalize on the element of surprise sparked by the differences between a photographer and the foreign environment in which he or she was immersed. Gordon Parks remembered how Stryker deliberately chose him to document the prevailing racism in Washington, D.C., in 1942 because he was black.[50] In short, the FSA photographers turned the sense of being foreigners in their own country to their advantage by looking upon their subjects with

42. "Obviously we were concerned with people. We had no other choice." Stryker, interview with Doud, 1963.

43. Rothstein, interview with Doud.

44. In interviews with Doud, the photographers all expressed disappointment at having spent little time together during their stints with the FSA, largely because the fast pace of assignments had them constantly scattered around the country.

45. Stryker and Wood, In This Proud Land, p. 8.

46. Mydans was assigned to photograph the cotton industry without knowing anything about cotton. When Stryker learned of Mydans's ignorance, he gave him a crash course on the cotton industry and its economics. (Stryker recounts this anecdote in In This Proud Land, p. 13.) Doud's 1960s interviews with the FSA photographers are full of stories about their difficulties adapting to strange surroundings.

47. Lange, interview with Doud.

48. Shahn, interview with Doud.

49. The shift from urban experience to rural experience and vice versa was very much in the air. New Deal officials, including Rex Tugwell, the head of the Resettlement Administration (the Farm Security Administration as of 1937), believed that some of the rural population should migrate to cities to find work, and that such movements would benefit the economy. See the introduction to Fleischhauer and Brannan, eds., Documenting America, p. 2.

50. Parks, interview with Doud.

profound curiosity; apparently inspired by the singularity of their experiences, they took nothing for granted.[51] In this respect they were forerunners of the Swiss photographer Robert Frank, who would travel the United States twenty years later assembling his book *The Americans*. Nevertheless, John Vachon's letters reveal his restlessness during the low periods on assignment when his work's objectives seemed vain or unclear, or when he was frustrated with Stryker's obtuse attitude and administrative slowness: "I feel... like an animated nonessential expenditure turned loose on the country. I feel guilty, I don't know how to represent myself."[52] Many FSA photographers experienced a similar of loss of identity spurred by the nomadic life they led.

Whether they traveled alone (Arthur Rothstein, John Vachon, Marion Post Wolcott), with their partners[53] (Dorothea Lange and Paul Taylor, Ben Shahn and Bernarda Bryson, Jack and Irene Delano, Ed and Louise Rosskam, Russell and Jean Lee), with assistants (Walker Evans and Peter Sekaer), or even flanked by the frequently bothersome local administrators delegated to introduce them to government-run initiatives, the photographers consistently shaped their assignments into rich experiences of intimacy and social interaction—entirely new for many of them—that occasionally evoked a photographic travel diary or travelogue.[54] Consider, for instance, a series of photographs John Vachon took in Montana in 1942. (Ed Rosskam declared that Vachon was, first and foremost, "a poet with a camera.")[55] Here, the subjective point of view of a traveler arriving in a small town in the Rockies—his surprise, his solitude—supplements or even dominates the photographs' documentary attributes. In the 1950s Robert Frank would photograph the same places, picking up where Vachon's pictures left off. Or examine Esther Bubley's 1943 series on traveling on Greyhound's bus lines, another subject Frank would return to, in 1959. The poetic potency of Bubley's bus series stems from the photographer's adoption of a passenger's point of view throughout the journey, as if she's peeking over the driver's shoulder and sitting among her fellow travelers. As John Vachon clearly expressed as early as 1937, the FSA photographer "must have a feeling."[56]

The use of a subjective point of view as a documentary tool is an apparent contradiction found in the work of many FSA photographers. Stryker clearly grasped the importance of subjectivity, as he sent several employees to photograph the same areas. Ben Shahn's first assignment in October 1935, for instance, was to photograph the Scott's Run mines in West Virginia, which Walker Evans had photographed in June–July of the same year. The intersection and complementarity of their points of view ensured a richer, more accurate portrayal of the subject.[57] At the same time, the tradition of frontal, distanced photography associated with Lewis Hine—which still prevailed in his 1932 work for the Tennessee Valley Authority—seemed a guarantee of perfect visual objectivity. But gradually the use of small-format cameras and the influence of the modernist European photographers—including Henri Cartier-Bresson, whose work was exhibited at Julian Levy's New York gallery in 1932 and 1935—induced photographers to relax their methods, embrace mobility, and pursue a more dynamic record of reality's flow. Ben Shahn, who had already elaborated his method of shooting freely in the streets of New York in 1932–35,[58] was probably the standard-bearer for liberating the tools of documentary photography. The need to strike a balance between the photographer's spontaneous,

51. In his interview with Doud, E. Rosskam described Rothstein as "a city boy who could gleefully go out to the West and bring back Roy's romantic view of the West, just exactly as only a Brooklyn boy could see it."

52. Orvell, ed., *John Vachon's America*, p. 190.

53. The active role the FSA photographers' spouses or partners played has too often been ignored. Though they were officially forbidden to accompany the photographers on assignment, they served as technical assistants, took notes, wrote the fastidious and detailed captions Stryker requested, acted as go-betweens, facilitating relations with impoverished populations, or posed as decoys to distract the photographer's actual subject. Bernarda Bryson and Irene Delano frequently played the part of the decoy.

54. In her interview with Doud, Irene Delano eloquently describes her travels as an intimate odyssey full of unexpected occurrences.

55. E. Rosskam, interview with Doud.

56. Orvell, ed., "Standards of the Documentary Files," in *John Vachon's America*, p. 284.

57. For another example: There is no dominant single image, or even single series of images, of cotton pickers in the South, but instead literally dozens of pictures taken by Shahn, Lee, Lange, and Post Wolcott in different places and times.

58. See Kao, Katzman, and Webster, *Ben Shahn's New York*.

personal reaction to a subject and the explicit legibility Stryker's administrative credo demanded resulted in an indecisiveness reflected in many FSA photographs. Yet this very irresolution makes several series by Vachon, Mydans, and Shahn, among others, particularly interesting and allows for their photographs to be interpreted on several levels.

The subjectivity intrinsic to certain FSA photographs did not compromise their documentary purpose. On the contrary, one could argue that, by allowing his photographers a great deal of freedom[59] and avoiding dogmatic instruction, Stryker was consciously protecting their independent capacity to assess the situations that confronted them. The photographers did not believe their work reflected a raw objectivity, which was in keeping with the prevailing documentary aesthetic of the era, particularly as seen in the cinema. The filmmaker Robert Flaherty, for instance, had filmed the conditions of the Eskimos in 1922 while directing his subjects as if they were actors.[60] And John Grierson, an English documentary filmmaker admired by specialists in the Roosevelt administration and by Paul Strand and Pare Lorentz (who made *The Plow That Broke the Plains*), declared at about the time of the FSA that a documentary was "the creative treatment of reality;"[61] he took pains to distinguish the real from its intellectual (re)construction, reality.[62] Stryker's photographers, plunged into the real and left to react to it personally and photographically, were actually verging on the "auteur photography" that suited Evans—despite Evans's constant grumbling about artistic constraints. What Stryker had done was to open the way not to a passive photographic report but to a wide variety of active interpretations of the real—an approach similar to the contemporaneous, more systematic efforts by Aaron Siskind's Photo League Feature Group.[63] For Siskind as for Stryker, the documentary photographer, rather than disappearing behind a literal, distanced representation of his subject, needed to reflect a personal vision that served, paradoxically, as a seal of authenticity. From this perspective, many of the FSA photographs seem to refute Elizabeth McCausland, who in a 1939 article on documentary photography cited the abandonment of personal expression as the defining characteristic of the new genre and the "new spirit of realism."[64] She wrote, "Montage of his personality over his subject will only defeat the serious aim of documentary photography.... The fact is a thousand times more important than the photographer."[65]

It is not an objective visual or interpretative neutrality but a *stylistic neutrality* that asserts itself in the majority of the photographs in the FSA archives. Neutrality figured prominently in the art of the 1930s. It suited the new documentary style Walker Evans tirelessly promoted as it called into question the emphasis modernism (exemplified by Stieglitz) put on a print's aesthetic quality and on lyrical and formal expression over subject. In contrast to the Stieglitz school's approach, Stryker's working methods largely deprived the FSA photographers of the clear identity of an artist recognizable by his stylistic touches. In a study of the editorial uses of a photo Evans took in Pennsylvania in 1935, Alan Trachtenberg demonstrated that it was not published as a work by the artist Walker Evans but as an FSA photograph illustrating the Roosevelt administration's ideals.[66] Because their pictures were in the public domain, the FSA photographers took a backseat to their subjects' imperatives, surrendering any notion of authorship—credit often was given solely to the government agency—and valuing documentary effectiveness over beauty or uniqueness. The chief criterion for an FSA photograph was

59. Aside from Walker Evans, all the FSA photographers praised Stryker for his flexibility and his respect for their creative freedom.

60. Flaherty's documentary *Nanook of the North* (1922) was a major commercial success.

61. Peter Morris, "Re-thinking Grierson: The Ideology of John Grierson," in T. O'Regan and B. Shoesmith, eds., *History on/and/in Film* (Perth: History & Film Association of Australia, 1987), pp. 20–30.

62. "In documentary, we deal with the actual, and in one sense with the real.... The only reality which counts in the end is the interpretation, which is profound." Ibid.

63. See the projects the Feature Group realized in 1936–41, particularly "The Bowery," "The Harlem Document, Lost Generation," and "Park Avenue; North & South." Some Feature Group picture stories appeared in *Look*; see "244,000 Native Sons," with photographs by Aaron Siskind and the Harlem Document Feature Group, May 21, 1940. *Look*'s editors did not tamper with the photographs or Michael Carter's captions, letting them stand as prime examples of the picture story.

64. "Today, we do not want emotion from art.... We want the truth.... That truth we receive visually from a photograph recording the undeniable facts of life today.... We turn back to the ages of realism." "Documentary Photography," *Photo Notes* (January 1939).

65. Ibid.

66. Alan Trachtenberg, "From Image to Story," in Fleischhauer and Brannan, eds., *Documenting America*, p. 50.

readability; it eclipsed any other consideration. "The word *composition*," Stryker later recognized, "was never talked about, never mentioned. It was a taboo word."[67] In keeping with his administration's avowed goals, Stryker asked his photographers to "recognize the pertinent thing in a particular situation"[68] and make it clearly visible. The FSA photographer was free to do as he or she wished in attaining that objective. Original methods and responses were practically guaranteed by the photographers' mixed bag of artistic disciplines (painting and photography in the case of Shahn and Delano), prior professional experiences (Lange and Evans), or, in some instances, the lack of any photographic background at all.

Echoing their abandonment of particular stylistic effects, the FSA photographers elevated the anonymous, recording a wide range of *anonymous* subjects, characters, actions, and places. In so doing they and other politically committed artists of the Great Depression contributed to a movement that durably influenced contemporary aesthetics. In literature (John Dos Passos, Erskine Caldwell, John Steinbeck) as in painting (Edward Hopper, Thomas Benton), the protagonist of 1930s American art was an anonymous figure. He was not a "man without qualities" in the existential sense Robert Musil described in his novel by that name, but a common man, wholly removed from celebrity or social extravagance, either of which would have singularized him. This protagonist was the antithesis of the heroes created during the previous decade by writers like F. Scott Fitzgerald and by Hollywood.

Together the FSA pictures present an immense portrait of the anonymous American as seen in the roles and routine gestures that define him in the context of work, leisure, home life, or religion. They collectively describe an average citizen, frequently interchangeable from one photo to the next, thus creating something similar to what the German photographer August Sander had recently undertaken with his Man of the Twentieth Century project: a *typology*. Walker Evans played a central role in that regard, with his long photographic series of signs and monuments and, especially, his emblematic image of the picture I.D.s displayed in a photographer's shop window in Georgia in 1936 ("Penny Picture Display, Savannah"). Though this typology is assuredly less sweetly stereotypical than the one displayed on the covers of the *Saturday Evening Post* during the Norman Rockwell years (1916–63), it did not always escape reductive touches, as were found, for example, in the FSA photos illustrating Sherwood Anderson's *Home Town*.

TOWARD A "DOCUMENTARY STYLE"

The influences to which the FSA photographers were subjected largely depended on their individual backgrounds. Roy Stryker was most vocal about his admiration of Lewis Hine's work but he turned down Hine's insistent requests to be hired, claiming Hine was too old. Many of the photographers on staff after 1940 (Vachon, Delano, Post Wolcott) did not have any real photographic roots. They were not impressed by Margaret Bourke-White—whom Rothstein much admired—and her artistic photographic record of the Soviet Union, *Eyes on Russia*; in fact, the FSA photographers were somewhat repelled by that 1931 volume. The book, much influenced by the European New Vision school and reeking of pictorialism, seemed less like a documentary work than like Communist propaganda—it was even hailed by the Russian director

67. Stryker, interview with Doud, 1963.
68. Ibid.

Sergey Eisenstein.[69] Ben Shahn considered Bourke-White's photographs, particularly in the book *You Have Seen Their Faces*,[70] "inadequate copies of our work,... a commercial job."[71] The stylistic traits of European formalism—high and low angles, off-kilter framing—were also rare in the FSA corpus, beyond the subtle traces found in the pictures of John Vachon or Marion Post Wolcott. Ben Shahn considered the avant-garde photographic vocabulary "horrible," no more than formula or "tricks."[72] Stryker encouraged the photographers, when they were in Washington between missions, to consult their colleagues' archives and recent photographs,[73] Mathew Brady's Civil War photographs (Walker Evans spent much of the fall of 1936 at the War Department, studying Brady's work),[74] and the work of nineteenth-century landscape photographers of the American West, such as William Henry Jackson. Stimulated by this self-education program, the later generation of FSA photographers generally found role models among its predecessors at the FSA: Evans, Shahn, or Lange. Gordon Parks spoke of drawing formative influences from the FSA files.[75] Consulting the files—for Parks and many others—generated a body of documentary references that ultimately created an "FSA style" based on bipolar influences: the images of Walker Evans and those of Ben Shahn.[76]

The two major aesthetics around which FSA photographers rallied—more or less consciously and in varying degrees—could hardly have been more distinct from one another. Walker Evans's style was characterized by the use of static equipment, particularly the large-format camera, with occasional recourse to more manageable gear such as the Leica; frontal composition; distance; avoidance of a discernably subjective point of view; and the use of ellipsis and irony. Most important, Evans systematically explored ways that signage and other elements (vernacular motifs, empty interiors, exterior surfaces) could elliptically express the social state, but always with an implied "literary" perspective specific to Evans and conducive to a reflection on time and its historical or existential profundity. Aside from certain superficial similarities in pictures of identical subjects, that reflective element distinguishes Evans's photos from, for example, John Vachon's, which are less developed but occasionally strive for comparable poetic depth.

Painter Ben Shahn's approach to his FSA assignments sharply contrasted with Evans's. His work was a continuation of the experimentation he had initiated in the streets of New York City in 1932, when he began using photography to explore new perspectives for his painting.[78] He believed both art forms belonged to the undifferentiated realm of the image: "I find difficulty in making distinctions between photography and painting: both are pictures."[79] That conviction explains Shahn's absence of constraints; his rare sense of freedom also extended to his use of photography to express a radical political vision rooted in Communist beliefs (of which he and his wife Bernarda were the sole proponents on the FSA team).[80] To avoid being intrusive and tampering with spontaneity, Shahn photographed exclusively with small-format cameras, frequently used an angle viewfinder to focus, and eschewed the flash, which, unlike Russell Lee, he considered "immoral."[82] His photography was essentially a political tool meant to direct the viewer away from stereotypical perceptions of the working class and social relations; in doing so, he strictly opposed the conventional, empathetic poses occasionally found in Lange's or Rothstein's photographs. Working on the fly, getting within inches of his subjects, shooting with

69. See Bendavid-Val, *Propaganda and Dreams*, p. 44 and following.

70. Erskine Caldwell and Margaret Bourke-White, *You Have Seen Their Faces* (New York: Modern Age Books Inc., 1937).

71. Shahn, interview with Doud.

72. "We would avoid all tricks; angle shots were just horrible to us." Ibid.

73. Shahn said, "When a man returned from the field... we'd look at the work." Ibid.

74. Mellow, *Walker Evans*, p. 336. Evans even proposed that Stryker mount an exhibition of Brady's work based on about a hundred prints he had selected while studying it.

75. Parks, interview with Doud: "I learned a lot from all the pictures in the files. It was my daily chore when I first went there to look at all the pictures, all the photographers, study them and imprint them on my own conscious, my own mind... and become aware of what was happening."

76. Stryker and nearly all the FSA photographers, particularly those who formed the second team constituted in 1940, recognized the double influence exercised by Evans and Shahn. See the interviews with Doud.

77. Vachon always asserted his profound admiration for Evans, once declaring that he often tried to follow in the footsteps of his illustrious model; he even photographed the same Atlanta billboard Evans had shot, framed roughly the same way (see p. 231). Orvell, ed., *John Vachon's America*, pp. 17, 251, 311.

78. See Kao, Katzman, and Webster, *Ben Shahn's New York*. In his interview with Doud, Shahn declared that being an FSA photographer inspired his later painting: "For a period of almost seven or eight years after, it was the basis of most of my work."

79. Ben Shahn, "Photos for Art," *US Camera* 9 (May 1946).

80. "To me the word 'propaganda' is a holy word when it is something I believe in." Shahn, interview with Doud.

81. "I used what is called an angle viewfinder," which lets you look off in another direction when you focus. "I would take away any self-consciousness [people] have. So most of my pictures don't have any posed quality." Ibid.

82. Shahn told Doud: "I was quite a purist about it when some people came in and began to use flash. I thought it was immoral." However, Katzman in *Ben Shahn's New York*, p. 306, demonstrated that Shahn used a flash to photograph certain Ohio interiors.

unprecedentedly severe framing, and achieving often complex results, Ben Shahn opened the way to the 1960s American street photography of William Klein, Garry Winogrand, and Lee Friedlander. Yet Shahn, who was well acquainted with the work of Cartier-Bresson,[83] also infused his pictures with a dreamlike quality and surrealistic effects that several other FSA photographers would appropriate. (Walker Evans had used a similar style in his New York pictures of the late 1920s.) Peter Sekaer, the Danish photographer who assisted Evans on several FSA assignments, chose a Ben Shahn photograph in this European vein ("Medicine Show, Huntington, Tennessee, October 1935") to illustrate the cover of the catalogue for an exhibition he organized in 1936, "Documentary Photographs from the Files of the Resettlement Administration."

Roy Stryker always favored Shahn's aesthetic over Evans's, though he was never short of praise for Evans's successes or his élan.[84] Many FSA photographers borrowed from both men, but the younger photographers more frequently made use of their predecessors' working methods than their aesthetic visions.

The majority of the FSA photos are not distinguishable from the largely forgotten pictures taken during the same period by photographers working on documentation for many other government agencies. In 1941 the prolific but little-known photographer Irving Rusinov of the Bureau of Agricultural Economics took pictures of the village of El Cerrito, New Mexico,[85] that were comparable to Russell Lee's work on the same subject ("Pie Town, New Mexico") and exhibited the shared influence of Walker Evans. The photographs the writer Eudora Welty shot in Mississippi for the Works Progress Administration rival Dorothea Lange's for social effectiveness and also throw in a peculiar sensuality.[86] And the depression-era photos by the German émigré John Gutmann curiously and unexpectedly illustrate the period's wonderful extravagance in a style characterized by a "very large visual vocabulary" of European modernism, as Max Kozloff put it.[87]

An in-depth study of American documentary photography of the 1930s—in which the FSA played a key role—would help distinguish those photographers who had a genuine vision from those who had merely a good eye and those who were only doing their job. It would provide a better understanding of the growing importance, beyond commissioned pieces, of the rise of the documentary style that was first defined by Walker Evans and is rich with the ambiguities found at the intersection of art and document. The documentary style progressively came to influence all American photography and to this day remains its unrivaled model.

83. The two photographers met in New York in 1935, and Shahn expressed his admiration for Cartier-Bresson in a review of the exhibit "The Photographs of Henri Cartier-Bresson" at the Museum of Modern Art in New York in February–April, 1947. He wrote: "To find the extraordinary aspect of the ordinary—that's what Cartier-Bresson does." The review appeared in *Magazine of Art* 40 (May 1947).

84. Shahn told Doud, Evans "loved the South. Particularly the... antebellum architecture, and I think Roy was rather disaffected by that rather rigid direction. He thought perhaps Walker ought to do more of the kind of things I was doing—people and movement and so on and so forth." Yet Stryker always credited Evans's photography as an early influence on the FSA's photographic ambitions. Referring to "Graveyard, Houses and Steel Mills," which Evans shot in Pennsylvania in 1935, Stryker said: "Pictures like these were pretty heady. It was important that they came in when they did, so early in our experience. They gave me the first evidence of what we could do." Stryker and Wood, *In This Proud Land*, p. 7.

85. Irving Rusinov, *A Camera Report on El Cerrito, a Typical Spanish-American Community in New Mexico*, pub. no. 479 (January 1942), Bureau of Agricultural Economics, United States Department of Agriculture.

86. Eudora Welty, *One Time, One Place: Mississippi in the Depression* (New York: Random House, 1971).

87. Max Kozloff and Lew Thomas, *The Restless Decade: John Gutmann's Photographs of the Thirties* (New York: Abrams, 1996), p. 15.

THE WAR YEARS (1942–43)

MARJORY COLLINS

JOHN COLLIER JR.

GORDON PARKS

ESTHER BUBLEY

1. Jeanie Cooper Carson, "Shifting Icons of Womanpower from Depression to Wartime in U.S. Office of War Information Propaganda," paper presented at the Berkshire Conference on the History of Women, University of North Carolina, Chapel Hill, June 1996, p. 11.

2. Ibid., p. 7.

Raised in wealth and educated at progressive private schools for girls before her family lost its money in the October 1929 stock market crash, Marjory Collins felt socially adrift during the Great Depression. As she wrote in the 1970s, she had wanted desperately to " 'break out of her middle class cocoon' and to make 'honest' pictures of the 'real' America in the manner of veteran FSA photographers."[1] This, she imagined, would make her " 'so sensitive to the emotions of others [she] could take better pictures than ever.' "[2] But in November 1941, Collins with great apprehension accepted a photographer's job at the New York office of the Foreign Service's U.S. Office of War Information (OWI). The work was wartime propaganda. She really wanted to produce the type of photographic studies that had made Roy Stryker's Historical Section famous since 1935, but America's entry into World War II after the December 7, 1941, attack on Pearl Harbor had made that job obsolete.

In January 1942 Collins managed to transfer from the Overseas Publications Branch in New York to the Washington, D.C., bureau of the Office of War Information, where she was to take news photographs for Roy Stryker's Historical Section. Although she was a member of Stryker's staff, she worried that the word

MARJORY COLLINS
ETHNIC MINORITIES

"news" in her title would consign her to commercial assignments presumably beneath the dignity of the rest of the staff. She failed to realize that, at that point, all the FSA-OWI photographers produced more than half their work for the Coordinator of Information's Foreign Information Service (COI-FIS).

Many of those COI assignments involved photographing "hyphenated Americans"—African-, Chinese-, Czech-, German- Irish-, Italian-, Jewish-, and Turkish-American people. The photographs illustrated publications that were dropped behind enemy lines to communicate to persecuted groups or residents of countries in the grip of the Axis powers that, in America, all people could live together in harmony. In the fifteen months between March 1942 and June 1943, when the Historical Section folded, Collins produced more than three thousand captioned photographs. She fulfilled the agency's objectives creatively—using the dramatic angles European émigré photojournalists had introduced to America, emphasizing in closeups the exoticism of Turkish dancers, or capturing the decisive moment in an ethnic classroom—breaking through the stereotypes of advertising and propaganda from previous wars. Assigned to make America look strong to its enemies, Collins sometimes subverted agency values to show the poverty and pain she observed. She later called her work for the OWI "wartime profiteering."[3]

B.W.B.

3. Ibid., p. 3.

MARJORY COLLINS

p. 271
Marjory Collins, Lititz, Pennsylvania.
Self-portrait at a public sale.
NOVEMBER 1942 8d23557

p. 273 top
New York, New York. Italian
bakery on First Avenue between
Tenth and Fourteenth Streets.
FEBRUARY 1943 8d12756

p. 273 bottom
New York, New York. Jewish
weaving shop on Broome Street.
AUGUST 1942? 8d21925

p. 274 top
New York, New York. Italian-
American cafe espresso shop on
MacDougal Street where coffee
and soft drinks are sold. The coffee
machine cost one thousand dollars.
AUGUST 1942? 8d21753

p. 274 bottom
New York, New York. Jewish
weaving shop on Broome Street.
AUGUST 1942? 8d21960

p. 275 top
New York, New York. Chinese
grocery store in Chinatown.
AUGUST 1942? 8d21957

p. 275 bottom
New York, New York. Chinaman
counting on an abacus in a Chinese
grocery store in Chinatown.
AUGUST 1942? 8d21958

p. 276
New York, New York. Orchestra
in a Turkish nightclub on Allen
Street. The girl plays a tambourine
between dances.
DECEMBER 1942 8d24227

p. 277 top
New York, New York. Turkish
nightclub on Allen Street.
DECEMBER 1942 8d11640

p. 277 bottom
New York, New York. Gypsy
woman who is habitué of Marconi's
Restaurant on Mulberry Street. She
dropped in for a bite to eat New
Year's Eve and did a spontaneous
dance to entertain the DiCostanzos'
family party.
DECEMBER 1942 8d23920

p. 278 top
New York, New York. A Czech
physician, Dr. Winn [or Wynn], and
his family, who moved to America
just before Hitler's occupation of
their country.
OCTOBER 1942 8d23183

p. 278 bottom
New York, New York. Janet and
Marie Winn [or Wynn], Czech-
American children, go roller-skating
in Central Park.
OCTOBER 1942 8d23021

p. 279 top
New York, New York. Dr. Winn [or
Wynn], a Czech American, telling
Janet a tall story in Central Park.
OCTOBER 1942 8d23030

p. 279 bottom
New York, New York. Twice a
week Janet Wynn [or Winn], age
eight, goes to a Czech school on
East Seventy-fourth Street,
between First and Second
Avenues, from three to five p.m.,
to learn to read, write, and speak
the Czech language. Although born
in Czechoslovakia, her three years
in this country in American schools
have caused her to forget much.
Here the Czech teacher directs her
as she writes a Czech word on the
blackboard.
OCTOBER 1942 8d22997

p. 280 top
New York, New York. Italian
grocery store owned by the Ronga
brothers on Mulberry Street.
JANUARY 1943 8d12273

p. 280 bottom
New York, New York. Mrs. Winn [or
Wynn], a Czech American, and her
daughters, Marie and Janet, going
shopping for groceries.
OCTOBER 1942 8d23006

p. 281 top
New York, New York. British and
American sailors at the Stage Door
Canteen.
AUGUST 1942? 8d07745

p. 281 bottom
Washington, D.C. Peoples
drugstore on G Street N.W. at
noon.
JULY 1942 8c28521

p. 282 top
New York, New York. The Lincoln
School of Teachers' College,
Columbia University. Third-grade
pupil acting the part of Hitler in
a program produced by his class.
JANUARY 1942 8d23065

p. 282 bottom
Oswego, New York. United Nations
heroes in the Flag Day parade
during United Nations week.
JUNE 1943 8d30922

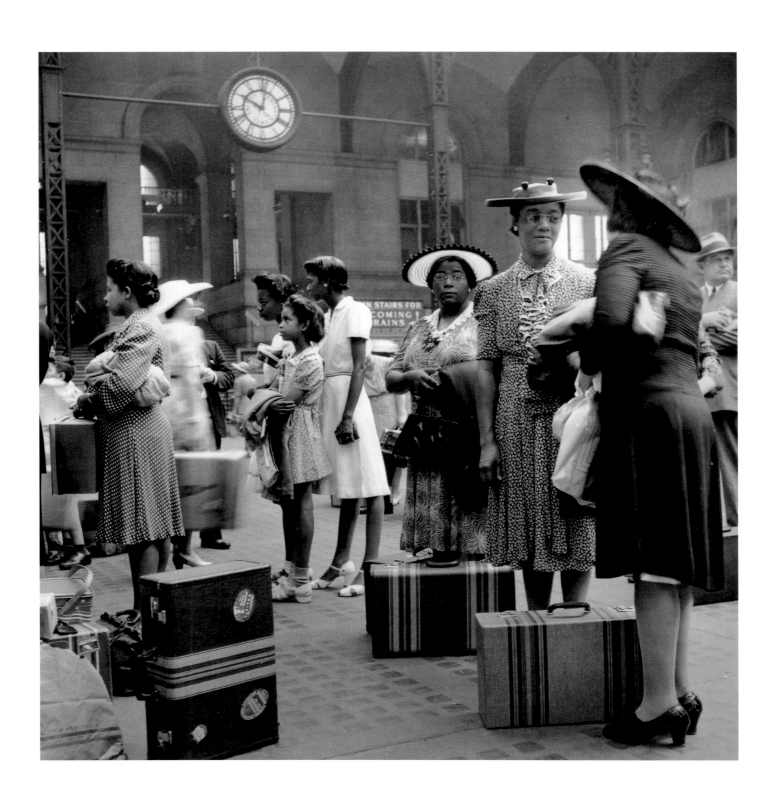

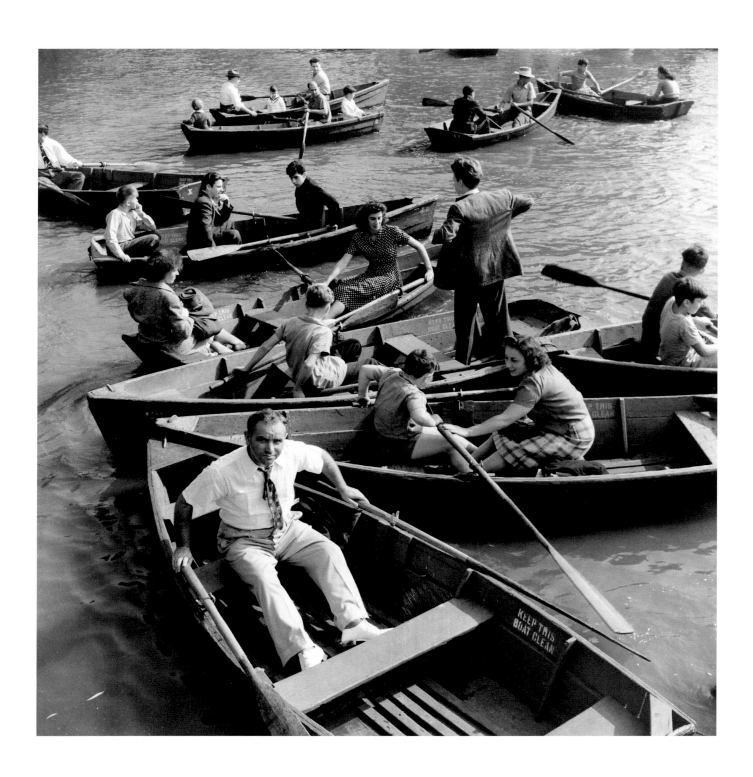

MARJORY COLLINS

p. 284

Washington, D.C. Sleeping in a car
on Sunday in Rock Creek Park.
JUNE–JULY 1942 8c36411

p. 285

Lititz, Pennsylvania. Irwin R. Steffy
having his car gone over in the
Pierson Motor Company garage.
He uses it to go into Lancaster
every day, where he is doing a
defense job at the Armstrong Cork
Company; he shares a ride when
hours permit. Before the war he
worked for nine years for Sprachts,
the undertaker. Now he serves
four hours a week as an airplane
spotter at the nearby observation
post.
NOVEMBER 1942 8d10157

p. 287

New York, New York. Waiting
for the trains at the Pennsylvania
railroad station.
AUGUST 1942? 8d21836

p. 288

New York, New York. Central Park
lake on Sunday.
SEPTEMBER 1942 8d22207

John Collier started off as a painter on the West Coast and developed an interest in photography after meeting Dorothea Lange in California. In 1941, just before the FSA's absorption by the OWI, Roy Stryker hired him; he would be part of the last generation of FSA photographers. From that point on, Stryker's team was devoted to documenting the United States's military mobilization and engagement in World War II.

Though he was more familiar with the West Coast, Collier's first assignments were in the East. He later said his East Coast experiences made him feel "like a foreigner in a foreign country,"[1] and, appropriately enough, Collier's photographic style was strongly anthropological. As Collier wrote in his seminal 1967 book *Visual Anthropology: Photography as a Research Method*: "Recording what people look like, what they wear, and the condition of their clothes is a descriptive opportunity offering rich clues to identifications comparable to those provided by exteriors and interiors of houses."[2] Collier was also greatly influenced by Russell Lee, from whom he adopted the use of powerful, frontal flash lighting to reveal every detail.

1. In Fleischhauer and Brannan, eds., *Documenting America*, p. 297.

2. Collier, *Visual Anthropology*, chap. 5, n.p.

JOHN COLLIER JR.
PENNSYLVANIA COAL MINES

In November 1942 Collier traveled to Pennsylvania to photograph the mines around Pittsburgh, specifically to document the resurgence of the local coal industry. Coal mining, which had experienced steady growth and prosperity since the eighteenth century, had reached its peak in 1918 and severely declined during the depression. Then war preparations in 1941 began revitalizing the industry. John Collier's pictures (he produced 235 negatives that are conserved in the FSA-OWI archives) celebrated the reopening of the mines, along with the new industrial dynamism and the manifest optimism that accompanied it.

Collier's mining series added to a long tradition of industrial photography. Under the aegis of the Coal Mines Administration, the Pennsylvania mines had been regularly photographed since the nineteenth century. Lewis Hine in 1911 made notable contributions, and later so did most of John Collier's FSA colleagues, particularly John Vachon, who took a series of photos in August 1940.

G.M.

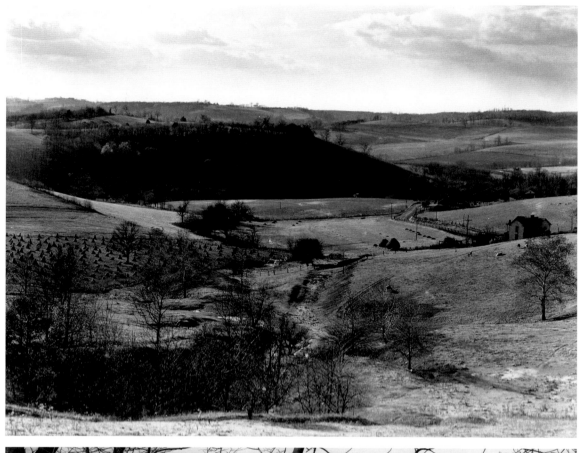

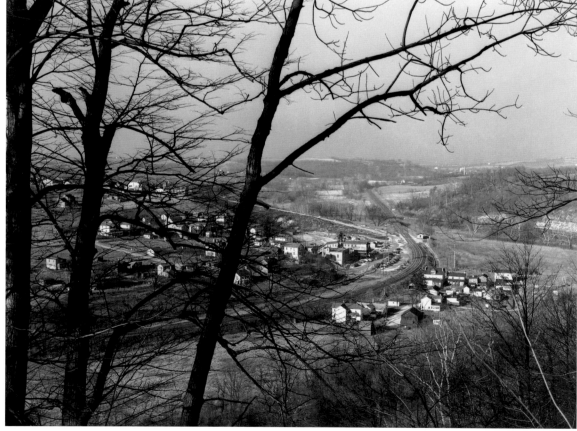

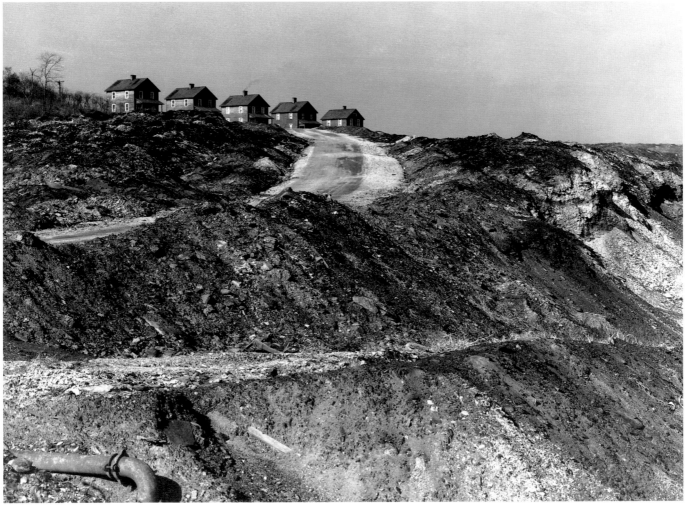

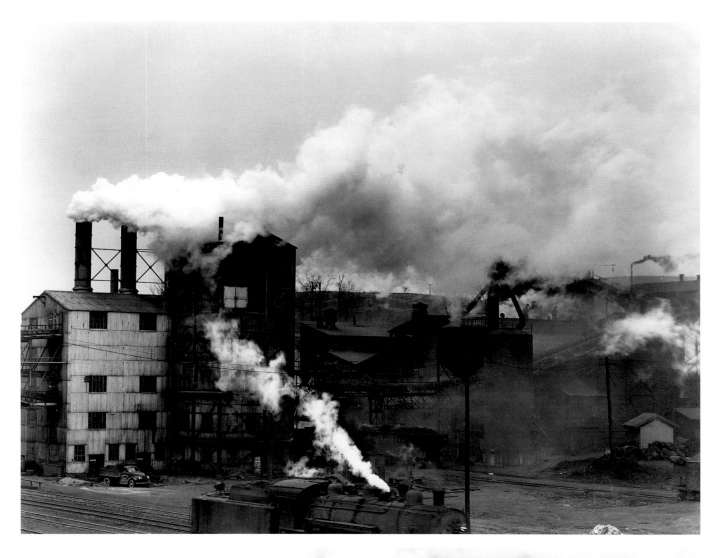

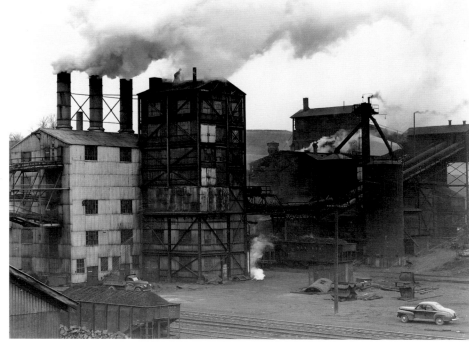

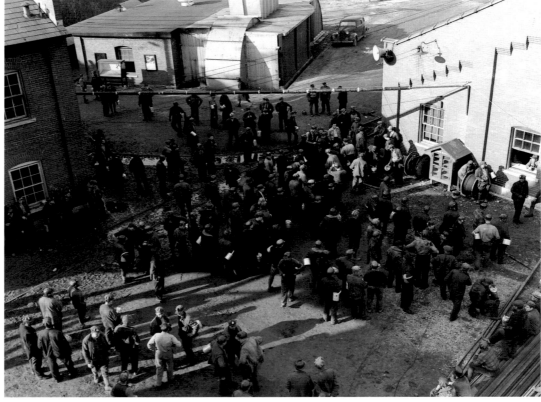

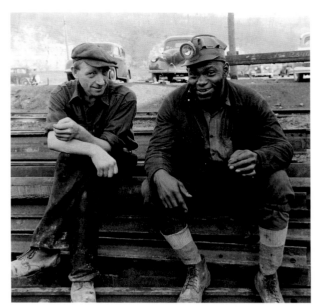

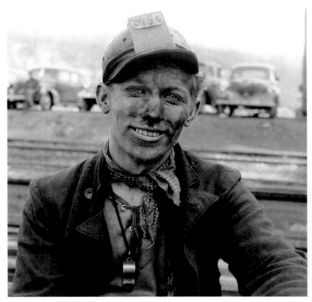

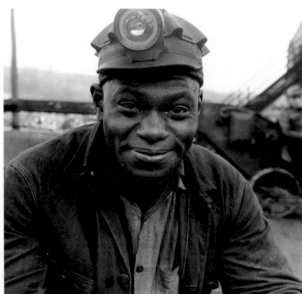

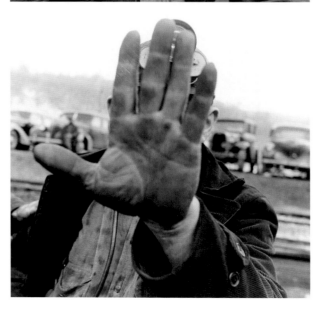

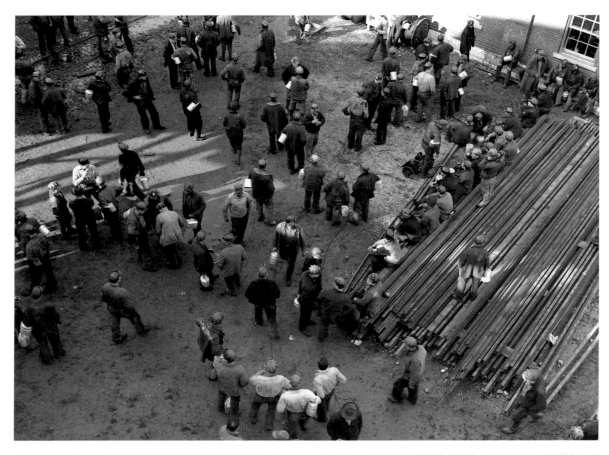

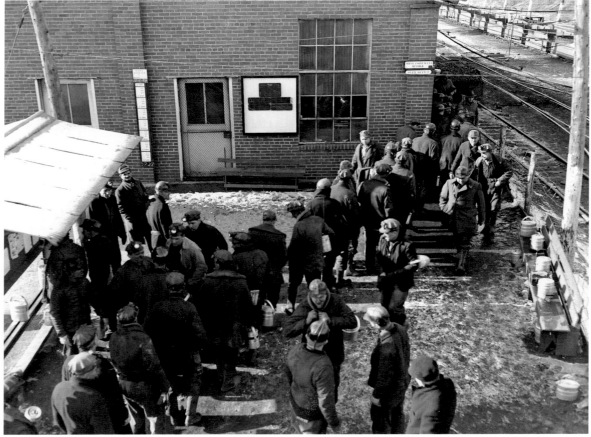

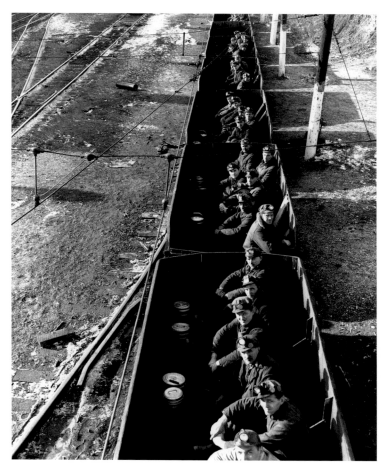

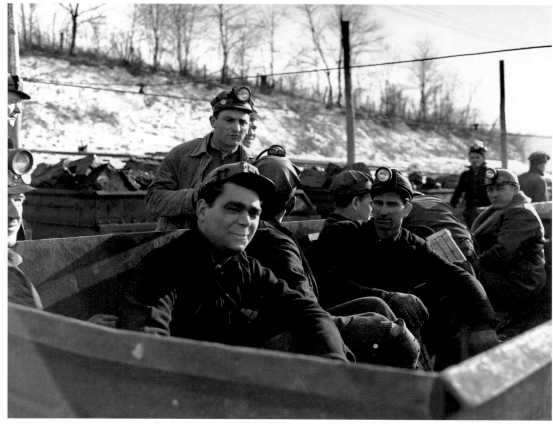

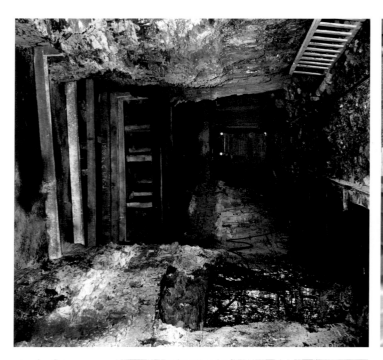

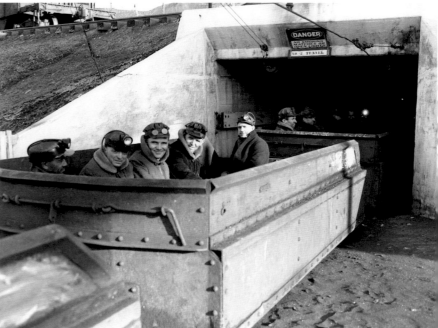

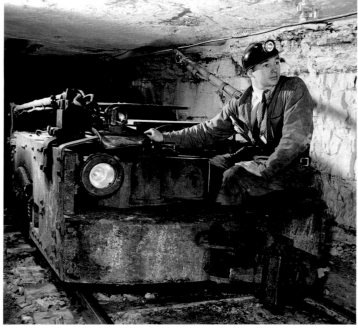

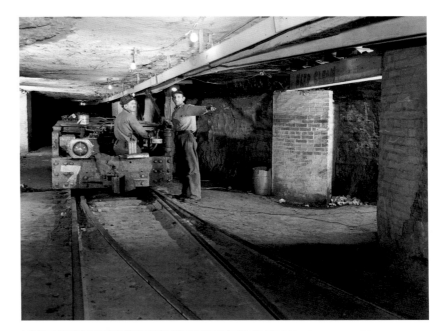

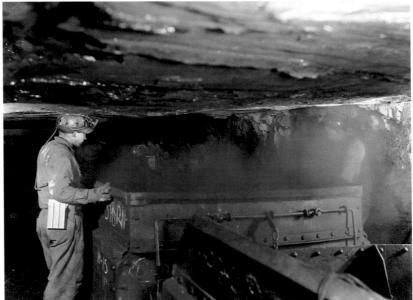

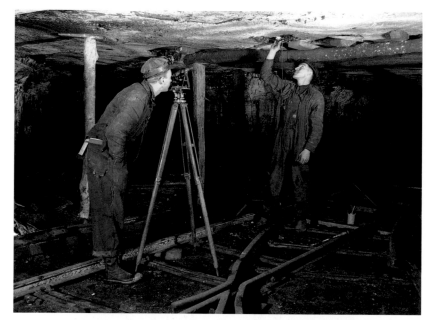

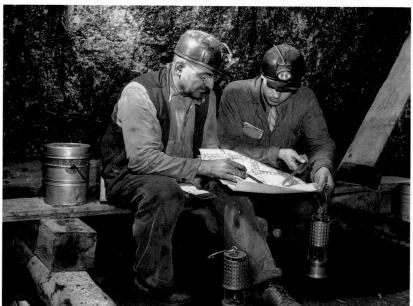

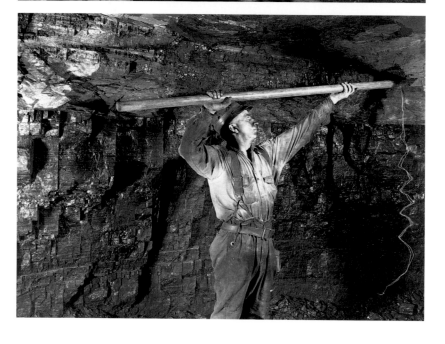

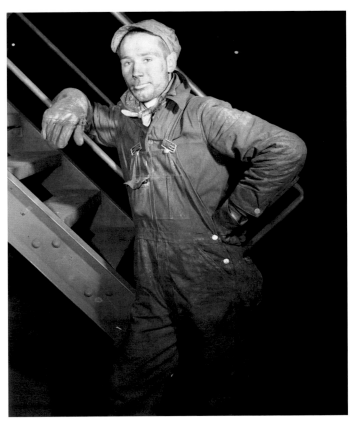

p. 291

John Collier Jr., FSA photographer, seated on a lawn with young boys in the background.

C. 1943 00270

p. 293 top

Pittsburgh, Pennsylvania (vicinity). Montour no. 4 mine of the Pittsburgh Coal Company. Above the coal seam, dairy and farm lands lay undisturbed. Only occasionally are "sinks" and large "pot holes" caused by the collapsing of "mined out" areas of the seam.

NOVEMBER 1942 8d09716

Note: All photos shot at Montour no. 4 mine complex unless otherwise noted.

p. 293 bottom

NOVEMBER 1942 8d10290

JOHN COLLIER JR.

p. 294 top

NOVEMBER 1942 8d09702

p. 294 bottom

Slag pile beneath company village.

NOVEMBER 1942 8d10630

p. 295 top

NOVEMBER 1942 8d11054

p. 295 bottom

Pittsburgh (vicinity), Champion no. 1 cleaning plant.

NOVEMBER 1942 8d11072

p. 296 top

Chicago, Illinois. General view of one of the Chicago and Northwestern Railroad yards.

DECEMBER 1942 8d11086

p. 296 bottom

Champion no. 1 coal cleaning plant.

NOVEMBER 1942 8d10921

p. 297 top

Champion no. 1 coal cleaning plant. Loading cars with clean coal.

NOVEMBER 1942 8d10930

p. 297 bottom

Champion no. 1 cleaning plant.

NOVEMBER 1942 8d11062

p. 298 top left

Tipple and slate conveyor.

NOVEMBER 1942 8d10287

p. 298 top right

NOVEMBER 1942 8d10618

p. 298 bottom

Miners meeting at change of shift.

NOVEMBER 1942 8d10613

p. 299 top

Miners waiting to go underground.

NOVEMBER 1942 8d23675

p. 299 center left

Coal miner at end of the day's work.

NOVEMBER 1942 8d23666

p. 299 center right

Miner waiting to go underground.

NOVEMBER 1942 8d23673

p. 299 bottom

Pittsburgh, Pennsylvania (vicinity).

NOVEMBER 1942 8d23667

p. 300 top

Miners meeting at change of shift.

NOVEMBER 1942 8d10625

p. 300 bottom

Pittsburgh, Pennsylvania (vicinity). Westland coal mine. Change of shift.

NOVEMBER 1942 8d11016

p. 301 top

Westland coal mine. "Mantrip" en route to the mine.

NOVEMBER 1942 8d11059

p. 301 bottom

Miners coming off shift.

NOVEMBER 1942 8d11029

p. 302 top left

Unusually high roof in mine due to a poor ceiling.

NOVEMBER 1942 8d23643

p. 302 top right

Westland coal mine. "Mantrip" going into a "drift mine."

NOVEMBER 1942 8d11038

p. 302 bottom

Electric mine engine.

NOVEMBER 1942 8d23624

p. 303 top

Transportation dispatcher giving orders to an outgoing coal trip in front of the dispatcher's office in the mine.

NOVEMBER 1942 8d10007

p. 303 center

Loading coal in the mine.

NOVEMBER 1942 8d09538

p. 303 bottom

Testing for gas with a safety lamp; if there is gas, the lamp will burn with a blue flame. The screening keeps the open flame confined but lets the gas in.

NOVEMBER 1942 8d09528

p. 304 left

Sign on safety door.

NOVEMBER 1942 8d23652

p. 304 top right

Doorway and interior of fire boss's room, where the records of inspection are kept.

NOVEMBER 1942 8d09718

p. 304 bottom right

Miner calling to the surface for orders.

NOVEMBER 1942 8d11020

p. 305 top

Each day's work is surveyed and plotted on a chart by the mine engineers.

NOVEMBER 1942 8d09857

p. 305 center

Section foreman and mine superintendent planning the progress of the mining.

NOVEMBER 1942 8d09524

p. 305 bottom

Ramming home a powder charge.

NOVEMBER 1942 8d11036

p. 306 top

Tipple hand.

NOVEMBER 1942 8d10909

p. 306 bottom left

Rotary dump, which empties coal cars into a chute that conveys the coal to railroad cars beneath.

NOVEMBER 1942 8d09714

p. 306 bottom right

Blacksmith shop.

NOVEMBER 1942 8d45009

p. 307 top

Champion no. 1 coal cleaning plant. Oiling the gears of the huge drums that dry the coal after washing.

NOVEMBER 1942 8d10925

p. 307 bottom

Champion no. 1 coal cleaning plant. Washing coal.

NOVEMBER 1942 8d10933

p. 308 top

Miners' wives learning first aid.

NOVEMBER 1942 8d11008

p. 308 center

Mine foreman at a production meeting.

NOVEMBER 1942 8d10006

p. 308 bottom left

C. 1935–45 8d11087

p. 308 bottom right

Jo Patenesky, miner, reading a letter from his son, who is in the army.

NOVEMBER 1942 8d11025

p. 309 top

NOVEMBER 1942 8d11041

p. 309 bottom

Assistant superintendent getting ready for a hunting trip.

NOVEMBER 1942 8d09523

JOHN COLLIER JR.

p. 311
Trampas, New Mexico. Maclovia
Lopez, wife of the majordomo
(mayor), spinning wool by the
light of the fire. The family has
ten sheep and spins the wool
for blankets, which are woven
in Cordova.
JANUARY 1943 8d25860

p. 312 top
Sales attention at a wayside
harvest market near Greenfield,
Massachusetts.
OCTOBER 1941 8c25847

p. 312 bottom
The rich and the poor crowded
into the Berkshires to enjoy
the fall colors. Mohawk Trail,
Massachusetts.
OCTOBER 1941 8c25888

p. 313 top
Grand Central Terminal, New York
City.
OCTOBER 1941 8c33198

p. 313 bottom
New York, New York. Ice skating in
Rockefeller Center.
DECEMBER 1941 8c34023

p. 314
Race Point, Massachusetts.
Portuguese surf-boat crew,
U.S. Coast Guard station.
SPRING 1942 8d04233

Gordon Parks, who in 1942 joined what had become the OWI's Historical Section, considered his work for the team to be of minor significance: "I really don't think I contributed much to the file.... I got a lot more out of it than I contributed."[1]

Parks was the only black photographer to work for the FSA-OWI, and Roy Stryker directed his apprentice's firsthand experience with racism toward a cathartic use of the camera. In the summer of 1942 Parks produced a series about Ella Watson, a black cleaning woman employed by the government in Washington. His photographs perfectly demonstrate the sense of dignity Parks restored to his subject during a period of heightened racial prejudice.

Parks again demonstrated his skillful construction of authentic "photo stories" in a less charismatic series about New York's Fulton Fish Market, which he shot in May–June 1943. The market, situated just south of the Brooklyn Bridge,

1. Parks, interview with Doud.

GORDON PARKS
FULTON FISH MARKET, NEW YORK

had been active since 1842; the first photographer to report on it was Sol Libsohn, whose 1938 work for the WPA underscored the market's human dimensions. Like Gordon Parks after him, Libsohn captured the market's dynamic, frenzied activity.

Parks's Fulton Fish Market assignment, for which he produced 202 negatives in the Library of Congress archive, was part of a larger series he did on the fishing trade. The government had requested additional documentation of the country's food-producing sector in 1943, as it increasingly sought to use the FSA's work for propaganda purposes. Stryker explained: "We are trying to get together a good story on food in the war period, and of course fish will have an important part in all food story [sic]."[2] Parks homed in on the market's daily rituals—unloading, cleaning, and weighing the fish—to convey a great sense of environment and detail.

2. Letter from Roy Stryker requesting the relevant authorities' assistance with Gordon Parks's assignment, April 17, 1943. Written records of the FSA-OWI, Prints and Photographs Division, Library of Congress, Washington, D.C.

G.M.

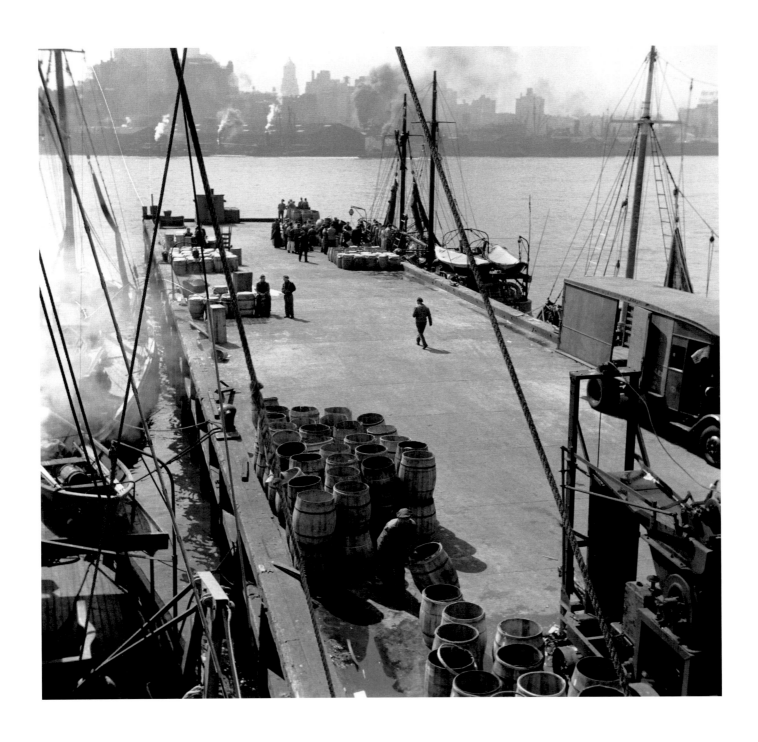

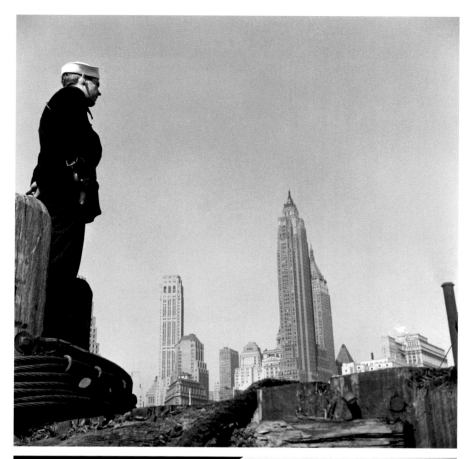

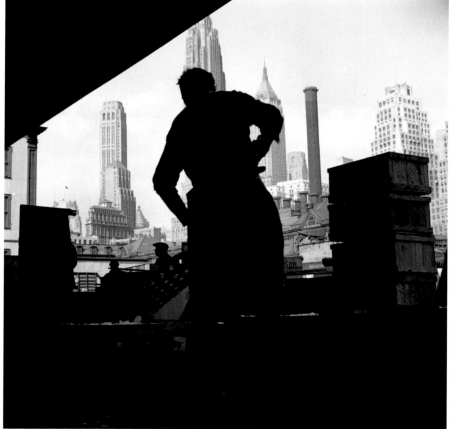

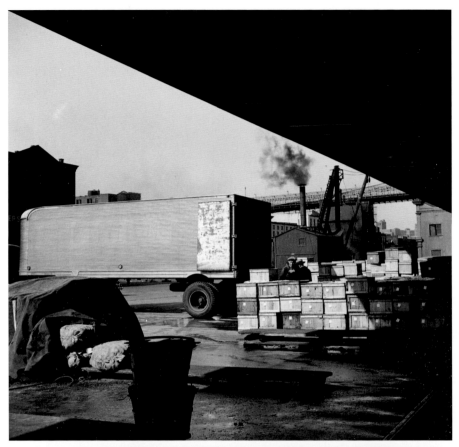

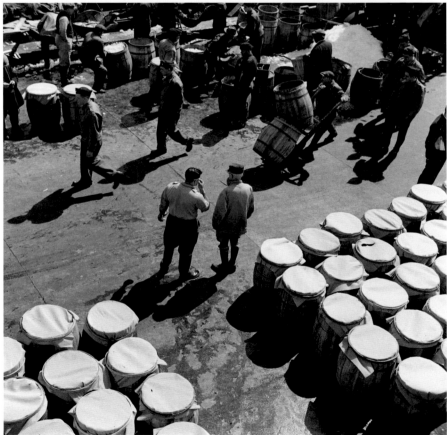

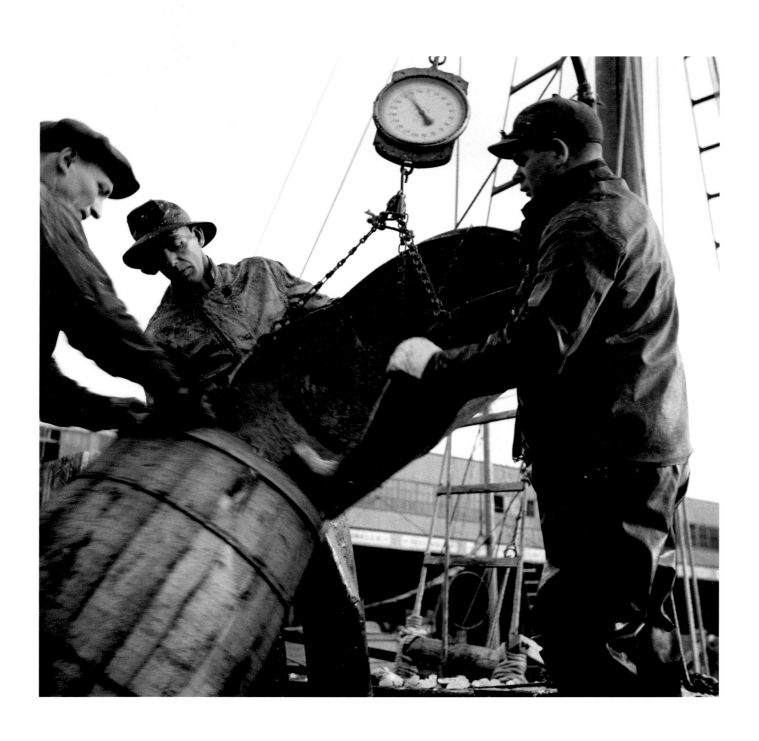

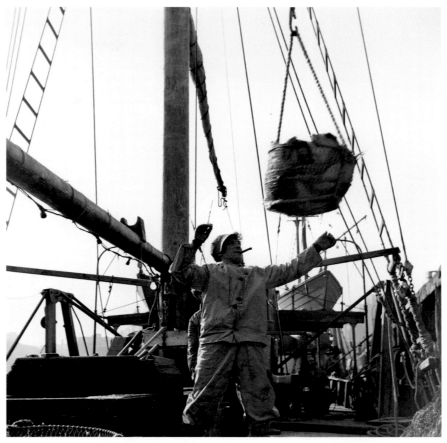

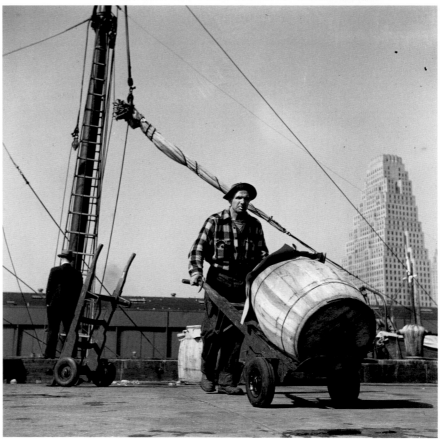

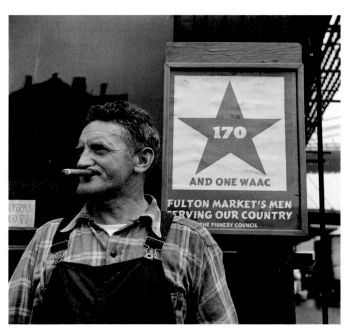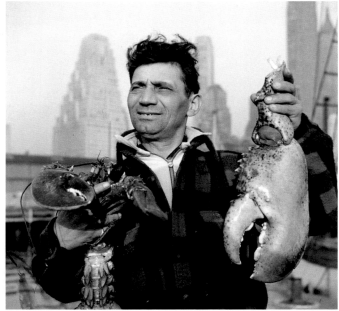

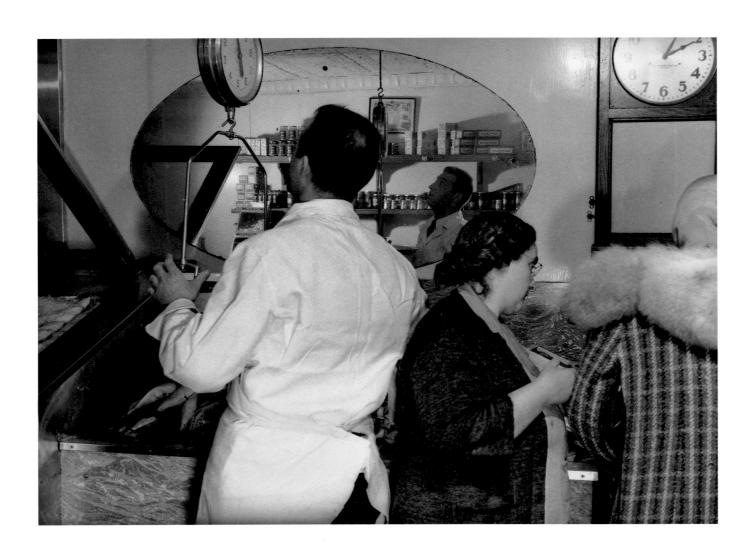

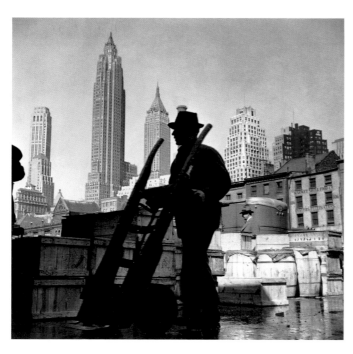

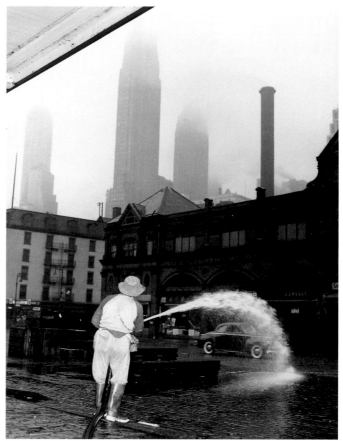

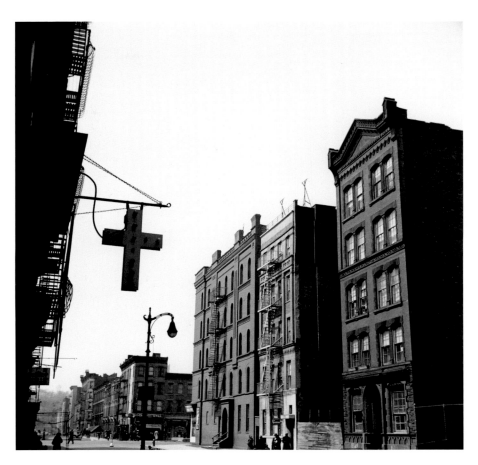

GORDON PARKS

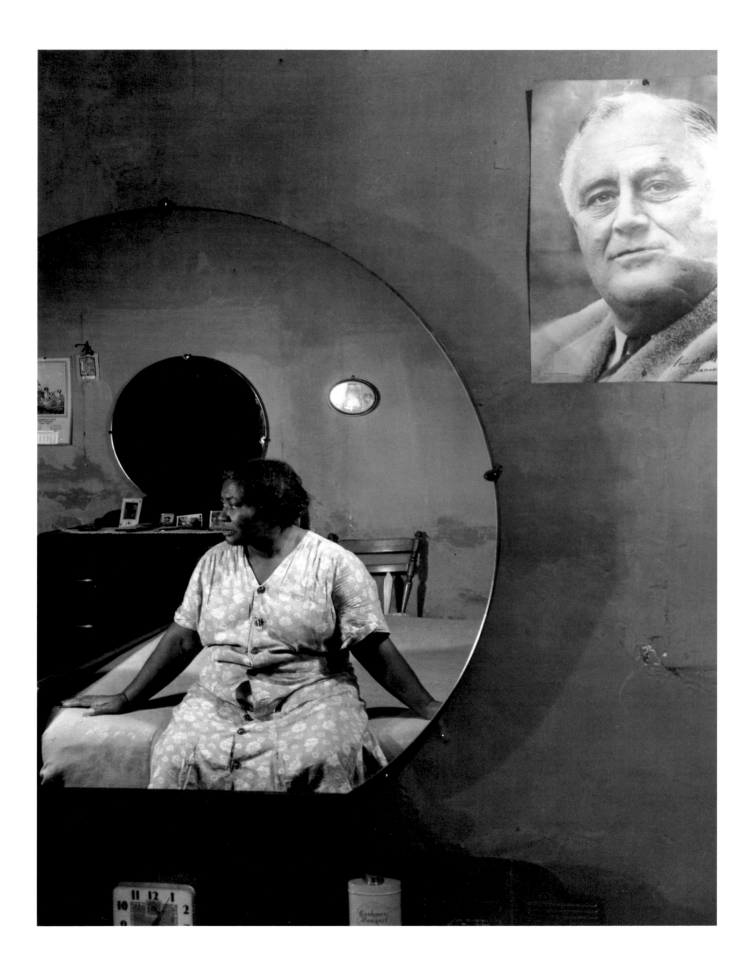

GORDON PARKS

Esther Bubley was only twenty
years old in 1941, when she settled in Washington, D.C., following an art
school education and a brief stint working for *Vogue* in New York. Eager to be-
come a photographer, Bubley had shown her first photos to Edward Steichen,
who encouraged her to persevere. In Washington Bubley got a job microfilm-
ing manuscripts and old books at the National Archives. In 1942 the OWI,
which had recently absorbed the FSA, hired her as a technician in the dark-
room. She continued to practice her own photography, taking as her subjects
the single women living in the many boardinghouses dotting the capital. Stryker
took notice of the pictures, purchased them for the FSA collection, and soon
hired Bubley to join his team of photographers. Since she did not have a dri-
ver's license, Stryker directed her to assemble a photographic record of pub-
lic transportation.[1]

The war era had brought sweeping change to and a profound reorganiza-
tion of America's way of life. The population was on the move: Families were dis-

1. For details, see Fleischhauer and Brannan, eds.,
Documenting America, p. 312.

ESTHER BUBLEY

BUS TRIPS

located, women hit the road in search of work, and men traveled to rejoin their military units. In September 1943 Bubley set out to document the Greyhound buses that had been traveling the country since 1930.

Some 446 pictures from this series are included in the FSA-OWI archive. Bubley took her photographs in the Southeast—riding on Greyhound's Memphis–Chattanooga and Louisville–Nashville lines—as well as in Indiana, Ohio, and Pennsylvania. As she lingered with passengers in bus stations and terminals by day and by night, Bubley took photos that captured their boredom and distress as they waited for transfers, registered racial inequalities, and described with a frequently humorous touch the codifcation of behavior aboard the bus. Her work described a rootless America and created a visual aesthetic that would have a profound influence on film noir.[2] She returned to the subject of long-distance bus travel while working for Stryker at Standard Oil of New Jersey in 1947, producing a celebrated series, Bus Story. In 1959 Robert Frank would replicate her experience, photographing the country while traveling by bus.

<div style="text-align:right">G.M.</div>

2. See Paula Rabinowitz's remarkable article, "Esther Bubley invents Noir," in *Film International* (March 2, 2003).

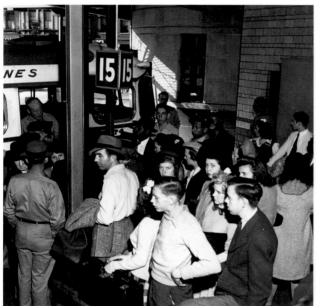
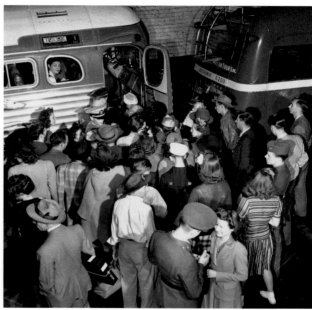
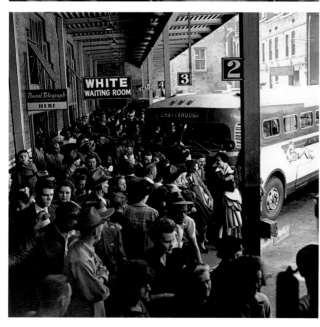

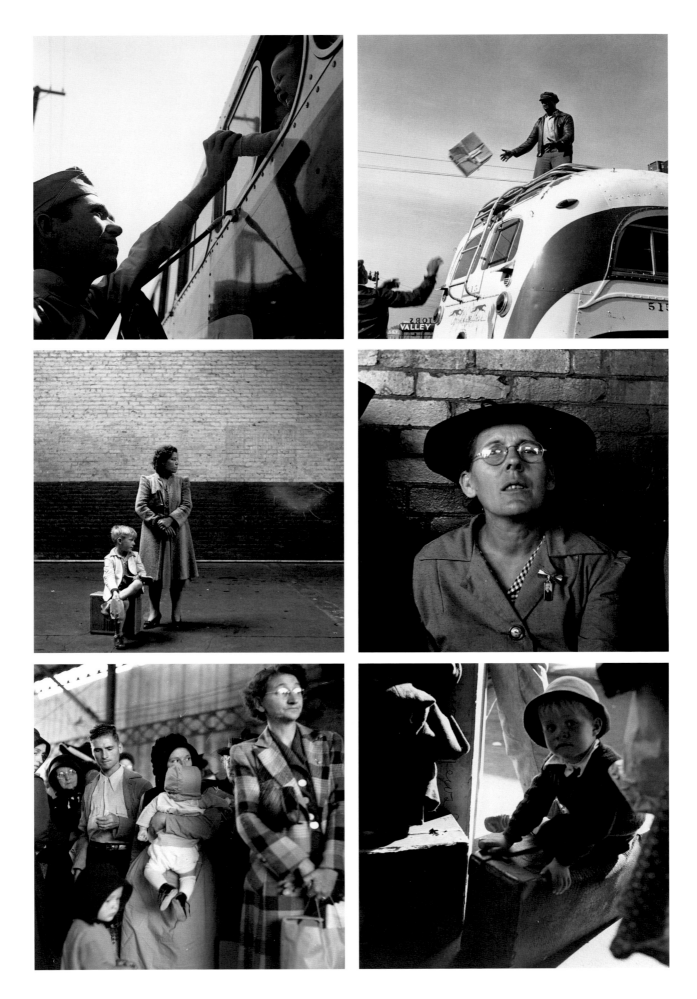

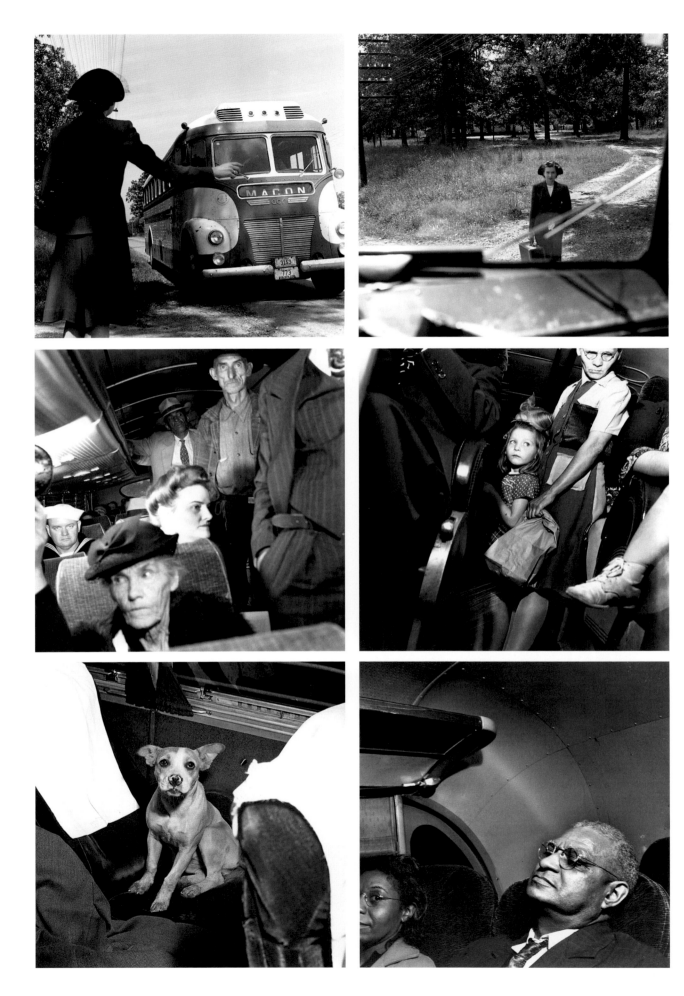

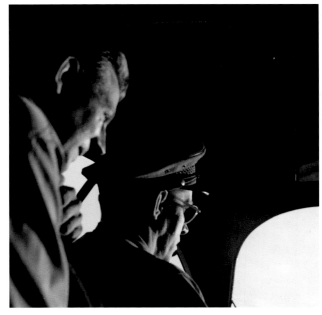

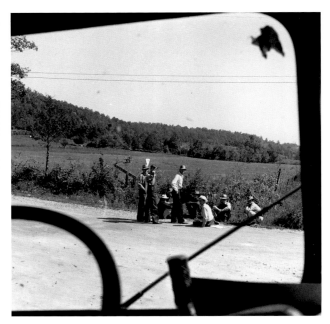

ESTHER BUBLEY

p. 335
Esther Bubley, FSA-OWI photographer, Bayway, New Jersey, 1944. Photograph by Gordon Parks

p. 337 top left
Cincinnati (vicinity), Ohio. The ticket agent of a small town.
SEPTEMBER 1943 8d33125

p. 337 top right
Indianapolis, Indiana. A soldier and a girl saying goodbye at the Greyhound bus station.
SEPTEMBER 1943 8d33268

p. 337 center left
Cincinnati, Ohio. Passengers boarding a Greyhound bus at the bus terminal.
SEPTEMBER 1943 8d33172

p. 337 center right
Bus trip from Knoxville, Tennessee, to Washington, D.C. People getting on the bus at Roanoke, Virginia.
SEPTEMBER 1943 8d33506

p. 337 bottom left
A Greyhound bus trip from Louisville, Kentucky, to Memphis, Tennessee, and the terminals.
SEPTEMBER 1943 8d33447

p. 337 bottom right
Bus trip from Knoxville, Tennessee, to Washington, D.C. A Trailways bus driver calling his own bus. There is no official starter at Knoxville to do this.
SEPTEMBER 1943 8d33465

p. 338 top left
Bus trip from Knoxville, Tennessee, to Washington, D.C.
SEPTEMBER 1943 8d33471

p. 338 top right
A Greyhound bus trip from Louisville, Kentucky, to Memphis, Tennessee, and the terminals.
SEPTEMBER 1943 8d33330

p. 338 center left
Bus trip from Knoxville, Tennessee, to Washington, D.C.
SEPTEMBER 1943 8d33509

p. 338 center right
A Greyhound bus trip from Louisville, Kentucky, to Memphis, Tennessee, and the terminals.
SEPTEMBER 1943 8d33345

p. 338 bottom left
Indianapolis, Indiana. Bus passengers in the Greyhound terminal.
SEPTEMBER 1943 8d33226

p. 338 bottom right
A Greyhound bus trip from Louisville, Kentucky, to Memphis, Tennessee, and the terminals. Small boy waiting for the bus at Chattanooga.
SEPTEMBER 1943 8d33325

p. 339 top left
A Greyhound bus trip from Louisville, Kentucky, to Memphis, Tennessee, and the terminals. Hailing a Macon-bound bus on the highway in Georgia.
SEPTEMBER 1943 8d33361

p. 339 top right
A Greyhound bus trip from Louisville, Kentucky, to Memphis, Tennessee, and the terminals. Girl waiting for bus by road's edge.
SEPTEMBER 1943 8d33359

p. 339 center left
A Greyhound bus trip from Louisville, Kentucky, to Memphis, Tennessee, and the terminals. Passengers standing in aisles on Memphis-Chattanooga Greyhound bus.
SEPTEMBER 1943 8d33439

p. 339 center right
Passengers standing in the aisle of a Greyhound bus going from Washington, D.C., to Pittsburgh, Pennsylvania.
SEPTEMBER 1943 8d32781

p. 339 bottom left
A dog that wandered through the open door of a Greyhound bus at a rest stop between Cincinnati, Ohio, and Chicago, Illinois. A passenger declined to share his seat with the dog and ejected him.
SEPTEMBER 1943 8d33199

p. 339 bottom right
A Greyhound bus trip from Louisville, Kentucky, to Memphis, Tennessee, and the terminals. Colored passenger on Louisville-Nashville bus.
SEPTEMBER 1943 8d33411

p. 340 top left
Bus driver and passenger en route from Columbus to Cincinnati, Ohio.
SEPTEMBER 1943 8d33089

p. 340 top right
A Greyhound bus trip from Louisville, Kentucky, to Memphis, Tennessee, and the terminals. Men sitting by roadside on Sunday afternoon, between Memphis and Chattanooga.
SEPTEMBER 1943 8d33416

p. 340 center left
Passengers who have struck up a friendship on a Greyhound bus en route from Pittsburgh, Pennsylvania, to St. Louis, Missouri, telling "moron" jokes.
SEPTEMBER 1943 8d33183

p. 340 center right
Indianapolis, Indiana. The waiting room of the Greyhound bus terminal at 5:30 a.m.
SEPTEMBER 1943 8d33249

p. 340 bottom left
A Greyhound bus trip from Louisville, Kentucky, to Memphis, Tennessee, and the terminals. This girl commutes daily to Memphis, where she goes to school.
SEPTEMBER 1943 8d33398

p. 340 bottom right
Passengers waiting for a Greyhound bus driver to start loading them on the bus at a small town in Pennsylvania.
SEPTEMBER 1943 8d32748

ESTHER BUBLEY

p. 343
Washington, D.C. Those who
are not too modest save time
by tripling up in the use of the
boardinghouse bathroom.
JANUARY 1943 8d33592

p. 344
Glen Echo, Maryland. Sailors at the
amusement park.
MARCH 1943 8d28123

p. 345
Washington, D.C. Jitterbugs at
an Elks Club dance, the "cleanest
dance in town."
APRIL 1943 8d28277

p. 346 top
Glen Echo, Maryland. Sun bathers
on the sand beach at the swimming
pool in the Glen Echo amusement
park. [The photographer's sisters
are pictured, Claire in the
foreground and Enid beside her.]
JULY 1943 8d32375

p. 346 bottom
Glen Echo, Maryland. Bathers at
Glen Echo swimming pool. [Enid
Bubley and her future husband,
Milton Raines.—B.W.B.]
JULY 1943 8d32353

1960s–80s Photographs in New York City.
1995 Publication of *Charlie Parker,* with text by Hank O'Neal and photos by Esther Bubley.
1998 Dies of cancer in New York.

JOHN COLLIER JR. (1913–1992)

1913 Born Sparkill, New York, to family of political activists. Spends childhood at Mabel Dodge Luhan's Taos, New Mexico, salon for avant-garde artists; also in Mill Valley, California.
1920 A sledding accident causes undiagnosed vision, hearing, and speech injuries.
1925 Apprentices to artist Maynard Dixon and his wife, photographer Dorothea Lange, in San Francisco. Lange addresses his learning difficulties.
1930 Sails as yeoman on a four-mast bark to Europe.
1930s Trains at California School of Fine Arts; works as photographer in San Francisco.
1933–45 Collier's father serves as U.S. Commissioner of Indian Affairs.
1941–43 Works as photographer for Roy Stryker at FSA and OWI.
1946 Photographs Indians of Otovalo, Ecuador, with anthropologist Anibal Buitron. Works as freelance photographer.
1948 Photographs Navajos.
1950s Works at Cornell University's anthropology department on photographic projects and researches the educational use of photographs and film.
1952–53 Photographs Navajos in Fruitland, New Mexico.
1958–90 Teaches photography at the California School of Fine Arts (San Francisco Art Institute).
1961–83 Teaches in the anthropology department of San Francisco State University; is named full professor.
1967 Publishes *Visual Anthropology: Photography as a Research Method.*
1990 Retires from teaching.
1992 Dies in San Jose, Costa Rica, and is buried in California.

MARJORY COLLINS (1912–1985)

1912 Born in New York City. Graduates from Brearley School, New York City.
1929 Freshman at Sweet Briar [Women's] College, Sweet Briar, Virginia.
1930 Makes her social debut, New York City.
1931 Announces her engagement to art historian John "Jack" Baur.

1935 Divorces Baur.
1935–40 Studies photography informally with Ralph Steiner; attends Photo League lectures.
1940–41 Works on staff at *PM* and *US Camera* magazines.
1941 In November takes job at the New York office of the Foreign Service, U.S. Office of War Information.
1942 Transfers in January to Washington, D.C., to do news photography for Roy Stryker. Makes "hyphenated Americans" series for Foreign Information Services, OWI.
1943 Makes "Rosie the Riveter" series in Buffalo, New York.
1944–45 Freelances in Alaska. Marries and divorces.
1946–48 Freelances in Egypt, Ireland, Ethiopia, Kenya, Rwanda, and Italy.
1948–50 Marries and divorces John Preston.
1950s–80s Settles in Vermont and freelances.
1962 Begins *Peace Concern* magazine.
1971–76 Publishes *Prime Time* magazine.
1984 Earns a master's degree in American Studies, Antioch College West, San Francisco.
1985 Dies of cancer in San Francisco.

JACK DELANO (1914–1997)

1914 Born Jacob Ovcharov in Voroshilovka, Ukraine, on August 1.
1923 After a short stay in New York, arrives with family in Pennsylvania.
1932–36 Attends Pennsylvania Academy of the Fine Arts.
1935 Tours art capitals of Europe for four months.
1936 Experiments with changing his name to the easily pronounced "Jack Delano."
1938 Photographs Pottsville, Pennsylvania, a coal mining town employing illegal workers, on a WPA grant.
1939 Applies to Roy Stryker for job, but none is available.
1940–41 Legally changes his name. Stryker hires him to replace Arthur Rothstein, who left for *Look* magazine. Marries Irene Esser. Photographs in the Northeast from August through February.
1941 Photographs in Greene County, Georgia, in February. In December arrives in Puerto Rico; photographs there and in St. Croix, Virgin Islands.
1942 In March returns to U.S. mainland. Photographs rail transportation for OWI.

CHRONOLOGIES

ESTHER BUBLEY (1921–1998)

1921 Born in Phillips, Wisconsin, to Russian Jewish immigrants. After attending Superior State Teachers College, takes a yearlong photography course at Minneapolis College of Art.
1940s–1972 Freelances for *Life* until it ceases publication.
1941 Moves to New York and briefly photographs for *Vogue.* Moves to Washington, D.C., looking for work.
1942 Makes microfilms for the National Archives.
1942–43 Works as a lab technician in the FSA darkroom.
1943 Is made an OWI staff photographer. Follows Stryker to Standard Oil of New Jersey. Wins Art Director's Club award.
1944–50 Freelances for Stryker at Standard Oil.
1945 Photographs in Tomball, Texas.
1947–65 Photographs freelance for other publications, including "How America Lives" for *Ladies' Home Journal.*
1953 Photographs in Morocco for UNICEF.
1956 First solo show, at Limelight Gallery, New York.

1943–46 Serves in U.S. Army as photographer and filmmaker in the Pacific and South America.
1945 Receives Guggenheim Foundation Grant to photograph in Puerto Rico.
1946 Returns to Puerto Rico to photograph; turns to filmmaking.
1950s Works as a freelance filmmaker.
1954 Birth of son, Pablo.
1958 Birth of daughter, Laura.
1960s Creates and administers public television for Puerto Rico.
1979 Receives Puerto Rico Foundation for the Humanities grant to prepare the exhibition "Contrasts: 40 Years of Change and Continuity in Puerto Rico."
1982 Death of wife, Irene.
1990 Publication of *Puerto Rico Mio: Four Decades of Change.*
1997 Publishes autobiography, *Photographic Memories.* Dies in Puerto Rico.

WALKER EVANS (1903–1975)

1903 Born into a financially comfortable family, St. Louis.
1908 Family moves to Chicago.
1919–25 Attends a series of private high schools and completes two years at Williams College. Spends one year working at New York Stock Exchange and New York Public Library.
1926–28 In Paris, tries writing and observes avant-garde life from the sidelines. Returns to New York with a new perspective. Becomes interested in photography.
1929 Meets Ben Shahn.
1933 Photographs on location for *The Crime of Cuba.* Begins publishing photos in artistic journals, including *Hound and Horn, The Architectural Record,* and *Creative Art.*
1935–37 Works as an information specialist for the RA; transfers to Historical Section. Photographs in West Virginia, Pennsylvania, Louisiana, Mississippi, Georgia, South Carolina, Alabama, Arkansas, and Tennessee.
1936 On sabbatical from RA, photographs Hale County, Alabama, with the writer James Agee of *Fortune.*
1938 Exhibition of "American Photographs," Museum of Modern Art (MoMA), New York.
1940 Receives Guggenheim fellowship, which is renewed in 1941.
1941 Publishes with Agee *Let Us Now Praise Famous Men,* a portrait of Southern

sharecroppers and their families, a classic today. Photographs in Florida for Karl Bickel's history, *The Mangrove Coast.* Marries Jane Smith Ninas, whom he divorces in 1956.
1943–65 Writes film criticism for *Time* for two years during World War II; transfers to *Fortune* as its first staff photographer.
1960 Marries Isabelle Boeschenstein, whom he divorces in 1971.
1964 Exhibition of *Fortune* photographs at Art Institute of Chicago.
1964–71 Is visiting professor of photography, Yale University.
1966 Publishes *Many Are Called,* his 1938 portraits of travelers unaware of his hidden camera. Publishes *Message from the Interior,* photographs of familiar places.
1971 Retrospective is held at MoMA.
1973 Revisits Hale County, Alabama, with artist William Christenberry in October. Library of Congress publishes *Walker Evans: Photographs for the Farm Security Administration.*
1974–75 Sells his collection of negatives for $150,000.
1975 Dies of stroke on April 10, New Haven, Connecticut.

THEODOR JUNG (1906–1986)

1906 Born in Vienna May 29.
1912 Leaves with his grandmother to join his mother and stepfather in the U.S.
1916 Acquires his first camera.
1920s Studies history, English literature, and book design in Chicago. Works as graphic designer for the *Chicago Times.*
1932 Loses his newspaper job.
1933 Returns in January to Vienna; attends lectures in lithography and printing graphics. Alarmed by Hitler's speeches, moves to Washington, D.C., in autumn.
1934 In February is hired by Federal Emergency Relief Administration (later the Works Progress Administration, or WPA) to draft statistical maps of unemployment's spread.
1935–36 Works in an educational unit of the Agricultural Adjustment Administration, "doing graphics, designing booklets, doing layouts, things of that nature." Roy Stryker hires him as photographer and designer of books and exhibitions. Photographs in Maryland, Ohio, and Indiana. Stryker fires him.
1937 Photographs for the *Consumers' Council*; serves as art director for the *Consumer's Guide.*

1940–43 Illustrates books for the War Food Administration. Photographs in Harper's Ferry, West Virginia.
1944 In autumn, settles in Denver. Works for advertising agency and designs books for the University of Colorado.
1955 Settles in Norman, Oklahoma. Works as book designer. Later serves as managing director, University of Oklahoma Press.
1958 Returns to Denver to work for Lowry Air Force Base. Freelances as book designer for University of California Press.
1960 In December, settles in San Francisco. Works for San Francisco Public Library.
1966–71 Works as book illustrator and designer in the publications department of Stanford University, Palo Alto, California.
1986 Dies in a Palo Alto retirement home.

DOROTHEA LANGE (1895–1965)

1895 Born to a middle-class family, Hoboken, New Jersey.
1913 Graduates from high school in New York.
1913–14 Trains to be a teacher at Teachers College, New York; studies photography there with Clarence White.
1914–15 Works in various photography studios, including Arnold Genthe's.
1918 Drops her father's surname (Nutzhorn) in favor of her mother's maiden name (Lange). Leaves for world tour, but all her money is stolen during her first stop, in San Francisco.
1919 Operates portrait studio.
1920 Marries Maynard Dixon, a bohemian type and a western regional painter.
1925 Son Daniel is born.
1928 Son John is born.
1929 In a New Mexico snowstorm, Lange experiences an epiphany that shapes her new direction in photography.
1932–33 Abandons family portrait studio for street photography.
1934 Meets Paul Schuster Taylor, professor of economics at University of California—Berkeley.
1935 Divorces Maynard Dixon; marries Paul Taylor. Passing as a typist, works as photographer for California's State Emergency Relief Administration (SERA), Division of Rural Rehabilitation. Taylor and Lange's SERA report reaches Stryker in Washington. Stryker hires Lange as photographer for the RA.

1936 In February photographs "The Migrant Mother" at Nipomo, California. Stryker fires her, due a shortage of funds.
1937 Stryker rehires her.
1939 With Taylor, publishes *An American Exodus*. Rejoins the FSA.
1942 Photographs Japanese internment camps with Ansel Adams for the War Relocation Authority.
1940s–1953 Nursing her health, she remains at home and travels with her husband.
1953 Photographs Utah's Mormons with Ansel Adams.
1954 Photographs in Ireland for *Life* magazine. The images are published in 1996 as *Dorothea Lange's Ireland*.
1955–57 Photographs "The Young District Attorney."
1950s–60s Photographs while traveling with her husband on agricultural consultancies.
1965 Prepares with curator John Sarkowsky a retrospective at MoMA. Dies of cancer in San Francisco.
1966 Retrospective exhibition at MoMA.

RUSSELL LEE (1903–1986)

1903 Born in Illinois.
1925 Graduates from Lehigh University, in Pennsylvania, with a degree in chemical engineering.
1925–29 Works at Certainteed Products Company in Illinois.
1927 Marries painter Doris Emrick.
1930 Lives in San Francisco.
1931–35 Lives in New York; studies at the Art Students League.
1935–36 Encouraged by Ben Shahn, pursues photography. In October 1936 he replaces Carl Mydans (who left for *Life*) as photographer for the RA.
1937 Chooses RA-FSA job over marriage to Doris.
1938 Takes up with Jean Smith. Photographs greenbelt towns and farms in southeast Missouri.
1939 Photographs in San Augustine, Texas. Divorces Doris and marries Jean.
1940 Photographs in Pie Town, New Mexico.
1941 Photographs West Coast war preparations.
1942 Resigns from the FSA.
1943–45 Serves as reconnaissance photographer for the Air Transport Command Overseas Technical Unit under Edward Steichen.

1946–47 Works for the Coal Mines Administration.
1947–mid-1950s Works for Standard Oil of New Jersey/Aramco.
1947–65 Photographs in Texas.
1960 Photographs in Italy.
1965–73 Teaches photography at University of Texas—Austin.
1986 Dies of cancer in Texas August 28.

CARL MYDANS (1907–2004)

1907 Born in Boston on November 30; grows up in Medford, Massachusetts. Through high school and college, sells articles to newspapers in Medford and Boston.
1930 Earns a bachelor's degree from Boston University School of Journalism. Sells articles to newspapers in New York City; works as reporter for *American Banker*. Studies photography.
1935–36 Works as photographer for RA's housing authority; transfers to Stryker's section. Uses his own 35mm roll-film camera, then called the "miniature," which would soon replace photojournalists' sheet-film cameras.
1936–71 Photographs for *Life* magazine.
1937–38 Travels throughout the U.S. on "soft assignments."
1939 Marries *Life* reporter Shelley Smith. The Mydanses work as a team overseas.
1941 They are sent to China to cover Sino-Japanese War.
1942 They are POWs in Japanese camps, first in Manila, then in Shanghai.
1943 Released, they return to the U.S.
1944 Carl covers World War II's Italian and French campaigns.
1945 Carl photographs General Douglas MacArthur retaking the Philippines.
1959 Publishes *More Than Meets the Eye*; moves family to Moscow.
1968 Reports on Vietnamese refugees. With Shelley, publishes *A Violent Peace*.
1969 Moves family to Japan.
1979 Publication of *China, A Visual Adventure*.
1985 Publication of *Carl Mydans: Photojournalist*.
2002 Shelley Mydans dies, Berkeley, California.
2004 Carl Mydans dies, Larchmont, New York.

GORDON PARKS (1912–2006)

1912 Born November 30, Fort Scott, Kansas.
1928–33 After his mother's death, he joins his sister's family in St. Paul, Minnesota; becomes homeless after disagreements with his brother-in-law. Attends high school until the stock market crashes in 1929. Works as piano player and busboy.
1933 Joins Civilian Conservation Corps in New York; works as a waiter in Chicago.
1933–61 Married to Sally Alvis, with whom he has three children: Gordon Parks Jr. (dies in a 1979 plane crash), Toni Parks Parson, and David Parks.
1935–41 Works as pianist and waiter on the railway. Buys first camera; photographs Chicago slums during train layovers. Relocates to Chicago; photographs fashion, high society, and slums.
1941 Receives the first Julius Rosenwald Fellowship granted to a photographer.
1942 Moves his family to Washington, D.C. Apprentices with Roy Stryker at FSA.
1943 Photographs for the OWI at Tuskegee, Alabama; photographs the 332nd Fighter Group, the first black air corps.
1944 Settles in New York City to be fashion photographer at *Glamour*, then *Vogue*. Freelances for Stryker's project at Standard Oil New Jersey.
1948–72 Photographs for *Life*.
1950 Based in Paris, is European correspondent for *Life*.
1962–73 Married to Elizabeth Campbell, with whom he has a daughter, Leslie Parks.
1963 Publishes fictionalized autobiography, *The Learning Tree*.
1966 Publishes first volume of his autobiography, *Choice of Weapons*, dedicated to Roy Stryker.
1971–72 His films *Shaft* and *Shaft's Big Score* are released.
1973–79 Married to Genevieve Young.
1973 His film *The Learning Tree* is released.
1979 Publishes second volume of his autobiography, *To Smile in Autumn*, covering 1944–78.
1990 Publishes a more extensive autobiography, *Voices in the Mirror*. Lives in New York.
2006 Dies in March in New York.

MARION POST WOLCOTT (1910–1990)

1910 Born in New Jersey; her father is a homeopathic physician.

1924 Her parents divorce.

1925 She and her sister attend boarding school.

1920s Spends weekends with her mother in Greenwich Village, moving in avant-garde circles.

1930s Studies modern dance in France and Austria; with her sister studies photography with Trude Fleischmann in Vienna. Teaches at progressive schools for the children of Jewish workers in Austria. Returns to U.S.; supports herself by teaching at a progressive school in a New York suburb.

1935–36 Lives in the compound of the Group Theater, a realist troupe.

1937 Serves as still photographer for Frontier Films, the antifascist, prolabor film company operated by Paul Strand, Ralph Steiner, and Elia Kazan.

1937–38 Photographs for the *Philadelphia Evening Bulletin*.

1938–42 Hired by Roy Stryker; photographs the southeastern United States, Vermont, and the West.

1941 Marries Lee Wolcott in June; resigns from the FSA eight months later.

1940s–60s Photographs her children and stepchildren and her travels, as a hobby.

1976 FSA exhibit at Witkin Gallery in New York brings her renewed attention.

1980s Lives in Santa Barbara, California.

1985 Receives the Dorothea Lange Award from the Oakland (California) Museum.

1986 Receives the Distinguished Photographer Award from the Women Photographers of America.

1989 Jack Hurley publishes *Marion Post Wolcott: A Photographic Journey*.

1990 Retrospective exhibition at International Center of Photography. Dies of cancer in California.

1992 Paul Hendrickson publishes *Looking for the Light: The Hidden Life and Art of Marion Post Wolcott*.

EDWIN ROSSKAM (1903–1985)

1903 Born in Munich on March 15 to American father and German mother.

1914–18 Is detained in Germany during World War I.

1919 Immigrates to U.S. Attends Haverford College and Pennsylvania Academy of Fine Arts.

c. 1924–29 Lives in Paris and Polynesia. Paints, learns photography, moves in avant-garde circles. Writes articles about Tahiti, illustrated by his photographs, for European magazines.

early 1930s Moves to Greenwich Village. Meets Louise Rosenbaum. Frequents the Photo League and other leftist artist organizations.

1936–37 Marries Louise; together they photograph for the *Philadelphia Record*.

1937–38 With Louise photographs Puerto Rico for *Life* (work never published).

1938–40 Editor of Alliance Book Corporation. Collaborates with Louise on documentary books: *San Francisco: West Coast Metropolis* and *Washington Nerve Center*.

1939–43 Is photo editor and visual information specialist for FSA-OWI.

1940 Collaborates with Sherwood Anderson on *Home Town*. Publishes *As Long as the Grass Shall Grow: Indians Today*.

1941 Collaborates with Richard Wright on *Twelve Million Black Voices: A Folk History of the Negro in the United States*.

1943–46 With Louise photographs oil workers for Standard Oil of New Jersey.

1945–53 Directs a photography project inspired by the FSA-OWI for the Puerto Rico Office of Information. Assists Governor Luis Muñoz Marín and Jack Delano in establishing Division of Community Education. Birth of his two daughters.

1948 Publishes with Louise *Towboat River*, based on their experiences on riverboats on the Mississippi and Ohio rivers.

1953 Settles in the New Deal town of Roosevelt, New Jersey. Photographs landscapes, paints, and returns to writing.

1964 Publishes novel *The Alien*.

1967–68 With Louise photographs children at Cranbury Migrant School for the New Jersey Education Program for Seasonal and Migrant Workers.

1972 With Louise publishes *Roosevelt, New Jersey: Big Dreams in a Small Town and What Time Did to Them*.

1983 Is included in book *Roy Stryker: U.S.A.: 1943–1951*.

1985 Dies of cancer in New Jersey.

1990 The Rosskams' photography is exhibited at Comfort Gallery, Haverford College.

2002 Is included in book *Long Time Coming: Portrait of America, 1935–1943*.

2003 Is featured in book *Bronzeville: Black Chicago in Pictures* and the associated exhibition organized by the International Center for Photography, New York.

LOUISE ROSSKAM (1910–2003)

1910 Birth of Leah Louise Rosenbaum in Philadelphia March 29 to a well-to-do, assimilated Hungarian Jewish family.

c. 1932–35 Receives degree in biology from the University of Pennsylvania. After graduation, works as research scientist in genetics. Trains as teacher in a progressive day school. Meets writer and artist Edwin Rosskam. Moves in leftist artist circles in Greenwich Village.

1936–37 Marries Edwin. Together they photograph for the *Philadelphia Record*.

1937–38 Photographs with Edwin in Puerto Rico for *Life* (works never published).

1938–39 Collaborates with Edwin on documentary books: *San Francisco: West Coast Metropolis* and *Washington Nerve Center*.

c. 1939–43 Works as freelance photographer for magazines. Makes photo albums of children for their families. Photographs her neighborhood in Washington, D.C.

1940 On a summer exchange project, photographs Vermont's small towns and countryside. Roy Stryker will claim the Vermont and Washington pictures for the FSA-OWI.

1943 Photographs victory gardens in Washington for the OWI.

1943–46 With Edwin photographs oil workers for Standard Oil of New Jersey.

1945–53 Photographs social conditions for the Puerto Rico Office of Information, which is directed by Edwin. Photographs political activities of the island's governor, Luis Muñoz Marín. Birth of two daughters.

1948 Publishes with Edwin *Towboat River*, based on their experiences on riverboats on the Mississippi and Ohio rivers.

1953 Settles in New Deal town of Roosevelt, New Jersey.

1967–68 With Edwin photographs children at Cranbury Migrant School for the New Jersey Education Program for Seasonal and Migrant Workers.

1972 With Edwin publishes *Roosevelt, New Jersey: Big Dreams in a Small Town and What Time Did to Them*.

1983 Is included in book *Roy Stryker: U.S.A.: 1943–1951*.

1985 Edwin dies of cancer.
1987 Is included in book *Let Us Now Praise Famous Women: Women Photographers for the U.S. Government, 1935–1944*.
1985–90 With grant from New Jersey Historical Commission (New Jersey Council on the Humanities), photographs dilapidated barns on abandoned farms in central New Jersey.
1990 Exhibition of the Rosskams' photography at Comfort Gallery, Haverford College.
1996–2003 Provides oral histories to scholars of documentary photography, some sponsored by Library of Congress's Center for the Book.
2002 Retrospective "A Life in Photography: Louise Rosskam and the Documentary Tradition" is mounted by Maier Museum of Art, Randolph-Macon Woman's College, which also publishes an exhibition catalogue.
2002–4 Exhibition "Barnscapes: The Changing Face of Agriculture in New Jersey" at New Jersey Museum of Agriculture and Montclair Historical Society.
2003 Dies of heart failure April 1.
2005 Retrospective "A Life in Photography" mounted at Center for Documentary Studies, Duke University.

ARTHUR ROTHSTEIN (1915–1985)

1915 Born in New York to Latvian immigrants.
1931–35 Attends Columbia University.
1934–35 For a National Youth Project organized by Roy Stryker, helps create a visual record of American agriculture.
1935 Goes to Washington, D.C.; sets up the darkrooms for Stryker. Becomes involved in field photography.
1936 Photographs the Dust Bowl.
1940 Works for *Look* magazine.
1943–46 Serves as photography officer, U.S. Signal Corps in China, Burma, and India.
1946 Is chief photographer for the United Nations Relief and Rehabilitation Administration in China.
1946–71 Photographs for *Look* until it ceases publication in 1971. Mentors Stanley Kubrick, Chester Higgins, and many others.
1947 Marries Grace Goodman, with whom he has four children.

1956 Publishes *Photojournalism: Pictures for Magazines and Newspapers*.
1961–71 Is adjunct faculty member of Columbia University's Graduate School of Journalism and Syracuse University's Newhouse School of Communication.
1963 Publishes *Creative Color in Photography*.
1967 Publishes with William Saroyan *Look At Us; Let's See; Here We Are; Look Hard, Speak Soft; I See, You See, We All See; Stop, Look, Listen; Beholder's Eye; Don't Look Now, But Isn't That You? (Us? U.S.?)*.
1970 Publishes *Color Photography Now*.
1971–72 Editor of *Infinity* magazine.
1972–85 Associate editor, then director of photography, for *Parade* magazine.
1978–84 Publishes three books of his photography with Dover Publications.
1979 Publishes *Arthur Rothstein: Words and Pictures*.
1985 Dies of cancer, New Rochelle, New York.
1986 Posthumous publication of *Documentary Photography*.

BEN SHAHN (1898–1969)

1898 Born September 12 in Kaunas, Lithuania, to an Orthodox Jewish family. Father is a skilled craftsman and anti-czarist activist.
1906 Family immigrates to New York. Grows up in Brooklyn.
1913 Interrupts his education to support family as a lithographer.
c. 1916–21 Studies at the Art Students League, New York University, City College of New York, and the National Academy of Design.
1922 Marries Tillie Goldstein.
1925–29 Travels to North Africa, Italy, Austria, France, and Spain.
c. 1931–36 Meets Walker Evans, with whom he spends time on Cape Cod and shares a studio in Greenwich Village. Evans introduces him to the Leica camera. Extensively photographs the streets of New York.
1932 Exhibits his series on Sacco and Vanzetti at Edith Halpert's Downtown Gallery.
1932–42 Assists Diego Rivera on ill-fated Rockefeller Center Mural. Meets Bernarda Bryson in Artist Union circles.
1934 Collaborates with Lou Block on ill-fated Riker's Island Penitentiary mural. Photographs prisoners in New York correctional facilities.

1935–38 Separates from Tillie and their two children. Works as graphic designer and photographer for RA and FSA. Travels throughout the South and Midwest with Bryson.
1937–38 Works on a mural in a school in the New Deal town Jersey Homesteads (later Roosevelt), New Jersey.
1938–39 Works on a mural for the Bronx (N.Y.) Post Office. Moves with Bryson to Jersey Homesteads, where they raise three children.
1940–42 Works on mural "The Meaning of Social Security," in Washington, D.C.
1942–43 Designs posters for the OWI.
1944–46 Designs posters for the Congress of Industrial Organizations (CIO).
1947 First major retrospective at the Museum of Modern Art, New York.
1948 Works on Henry Wallace's Progressive Party campaign.
1951 Teaches at Black Mountain College. First biography of Shahn is published: *Portrait of an Artist as an American*.
1956–57 Is Charles Eliot Norton Professor of Poetry at Harvard University. His lectures are published as *The Shape of Content*.
1959 Questioned by the House Un-American Activities Committee.
1967 Marries Bernarda Bryson.
1969 Dies of a heart attack March 14. Exhibition "Ben Shahn as Photographer" opens at the Fogg Art Museum.
1970 Bernarda Bryson Shahn donates Shahn's photographs to the Fogg Art Museum.
1975 *The Photographic Eye of Ben Shahn* is published.
1976–77 Retrospective exhibition at the Jewish Museum, New York.
1989 Publication of *Ben Shahn: New Deal Artist in a Cold War Climate, 1947–1954*.
1998 Publication of *Common Man, Mythic Vision: The Paintings of Ben Shahn* and *Ben Shahn: An Artist's Life*.
1999 Dolores Taller donates the Stephen Lee Taller Ben Shahn Archive to Harvard University.
2000–2001 Publication of *Ben Shahn's New York: The Photography of Modern Times* in conjunction with major traveling exhibition organized by the Harvard University Art Museums.

ROY STRYKER (1893–1975)

1893 Born Montrose, Colorado.

1912–13 Attends mining school.

c. 1917–19 Serves in infantry in France in noncombat zones.

1921 Marries Alice Frasier.

1921–24 Completes Columbia University in three years.

1924 Attends Columbia for postgraduate studies in economics; is assistant to his professor, Rexford Tugwell.

1925 Publication of *American Economic Life*, with photos gathered by Stryker.

1934 Works during the summer for Tugwell at the Agricultural Adjustment Administration.

1935 Heads the RA's Historical Section.

1937 The project shifts to the FSA.

1942 The project shifts to the OWl.

1943–50 Heads Standard Oil of New Jersey's photographic project.

1950–53 Heads Pittsburgh photographic project.

mid-1950s Heads Jones and Laughlin Steel Corporation photographic project.

1950s–60s Serves as a consultant. Retires to Colorado.

1973 Publishes with Nancy C. Wood *In This Proud Land: America, 1935–1943, As Seen in the FSA Photographs.*

1975 Dies in Colorado September 26.

JOHN VACHON (1914–1975)

1914 Born in St. Paul, Minnesota.

1935 Graduates from St. Thomas College, Minnesota. Goes to Washington, D.C., to pursue graduate studies in English literature at Catholic University.

1936 Leaves the university. Stryker hires him to do clerical work for the RA; his first title is "assistant messenger." He meets his future wife, Penny.

1937 Begins using a camera, photographs extensively in the Washington area, and develops a sense of documentary photography.

1938 Stryker gives him his first photographic assignments. Travels to Nebraska to photograph agricultural programs and the city of Omaha. Works with a Speed Graphic. Marries Penny.

1939 Birth of daughter Ann.

1939–43 The family lives in Greenbelt, Maryland.

1940–42 Works as junior photographer for the FSA. Photographs in North and South Dakota.

1941 Birth of son Brian.

1942–43 Is staff photographer for the OWl. Photographs in Montana and Minnesota.

1943 Works with Stryker on the project for Standard Oil of New Jersey. Stryker sends him on assignment to Venezuela.

1944 Drafted into U.S. Army; works in the Signal Corps.

1946 Birth of daughter Gail. Travels to Poland to document the United Nations' relief efforts; his work is published in 1995, *Poland, 1946: The Photographs and Letters of John Vachon.*

1947 Rejoins the Standard Oil project, photographing in North and South Dakota.

1948 Joins *Look* as staff photographer. Works for the magazine until it folds in 1971.

1960 Death of Penny Vachon.

1960 Marries Marie-Françoise Forrestier.

1961 Birth of daughter Christine.

1962 Birth of son Michael.

1971–75 Works as freelance photographer in New York.

1973 Receives a Guggenheim Fellowship to photograph in North Dakota.

1975 Dies of cancer in New York.

2003 Publication of *John Vachon's America: Photographs and Letters from the Depression to World War II.*

THE CHRONOLOGIES WERE PREPARED BY BEVERLY W. BRANNAN.

BIBLIOGRAPHY

GENERAL WORKS

• Bendavid-Val, Leah. *Propaganda and Dreams: Photographing the 1930s in the USSR and the USA.* Zurich and New York: Stemmle, 1999.

• Daniel, Pete, et al. *Official Images: New Deal Photography.* Washington, D.C.: Smithsonian Institution Press, 1987.

• Denning, Michael. *The Cultural Front: The Laboring of American Culture in the Twentieth Century.* New York: Verso, 1997.

• Finnegan, Cara A. *Picturing Poverty: Print Culture and FSA Photographs.* Washington, D.C.: Smithsonian Books, 2003.

• Fleischhauer, Carl, and Beverly W. Brannan, eds. *Documenting America, 1935–1943.* Berkeley: University Press of California in association with the Library of Congress, 1988.

• Guimond, James. *American Photography and the American Dream.* Chapel Hill and London: The University Press of North Carolina, 1991.

• Hurley, F. Jack. *Portrait of a Decade: Roy Stryker and the Development of Documentary Photography in the Thirties.*

Baton Rouge: Louisiana State University Press, 1972.

• Javitz, Romana. Interview with Richard K. Doud. New York, February 23, 1965. Archives of American Art, Smithsonian Institution, Washington, D.C. Microfilm.

• Keller, Ulrich. *The Highway as Habitat: A Roy Stryker Documentation.* Santa Barbara, Calif.: University Art Museum, 1986.

• Kennedy, David M. *Freedom From Fear: The American People in Depression and War, 1929–1945.* New York: Oxford University Press, 1999.

• Lesy, Michael. *Long Time Coming: A Photographic Portrait of America, 1935–1943.* New York: W.W. Norton and Co., 2002.

• MacLeish, Archibald. *Land of the Free.* New York: Harcourt, Brace and Co., 1938.

• McElvaine, Robert S. *The Great Depression, America, 1929–1941.* New York: Times Books, 1984.

• Meyerowitz, Joel, and Colin Westerbeck. *Bystander: A History of Street Photography with a New Afterword on Street Photography since the 1970s.* New York: Bulfinch, 2001.

• Nixon, Herman Clarence. *Forty Acres and Steel Mules.* Chapel Hill: University of North Carolina Press, 1938.

• O'Neal, Hank. *A Vision Shared: A Classic Portrait of America and Its People. 1935–1943.* New York: St. Martin's Press, 1976.

• Stange, Maren. *Symbols of Ideal Life: Social Documentary Photography in America, 1890–1950.* New York: Cambridge University Press, 1989.

• Stott, William. *Documentary Expression in Thirties America.* New York: Oxford University Press, 1973.

• Stryker, Roy E., and Nancy C. Wood. *In This Proud Land: America, 1935–1943, as Seen in the FSA Photographs.* New York: Galahad Books, 1973.

• *These Are Our Lives, as Told by the People and Written by Members of the Federal Writers' Project of the Works Progress Administration in North Carolina, Tennessee and Georgia.* Chapel Hill: The University of North Carolina Press, 1939.

ESTHER BUBLEY

• Brannan, Beverly W. "Private Eye: Esther Bubley." *Smithsonian Magazine,* March 2004. www.smithsonianmag.com/smithsonian/issues04/mar04/indelible.html.

• Brannan, Beverly W., and Kathy Ann Brown. Bubley included in Library of Congress exhibition "Women Come to the Front," www.loc.gov/exhibits/wcf/wcf0001.html.

• Brannan, Beverly W., Kathy Ann Brown, and April Watson. American Women Photojournalists website's section on Bubley, www.loc.gov/rr/print/coll/womphotoj/bubleyintro.html

• Bubley, Jean, and Bonnie Yochelson. *Esther Bubley on Assignment.* New York: Aperture, 2005.

• O'Neal, Hank. *Charlie Parker.* With photographs by Esther Bubley. Paris: Filipacchi, 1995. In French.

MARJORY COLLINS

• Collins, Marjory. Papers. Schlesinger Library, Harvard University, Cambridge, Mass.

• Parks, Gordon. *A Choice of Weapons.* New York: Harper and Row, 1966, pp. 234–37.

JOHN COLLIER JR.

• Adair, John, Kurt W. Deuschle, Clifford R. Barnett, et al. *People's Health: Medicine and Anthropology in a Navajo Community.* With photographs by John Collier Jr. Albuquerque: University of New Mexico Press, 1988.

• Collier, John, Jr. *Visual Anthropology: Photography as a Research Method.* New York: Holt, Rinehart and Winston, 1967.

• ———. Interview with Richard K. Doud. Sausalito, Calif., January 18, 1965. Archives of American Art, Smithsonian Institution, Washington, D.C. www.aaa.si.edu/collections/oralhistories/transcripts/collie65.htm

• Collier, John, Jr., and Anibal Buitron. *The Awakening Valley.* Chicago: University of Chicago Press, 1949.

• Doty, C. Stewart, Dale Sperry Mudge, and Herbert John Benally. *Photographing Navajos: John Collier, Jr. on the Reservation, 1948–1953.* With photographs by John Collier Jr. Albuquerque: University of New Mexico Press, 2002.

JACK DELANO

(as photographer only)

• Delano, Jack. Papers. Manuscript Division, Library of Congress, Washington, D.C.

• ———. LOT 13323, Prints and Photographs Division, Library of Congress, Washington, D.C. Photographs of bootleg anthracite coal miners and mining communities in Schuylkill County, Pennsylvania, including the towns of Pottsville, Minersville, Shenandoah, and Mahanoy City. Many photos of miners illegally working mines closed during the depression: views of coal mining and processing facilities. Two handmade spiralbound albums made by Delano in 1939. Photos taken for the WPA–Federal Art Project.

• ———. *Photographic Memories*. Washington, D.C.: Smithsonian Institution Press, 1997.

• Delano, Jack and Irene. Interview with Richard K. Doud. Rio Piedras, Puerto Rico, June 12, 1965. Archives of American Art, Smithsonian Institution, Washington, D.C. www.aaa.si.edu/collections/oralhistories/transcripts/delano65.htm

• Delano, Jack, Ronald E. Ostman, and Royal D. Colle. *Superfortress over Japan: Twenty-four Hours with a B-29*. Osceola, Wisc.: Motorbooks International, 1996.

• Valle, James E. *The Iron Horse at War: The United States Government's Photodocumentary Project on American Railroading during the Second World War*. With photographs by Jack Delano. Berkeley, Calif.: Howell-North Books, 1977.

WALKER EVANS

• Agee, James, and Walker Evans. *Let Us Now Praise Famous Men: Three Tenant Families*. Boston: Houghton Mifflin Co., 1941.

• Brannan, Beverly W., and Judith Keller. "Walker Evans: Two Albums in the Library of Congress." *History of Photography* (Washington, D.C.), 19, no. 1 (Spring 1995): 60–66.

• Evans, Walker. *American Photographs*. New York: Museum of Modern Art, 1938.

• ———. *Many Are Called*. Boston: Houghton Mifflin Co., 1966.

• ———. Papers. Metropolitan Museum of Art, New York.

• ———. *Walker Evans at Work*. New York: Harper and Row, 1982.

• Greenough, Sarah. *Walker Evans Subways and Streets*. Washington, D.C.: The National Gallery of Art, 1991.

• Keller, Judith. *Walker Evans: The Getty Museum Collection*. Malibu, Calif.: J. Paul Getty Museum, 1995.

• Mellow, James R. *Walker Evans*. New York: Basic Books, 1999.

• Mora, Gilles, and John Hill. *La Soif du Regard*. Paris: Seuil, 1993.

• Rathbone, Belinda. *Walker Evans: A Biography*. New York: Houghton Mifflin Co., 1995.

• Rosenheim, Jeff L. "Walker Evans and Jane Ninas in New Orleans, 1935–1936." New Orleans: Historic New Orleans Collection, 1991.

• *Walker Evans*. New York: The Museum of Modern Art, 1971.

THEODOR JUNG

• Auer, Anna. *Übersee Flucht und Emigration: österreichischer Fotografen, 1920–1940 = Exodus from Austria: Emigration of Austrian Photographers 1920–1940*. Vienna: Kunsthalle Wien, c. 1997.

• Jung, Theodor. Interview with Richard K. Doud. San Francisco, January 19, 1965. Archives of American Art, Smithsonian Institution, Washington, D.C. Microfilm.

DOROTHEA LANGE

• Borhan, Pierre, with essays by A. D. Coleman, Ralph Gibson, and Sam Stourdze. *Dorothea Lange: The Heart and Mind of a Photographer*. Boston: Little, Brown and Co., 2002.

• Brannan, Beverly W., and Kathy Ann Brown. Lange included in Library of Congress exhibition "Women Come to the Front," www.loc.gov/exhibits/wcf/wcf0001.html.

• Fulton, Marianne, ed. *Pictorialism into Modernism: The Clarence H. White School of Photography*. George Eastman House in Association with the Detroit Institute of Arts. New York: Rizzoli, 1996.

• Heyman, Therese Thau. *Celebrating a Collection: The Work of Dorothea Lange*. Oakland, Calif.: Oakland Museum, 1978.

• Lange, Dorothea. Interview with Richard K. Doud. New York, May 22, 1964. Archives of American Art, Smithsonian Institution, Washington, D.C. www.aaa.si.edu/collections/oralhistories/transcripts/lange64.htm

• ———. Papers. Oakland Museum of Art, Oakland, Calif.

• Meltzer, Milton. *Dorothea Lange: A Photographer's Life*. New York: Farrar, Straus, Giroux, 1978.

• Ohrn, Karin Becker. *Dorothea Lange and the Documentary Tradition*. Baton Rouge: Louisiana State University Press, 1960.

• Partridge, Elizabeth, ed. *Dorothea Lange: A Visual Life*. Washington, D.C.: Smithsonian Institution Press, 1994.

• ———, ed. *Restless Spirit: The Life and Work of Dorothea Lange*. New York: Viking, 1998.

• Taylor, Paul S., and Dorothea Lange. *An American Exodus: A Record of Human Erosion*. New York: Reynal and Hitchcock, 1939.

RUSSELL LEE

• Appel, Mary Jane. "Russell Werner Lee: The Man Who Made America's Portrait," in *Russell Lee: A Centenary Exhibition*, exhibition catalogue. San Marcos: Texas State University, 2003.

• Hurley, Jack. *Russell Lee, Photographer*. Dobbs Ferry, N.Y.: Morgan and Morgan, 1978.

• Lee, Russell. Interview with Richard K. Doud. Woodstock, N.Y., June 2, 1964. Archives of American Art, Smithsonian Institution, Washington, D.C. www.aaa.si.edu/collections/oralhistories/transcripts/lee64.htm

• ———. Papers. Texas State University, San Marcos.

• Wroth, William, ed. *Russell Lee's FSA Photographs of Chamisal and Penasco, New Mexico*. Santa Fe, N.M.: Ancient City Press, 1985.

CARL MYDANS

• Mydans, Carl. *Carl Mydans, Photojournalist*. New York: Harry N. Abrams, 1985.

• ———. Interview with Richard K. Doud. New York, April 29, 1964. Archives of American Art, Smithsonian Institution, Washington, D.C. Microfilm.

GORDON PARKS

(as photographer only)

• Parks, Gordon. *A Choice of Weapons*. New York: Harper and Row, 1966.

• ———. Interview with Richard K. Doud. New York, April 28, 1964. Archives of American Art, Smithsonian Institution, Washington, D.C. www.aaa.si.edu/collections/oralhistories/transcripts/parks64.htm

MARION POST WOLCOTT

- Hendrickson, Paul. *Looking for the Light: The Hidden Life and Art of Marion Post Wolcott.* New York: Alfred A. Knopf, 1992.
- Hurley, F. Jack. *Marion Post Wolcott: A Photographic Journey.* Albuquerque: University of New Mexico Press, 1989.
- Post Wolcott, Marion. Interview with Richard K. Doud. Mill Valley, Calif., January 18, 1965. Archives of American Art, Smithsonian Institution, Washington, D.C. www.aaa.si.edu/collections/oralhistories/transcripts/wolcot65.htm.
- ———. Papers. Center for Creative Photography, Tucson, Ariz.
- Stein, Sally. *Introduction to Marion Post Wolcott: FSA Photographs.* Carmel, Calif.: Friends of Photography, 1983.

EDWIN ROSSKAM

- Rosskam, Edwin. Interview with Richard K. Doud. Roosevelt, N.J., August 3, 1965. Archives of American Art, Smithsonian Institution, Washington, D.C. www.aaa.si.edu/collections/oralhistories/transcripts/rosska65.htm.
- ———. "The making of a mural." [Handmade photobook presented by photographer-editor Edwin Rosskam to his mother, Christmas, 1942. Shows preparation of giant photomontage in Grand Central Station, New York, at the beginning of World War II.] Accession no. PR 13 CN 1996:043, Prints and Photographs Division, Library of Congress, Washington, D.C.
- ———. *Roosevelt, New Jersey: Big Dreams in a Small Town and What Time Did to Them.* New York: Grossman, 1972.
- Rosskam, Edwin, and Louise Rosskam. *Towboat River.* New York: Duell, Sloan and Pearce, 1948.
- Saretzky, Gary. "Documenting Diversity: Edwin Rosskam and the Photo Book, 1940–41." *The Photo Review,* vol. 23, no. 4 (Fall 2000).
- ———. "'She Worked Her Head Off': Edwin and Louise Rosskam and the Golden Age of Documentary Photography Books." *The Photo Review,* vol. 23, no. 4 (Fall 2002).
- Stange, Maren. *Bronzeville: Black Chicago in Pictures, 1941–1943.* New York: The New Press, 2003.
- Wright, Richard, and Edwin Rosskam. *Twelve Million Black Voices: A Folk History of the Negro in the United States.* New York: Viking Press, 1941.

LOUISE ROSSKAM

- Katzman, Laura, and Beverly W. Brannan. *A Life in Photography: Louise Rosskam and the Documentary Tradition.* Brochure for retrospective exhibition at Maier Museum of Art. Lynchburg, Va.: Randolph-Macon Woman's College, 2002.
- Rosskam, Louise. Interview with Richard K. Doud. Roosevelt, N.J., August 3, 1965. Archives of American Art, Smithsonian Institution, Washington, D.C. www.aaa.si.edu/collections/oralhistories/transcripts/rosska65.htm.
- ———. Interview with Gary Saretzky. Roosevelt, N.J., March 24, 2000. www.visitmonmouth.com/oralhistory/bios/RosskamLouise.htm.
- ———. Twenty prints by photojournalist Louise Rosskam and portraits of Rosskam taken by family and friends. Lot 13349, Prints and Photographs Division, Library of Congress, Washington, D.C.

ARTHUR ROTHSTEIN

- Peterson, John. Biography in progress.
- Rothstein, Arthur. *Arthur Rothstein, Words and Pictures.* New York: Amphoto/Billboard Publications, c. 1979.
- ———. *Color Photography Now.* New York: American Photographic Book Pub. Co., 1970.
- ———. *Documentary Photography.* Boston: Focal Press, 1986.
- ———. Interview with Richard K. Doud. New York, May 25, 1964. Archives of American Art, Smithsonian Institution, Washington, D.C. www.aaa.si.edu/collections/oralhistories/transcripts/rothst64.htm.
- ———. Papers. Manuscript Division, Library of Congress, Washington, D.C.
- ———. *Photojournalism: Pictures for Magazines and Newspapers.* New York: American Photographic Book Pub. Co., 1956
- ———. Unprocessed photographic collection. Prints and Photographs Division, Library of Congress, Washington, D.C.
- Rothstein, Arthur, and William Saroyan. *Look at Us; Let's See; Here We Are; Look Hard, Speak Soft; I See, You See, We All See; Stop, Look, Listen; Beholder's Eye; Don't Look Now, But Isn't That You? (Us? U.S.?).* New York: Cowles Education Corp., 1967.

BEN SHAHN

- Greenfeld, Howard. *Ben Shahn: An Artist's Life.* New York: Random House, 1998.
- Kao, Deborah Martin, Laura Katzman, and Jenna Webster. *Ben Shahn's New York: The Photography of Modern Times.* Cambridge, Mass.: Fogg Art Museum, Harvard University, 2000.
- Rodman, Selden. *Portrait of the Artist as an American.* New York: Harper, 1951.
- Shahn, Ben. Interview with Richard K. Doud. Roosevelt, New Jersey, April 14, 1964. Archives of American Art, Smithsonian Institution, Washington, D.C. www.aaa.si.edu/collections/oralhistories/transcripts/shahn64.htm.
- ———. Papers. Fogg Art Museum, Harvard University, Cambridge, Mass.
- Shahn, Bernarda Bryson. *Ben Shahn.* New York: Harry N. Abrams, 1972.

ROY EMERSON STRYKER

- Stryker, Roy E. Interviews with Richard K. Doud. Montrose, Colo., October 17, 1963; June 13, 1964; January 23, 1965. Archives of American Art, Smithsonian Institution, Washington, D.C. www.aaa.si.edu/collections/oralhistories/transcripts/stryke63.htm. A June 14, 1964, interview with Doud, is available only on microfilm.
- ———. *Roy Stryker Papers, 1912–1972.* Edited by David Horvath. Louisville: University of Louisville Photographic Archives; Teaneck, N.J.; distributed by Chadwyck-Healey, 1982. Microfilm.
- Stryker, Roy E., and Mel Seidenberg. *A Pittsburgh Album, 1758–1958: Two Hundred Years of Memories in Pictures and Text.* Pittsburgh (?), Pa., 1959.
- Stryker, Roy E., and Nancy C. Wood. *In This Proud Land: America, 1935–1943, As Seen in the FSA Photographs.* New York: Galahad Books, 1973.
- Thomas, Clarke M., Constance B. Schulz, and Steven W. Plattner. *Witness to the Fifties: Pittsburgh Photographic Library, 1950–1953.* Pittsburgh, Pa.: University of Pittsburgh Press, 1999.
- Tugwell, Rexford G., Thomas Munro, and Roy Stryker. *American Economic Life and the Means of Its Improvement.* 2d rev. ed. New York: Harcourt, Brace & Co., 1925.

JOHN VACHON

- Orvell, Miles, ed. *John Vachon's America: Photographs and Letters from the Depression to World War II*. Berkeley and Los Angeles: University of California Press, 2003.
- Vachon, Ann, ed. *Poland, 1946: The Photographs and Letters of John Vachon*. Washington, D.C.: Smithsonian Institution Press, 1995.
- Vachon, John. Papers. Manuscript Division, Library of Congress, Washington, D.C.
- ———. Interview with Richard K. Doud. New York, April 28, 1964. Archives of American Art, Smithsonian Institution, Washington, D.C. www.aaa.si.edu/collections/oralhistories/transcripts/vachon64.htm

COLOR PHOTOGRAPHS

- Hendrickson, Paul. *Bound for Glory: America in Color, 1939–1943*. New York: Harry N. Abrams in association with the Library of Congress, 2004.
- Stein, Sally. "FSA Color: The Forgotten Document." *Modern Photography,* January 1979: 90–99, 162–64, 166.

COLLECTED WORKS

- Anderson, Sherwood. *Home Town: Photographs by Farm Security Photographers*. New York: Alliance Book Corp., c. 1940.
- Brannan, Beverly W., and David Horvath, eds. *A Kentucky Album: Farm Security Administration Photographs, 1935–1943*. Lexington: University Press of Kentucky, 1986.
- Carlebach, Michael, and Eugene F. Provenzo Jr. *Farm Security Administration Photographs of Florida*. Gainesville: University Press of Florida, 1993.
- Cohen, Allen, and Ronald L. Filippelli, eds. *Times of Sorrow and Hope: Documenting Everyday Life in Pennsylvania during the Depression and World War II: A Photographic Record*. University Park: Pennsylvania State University Press, 2003.
- Colson, J. B. *Far from Main Street: Three Photographers In Depression-Era New Mexico: Russell Lee, John Collier, Jr., and Jack Delano*. Santa Fe: Museum of New Mexico Press, 1994.
- Curtis, James. *Mind's Eye, Mind's Truth: FSA Photography Reconsidered*. Philadelphia: Temple University Press, 1989.

- Dablow, Dean. *The Rain Are Fallin: A Search for the People and Places Photographed by the Farm Security Administration in Louisiana, 1935–1943*. Tollhouse, Calif.: Scrub Jay Press, 2001.
- Doty, C. Stewart. *Acadian Hard Times: The Farm Security Administration in Maine's St. John Valley, 1940–1943*. With photographs by John Collier Jr., Jack Delano, and Jack Walas. Orono: University of Maine Press, 1991.
- Graff, Nancy Price. *Looking Back at Vermont: Farm Security Administration Photographs, 1936–1942*. Middlebury, Vt.: Middlebury College Museum of Art; Hanover, N.H.: distributed by University Press of New England, 2002.
- Johnson, Brooks. *Mountaineers to Main Streets: The Old Dominion Seen through the Farm Security Administration Photographs*. Norfolk, Va.: Chrysler Museum, 1985.
- Leonard, Stephen J. *Trials and Triumphs: A Colorado Portrait of the Great Depression with FSA Photographs*. Niwot: University Press of Colorado, 1993.
- Martin-Perdue, Nancy J., and Charles L. Perdue Jr., eds. *Talk about Trouble: A New Deal Portrait of Virginians in the Great Depression*. Chapel Hill: University of North Carolina Press, 1996.
- Murphy, Mary. *Hope in Hard Times: New Deal Photographs of Montana, 1936–1942*. Helena: Montana Historical Society Press, 2003.
- Natanson, Nicholas. *The Black Image in the New Deal: The Politics of the FSA Photography*. Knoxville: University of Tennessee Press, 1992.
- Parker, Paul E. *A Portrait of Missouri, 1935–1943: Photographs from the Farm Security Administration*. Columbia: University of Missouri Press, 2002.
- Plattner, Steven W. *Roy Stryker: U.S.A., 1943–1950: The Standard Oil (New Jersey) Photography Project*. Austin: University of Texas Press, 1983.
- Reid, Robert L. *Back Home Again: Indiana in the Farm Security Administration Photographs, 1935–1943*. Bloomington and Indianapolis: Indiana University Press, 1987.
- ———. *Picturing Minnesota, 1936–1943: Photographs from the Farm Security Administration*. St. Paul: Minnesota Historical Society Press, 1989.
- ———. *Picturing Texas: The FSA-OWI Photographers in the Lone Star State,*

1935–1943. Austin: Texas State Historical Association, 1994.
- Reid, Robert L., and Larry A. Viskochil, eds. *Chicago and Downstate: Illinois as Seen by the Farm Security Administration Photographers, 1936–1943*. Chicago: Chicago Historical Society; Urbana: University of Illinois Press, 1989.
- Schulz, Constance B., ed. *Bust to Boom: Documentary Photographs of Kansas, 1936–1949*. Lawrence: University Press of Kansas, 1996.
- ———, ed. *Michigan Remembered: Photographs from the Farm Security Administration and the Office of War Information, 1936–1943*. Detroit: Wayne State University Press, 2001.
- ———, ed. *A South Carolina Album, 1936–1949: Documentary Photography in the Palmetto State from the Farm Security Administration, Office of War Information, and Standard Oil of New Jersey*. Columbia: University of South Carolina Press, 1991.
- Stoeckle, John D., and George Abbott White. *Plain Pictures of Plain Doctoring*. Cambridge, Mass.: MIT Press, 1985.

Editorial director: Gilles Mora

Pre-press: Amilcare Pizzi, Milan, Italy

Project manager, English-language edition: Magali Veillon

Editor, English-language edition: Nancy E. Cohen

Designer, English-language edition: Shawn Dahl

Cover design, English-language edition: Brady McNamara

Production manager, English-language edition: Colin Hough Trapp

Gilles Mora's texts were translated from the French by Nicholas Elliott

Library of Congress Cataloging-in-Publication Data

Brannan, Beverly W., 1946–

 FSA : the American vision / Beverly W. Brannan and Gilles Mora.
 p. cm.

 Includes bibliographical references.

 ISBN 10: 0–8109–5497–4 (hardcover)
 ISBN 13: 978–0–8109–5497–7

 1. Documentary photography—United States—History—20th century. 2. United States.
 Farm Security Administration—History. I. Mora, Gilles, 1945– II. Title.

 TR820.5.B736 2006
 779'.9973910922—dc22

 2006012013

Published in 2006 by Abrams, an imprint of Harry N. Abrams, Inc.

Printed and bound in Italy

10 9 8 7 6 5 4 3 2 1

HNA
harry n. abrams, inc.
a subsidiary of La Martinière Groupe

115 West 18th Street
New York, NY 10011
www.hnabooks.com